# URBAN ART
## *CHICAGO*

### A GUIDE TO COMMUNITY MURALS, MOSAICS, AND SCULPTURES

OLIVIA GUDE AND JEFF HUEBNER

IVAN R. DEE

Chicago

Library of Congress Cataloging-in-Publication Data:
Gude, Olivia.
Urban art Chicago : A guide to community murals, mosaics, and sculptures / Olivia Gude and
Jeff Huebner.
p. cm.
Includes bibliographical references and index.
ISBN 1-56663-284-6 (alk. paper)
1. Community art projects—Illinois—Chicago—Guidebooks. 2. Public art—Illinois—Chicago—
Guidebooks. 3. Chicago (Illinois)—Guidebooks. 4. Artists and community—Illinois—Chicago.
I. Huebner, Jeff, 1954– II. Title.

N8844.G83 2000
709'.773'1107477311—dc21
00-024116

This book is dedicated to William Walker and John Pitman Weber,
men of vision and dedication who founded a group and fostered a movement.

# ACKNOWLEDGMENTS

It is fitting that the idea for *Urban Art Chicago* began in a graduate seminar entitled "Communities of Discourse" at the University of Illinois at Chicago. In the seminar, Olivia Gude and students looked at ways that artists can form artistic practices that arise out of and respond to the needs of communities. Eileen Engel Wagner, then a graphic design graduate student, decided to put her artistry to use to create a prototype for the first guide to Chicago community public art in more than twenty years. Her initial work and enthusiasm for the project encouraged us to take up the task of researching and writing this book. We are grateful to Eileen for creating a new design for this final, expanded version of the guide.

Like community public art, this guide is an intensively collaborative endeavor. Many organizations and individuals have made this guide possible. We would like especially to thank Chicago Public Art Group director Jon Pounds, whose "unrealistic optimism" has turned this and many other community art projects from a vision into reality. His support in choosing artworks, collecting documentation, managing interns, fundraising, and designing the location maps was invaluable. We appreciate the assistance of CPAG staffers Karin Warch and Franklin Cason in ferreting out details from CPAG's thirty years of archives on Chicago community art. We are grateful for the careful work of our research assistants Angie Smith, Frank Mitchell, and Sofya Hatten.

We appreciate the many dedicated photographers who have documented the Chicago community public art movement. Thanks to Jim Prigoff for his many trips to Chicago over the years to get just the right shot. Thanks to Eric Wagner of Infocomm for prepress production support. The attention to detail of our editors Ivan Dee and Hilary Schaefer was critically important to the accuracy and style of the book.

The essay "The Chicago Mural Movement: Toward a History" grew out of previously published works by Jeff Huebner with additional insights and information added by Olivia Gude. We gratefully acknowledge research on Pilsen murals provided by Inara Cedrins, who shared her unpublished graduate thesis with us.

We consulted many artists and organizers in our search for the most interesting community art pieces. Thanks to Juan Chávez, Nina Smoot Cain, Tim Drescher, Marcos Raya, John Pitman Weber, Bernard Williams, and Mirtes Zwierzynski for their wisdom and advice.

Support for the research, production, and distribution of U*rban Art Chicago* was provided by:
Chicago Public Art Group
Illinois Humanities Council
Butz Foundation
Graham Foundation
National Endowment for the Arts
Illinois Arts Council
American National Bank Foundation
Elizabeth F. Cheney Foundation
Playboy Foundation
Polk Bros. Foundation
Great Cities Institute, University of Illinois at Chicago

# CONTENTS

# PREFACE

Chicago, often described as a "city of neighborhoods," is intimately associated with the beginnings of community public art. In the late 1960s Chicago artist-activists began outlining neighborhood agendas on the walls of underpasses, community centers, and supportive businesses. Sparked by the many grass-roots cultural and political movements of the 1960s and 1970s, murals spread quickly from their big-city origins in Chicago, New York, and Los Angeles to towns and cities throughout the Americas and ultimately around the world.

The concept of community murals is now so familiar that it is difficult to believe that until the late 1960s the form did not exist. In the past, murals were commissioned by private patrons or government agencies and, in harsh Northern climates, were usually painted safely indoors. Community muralists did not wait for official commissions; then, as now, they worked closely with neighborhood residents, community organizations, and funders to conceive, organize, and support their projects. Community public art is on the streets and in the schools and community centers, unprotected from vandalism except by the protective goodwill of the surrounding community.

Except for monuments in parks or plazas, before the advent of the community mural movement the art of public space represented business—the signs and billboards of everyday commerce. Community murals pictured a different America—striving to achieve social justice, showing respect for difference, and often affirming traditional values of family, neighborhood, and spirituality. Many contemporary murals continue to investigate the complex relationship between the reclamation of cultural heritage and the ability to envision new social possibilities. It is an interesting paradox that the mural form, known for its celebration of ethnic pride, is also noted for its commitment to visualizing a harmonious, multiracial society.

Community public art creates unique urban places. As community artists have expanded into working in other media—mosaics, sculptural concrete, landscape, and space design—new possibilities have emerged. Many of these new media represent the strength of community—not through direct narration of community stories in images but as demonstrations of the community's power to positively shape its own environment. Community public art creates a sense of ownership and pride in place. It reaffirms the tradition of belonging to and caring for the place one calls "home."

This book—the first devoted solely to the Chicago community public art movement—is a guide to the most visually stimulating and historically significant projects produced over the last three decades. The desire to showcase the outstanding works, and the costs of producing this book, demanded that we make difficult choices about what to include from roughly three hundred extant pieces. This was especially challenging because community art projects are close to home and heart. We regret having to omit works that may be favorites of some readers. One guideline we reluctantly followed was not to include significant works that are very badly damaged or destroyed. Occasionally an entry will direct you to nearby works which, while faded or chipping, are still legible reminders of the early days of the mural movement.

Another guideline was to include only *community* public artworks. This, of course, calls up important questions, What are the defining characteristics of a *community-based* artwork? Does it mean the community chose the theme, paid for it, helped design the work, actually made it—or all of the above?

There are no simple answers to these questions. A community mural may be painted by a single artist who, in touch with the values and issues of a place, goes out alone to face a wall with a ladder, a brush, and a few cans of paint. A community project may be created by a team of visiting artists who work with neighborhood youths to design and produce the work under the artists' direction. Or a community artwork may arise out of an elaborate decision-making process facilitated by an artist and involving community members of all ages. A project may involve community participants only in the design phase, or it may involve them in executing a design created by the lead artist. The imagery in the project may be the result of the collective refinement of images contributed by community members, or it may incorporate the individual designs of dozens or hundreds of people.

Assigning artistic credit for community artworks often raises complex questions about how murals are conceived and painted. The mythology of the form suggests that the works are a kind of folk art or *art brut*—direct communications from community members to the community, unmediated by the support of professional artists. In actual practice, most of the significant and expressive community public art projects are led by one or several trained artists who have a strong hand in directing the work. Accordingly, this book lists for each mural the lead artist or artists whose aesthetic sensibilities and organizational styles shaped the look of the completed work. This does not diminish the importance of youth and adult par-

ticipants; rather, it places in context the authentic contributions of community members within the forms created by experienced community artists.

Community public artworks are also defined by a project's sponsorship. Often local or professional artists are engaged by community or neighborhood organizations to create projects that exemplify their missions of service, advocacy, or activism. By contrast, an artist wishing to address a particular issue or theme sometimes seeks out a group to contribute to a project artistically and financially. Many community public artworks are created through art education programs designed for at-risk or artistically gifted youths. Occasionally a government agency or other entity commissions a work through an organization such as the Chicago Public Art Group, and the artists plan the work in a way that turns what could have been a conventional individual commission into one that incorporates community input. Many community artworks have multiple funders and sponsors; the partnering of city agencies, schools, foundations, community organizations, and neighborhood contributors becomes an important component of the meaning of the artwork—the very existence of the work is a tribute to the efficacy of dialogue and collaboration.

Perhaps the best way to understand the nature of community public art is not solely through how it is made but by how it is perceived once completed. In effective community-based art, the conventional relationship of artist to audience is blurred and redefined. The audiences become the artists as they participate in the conception and making of the work. The artists become part of the community through learning the people's history and through participating in the life of a place. The art's content, along with the stories of how it was made, combine to create an artwork that is "owned" by the community. As someone once said at a public art hearing, "We want one of those murals which are about us."

Since its beginnings as a mural movement, the community public art movement has evolved to use a variety of materials and methods. Each medium has unique advantages as well as built-in limitations. Early murals were often executed with enamel paint or with a hodgepodge of donated materials on walls already coated with layers of unknown paints. Nowadays high-quality acrylic paint is used on bare walls coated with acrylic gesso, because this allows the wall to "breathe." An advantage of painted murals is the relative ease of including many complex narrative elements in a realistic style and, in more recent murals, of incorporating a variety of pictorial styles within a single work.

This book includes projects in all the major media that have been used in community public art—painted murals on

walls and panels; mosaics of glass and ceramic tile as well as stone; sculpted, cast, frescoed, and sgraffitoed concrete; carved wood and stone, and hand-formed ceramics. Although the book is intended as a guide for locating and viewing artworks, it can also be read as a continuous text because it gives details about materials and methods at the first entry for a work that utilizes a particular media or style.

Throughout the opening essay and the entries, we highlight the role of several ongoing and defunct arts organizations that have supported community public art. These include the Public Art Workshop, MARCH (Movimiento Artístico Chicano), Taller Mestizarte, archi-treasures, and the Chicago Public Art Group (formerly the Chicago Mural Group). It is important to recognize that while some works are the result of a collaboration between a single artist and a community group, many projects are created through partnerships between the community and arts organizations. Arts groups sometimes provide material support for projects, but most important they provide a context for artists to develop and share technical and aesthetic know-how.

Chicago Public Art Group is the cosponsor of many of the works in this book. The longevity of CPAG (which celebrated its thirtieth anniversary in 2000); the Group's commitment to providing solid financial, administrative, and material support for community arts projects; and its ongoing series of workshops to cultivate and disseminate new technical possibilities has motivated many of the city's most accomplished community public artists to do some of their work under its auspices. To avoid the repetitiousness of mentioning CPAG as a cosponsor in many entries, we used its initials—CMG for work from 1970 through 1984, CPAG for work from 1985 through 1999—in parentheses at the end of the site entry.

Our final criterion for selecting artworks to include in this book is what we call the "Wow Factor." As in other art forms, the significance and meaning of community public art depend on how effectively it melds color, form, and content into a compelling aesthetic experience as well as on an understanding of the processes by which the work was made. In public art the use of space, scale, and context are also important contributing factors to a work's impact. In choosing art for this book, we have imagined the moment when you turn the corner or when your students step off the bus—the moment when you say, "Wow, this was worth the trip."

Olivia Gude and Jeff Huebner

*Chicago*
*January 2000*

# URBAN ART CHICAGO

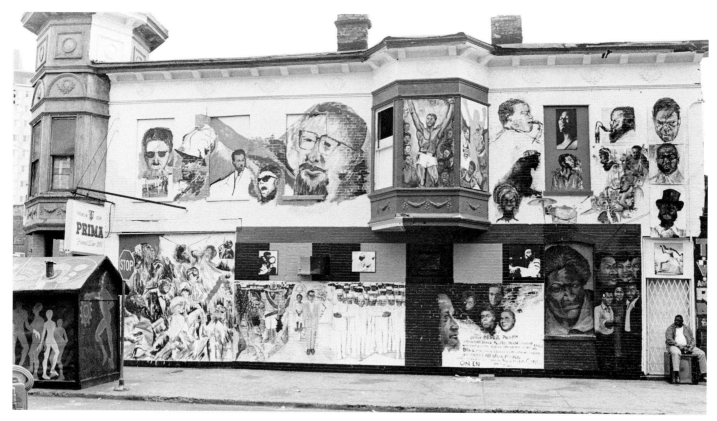

*Wall of Respect*, 1967.

# THE CHICAGO MURAL MOVEMENT: TOWARD A HISTORY

It began inauspiciously. In August 1967 some twenty artists belonging to the Visual Art Workshop of the Organization for Black American Culture, or OBAC (pronounced *obasi*, the Yoruba word for "chieftain"), began painting an outdoor mural on a two-story building at the southeast corner of 43rd Street and Langley Avenue, an impoverished area on the South Side of Chicago which was slated for urban renewal.

The **WALL OF RESPECT**, as the work was called, featured fifty portraits of notable African Americans—statesmen, religious leaders, musicians, athletes, actors, literary figures. The wall quickly became a local landmark. Its creation was accompanied by a month-long street arts festival and drew visitors from throughout the city and country. "This Wall," declared its inscription, "was created to Honor our Black Heroes, and to Beautify our Community."

Yet the **WALL OF RESPECT** did more than just honor and beautify; it was a significant event that was also designed to educate and empower people who were not well served by the content and concerns of the mainstream art world. Spurred by the civil rights struggles of the 1950s and the emergence of the black power movement in the 1960s, the wall's social consciousness and collaborative activity launched an art revolution: it marked the beginning of the community-based mural movement, which soon spread to other minority, working-class Chicago neighborhoods, to across the nation—and beyond.

Like all revolutions, the mural's creation was rooted in subversive notions: art as a tool for social change and the right of people to use art publicly to portray themselves—to reclaim their culture and history, and to assert pride in their heritage. It was a collective act of community-conscious artists, done by, for, and of their people.

William Walker, the only group member who had been trained as a muralist and who was a key person in rallying community support, is often considered to be the wall's originator. Because he continued to be active in Chicago as a muralist and was the main link between the **WALL OF RESPECT** and the artists who began to identify themselves as muralists over the next few years, Walker is generally regarded as the movement's founding father.

Walker's aesthetics and social concerns, and those of other early community muralists, were influenced by the revolutionary Mexican masters—including "*Los Tres Grandes*," Diego Rivera, José Clemente Orozco, and David Alfaro Siqueiros—as well as by New Deal murals of the Works Progress Administration (WPA). The movement's progenitors also owed a debt to earlier

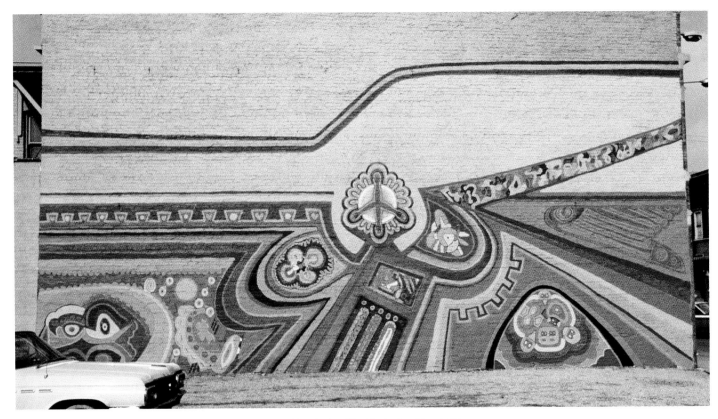

*Wall of Brotherhood* by Mario Castillo, 1969.

African-American artists such as Aaron Douglass, Charles White, and Hale Woodruff who maintained their own mural tradition before, during, and after the WPA era and who produced interior mural commissions that portrayed themes relating to the black American experience.

About the same time another Chicago mural movement was also emerging in the predominantly Mexican-American neighborhoods of Pilsen and Little Village. Inspired by the United Farm Workers and Chicano civil rights movements, artists took to the barrio walls and began expressing their cultural heritage and history as well as the struggles and aspirations of *la raza*. Mario Castillo and area youths painted two largely abstract murals—**METAFISICA** (1968) and **WALL OF BROTHERHOOD** (1969)—which were among the first Latino community murals in the United States—by 1990 both were gone.

Near the Cabrini-Green public housing complex, John Pitman Weber, a white artist who had recently received a graduate degree from the School of the Art Institute, in 1969 painted his first mural, **ALL POWER TO THE PEOPLE**, with black youths. A year later Raymond Patlán, who had painted a mural in Vietnam in the late 1960s, began painting his ethno-historical mural cycle at Casa Aztlán, which soon became a base of operations for several Pilsen muralists.

From the beginning, outdoor mural activity in Chicago was characterized by artists and communities working together. The city's ethos—and building scale—provided a rich soil in which "the people's art movement" could take root and grow: Chicago was historically a center of socially conscious art and literature, of innovative community organizing efforts, and of working-class culture and labor conflict. The protest and liberation movements, and social upheavals, of the late 1960s inspired artists to question the status of artworks as consumer collectibles and to look for ways to decommodify art and contribute to the emerging culture. Message-oriented street murals developed as an ideal way for artists to bypass the museum and gallery systems and to make art more relevant to peoples' everyday lives.

In 1970 Weber and Walker cofounded the Chicago Mural Group. A multiracial cooperative of artists and cultural activists, CMG's mission was to create meaningful public art in the city's diverse neighborhoods through direct people-to-artist and artist-to-people communication. In what was then an unprecedented practice, the muralists often involved community residents who were mostly untrained as artists in the actual painting of the work.

The "Murals for the People" exhibit at Chicago's Museum of Contemporary Art in early 1971 lent this populist, street art institutional legitimacy and was the occasion for the issuance of a manifesto, "The Artists' Statement." Museumgoers could view muralists Weber, Walker, Eugene Eda, Mark Rogovin, and Mitchell Caton actually painting pieces on panels which were later installed in community sites.

As new resources for funding became available, works proliferated. By the end of 1971, more than sixty walls had been painted throughout Chicago, including such seminal (yet no longer extant) works as Walker's **PEACE AND SALVATION: WALL OF UNDERSTANDING**, Eda's **WALL OF MEDITATION**, Weber's **WALL OF CHOICES**, Don McIlvaine's **BLACK MAN'S DILEMMA,** and Caton's **RIP OFF/UNIVERSAL ALLEY** and **NATION TIME**. Over the next several years CMG expanded to include such artists as Barry Bruner, Esther Charbit, Justine DeVan, Astrid Fuller, José Guerrero, Santi Isrowuthakul, Oscar Martinez, Celia Radek, Jim Yanagisawa, and Caryl Yasko.

Starting in the early 1970s, other artists and organizations tapped the potential of the evolving art genre to involve—and to politicize—racial and class-based constituencies. Puerto Rican Art Association members painted murals in West Town and Humboldt Park depicting Puerto Rican nationalist movement figures and events. In 1972 Mark Rogovin, who had studied at the Siqueiros Workshop in Cuernavaca, Mexico, founded the Public Art Workshop. This mural-painting and resource center was based in the West Side Austin neighborhood where Rogovin led residents in the painting of such early influential works as **PROTECT THE PEOPLE'S HOMES** and the extant **BREAK THE GRIP OF THE ABSENTEE LANDLORD**.

The formation of the Chicago chapter of MARCH (Movimiento Artístico Chicano) in the mid-1970s by arts activists José González, Victor Sorell, and others galvanized mural activity in Pilsen as well as in other Latino communities. Along with Patlán, Guerrero, and Martínez, all of whom worked with CMG, Ricardo Alonzo, Carlos Barrera, Carlos Cortez, Aurelio Díaz, Vicente Mendoza, Oscar Moya, Benny Ordoñez, Marcos Raya, Rey Vasquez, Salvador Vega, and Roman Villarreal defined Chicago's Mexicano/Latino muralism of the decade.

Through the 1970s mural production became a more formalized activity, which often involved the participation of youths in government-sponsored summer employment programs such as CETA (Comprehensive Employment Training Act). Partly as a result of this, as well as the tenor of the times and the artists' desire to model idealistic values for youth participants, a general shift occurred from murals of a militant political nature toward works with a more eclectic range of content, including multiracial and consensus-building themes. Works such as Yasko and Radycki's **ROOTS AND WINGS** (1976) and Weber and Bruner's **OUR LIVES—NUESTRAS VIDAS** (1978) are examples of murals that sought to represent common ground in racially mixed neighborhoods.

Murals also reflected such themes as cultural and ethnic pride; community concerns and solutions; neighborhood history and solidarity; the benefits of family, education, and personal achievement; and feminist and labor issues. An increased emphasis on aesthetics appeared as mural art grew more sophisticated—formally, stylistically, and collaboratively. In 1977

*Black Women Emerging* by Justine DeVan, 1977.

the publication of the first full-length book on street murals, *Toward a People's Art: The Contemporary Mural Movement* by Eva Cockcroft, John Pitman Weber, and James Cockcroft documented the complex social, political, and aesthetic issues that formed the early years of the movement, primarily focusing on Chicago and New York.

Landmark murals from 1974–1979 that survive include **HISTORY OF THE PACKINGHOUSE WORKER** by Walker; **WALL OF DAYDREAMING AND MAN'S INHUMANITY TO MAN** by Caton, Walker, and Isrowuthakul; various murals in Hyde Park by Fuller; **TILT (TOGETHER PROTECT THE COMMUNITY)** by Weber and others; **BLACK WOMEN EMERGING** by DeVan; and **A LA ESPERANZA**, designed by Jaime Longoria and painted by several Pilsen muralists at the newly built Benito Juarez High School.

The mid- to late 1970s was also characterized by many pieces in which a number of professional artists collaborated on a single design. The muralists challenged the convention of the solitary artistic genius in such innovative collaboratively designed and painted works as **PRESCRIPTION FOR GOOD HEALTH CARE**, **A TIME TO UNITE**, and **RAZEM**. Other forms of collaboration involved multisectioned works in which artists worked side by side to address a theme or issue such as the **PREVENT WORLD WAR III** mural in Pilsen.

Two 1976 CMG works would strongly influence the aesthetic direction of the Chicago mural movement into the next decade. **ROOTS AND WINGS**, among the first community murals in the nation to incorporate cast concrete, signaled the group's interest in exploring new forms and materials. **A TIME TO UNITE** first united the visions and styles of Mitchell Caton and Calvin Jones.

Over the next decade Caton and Jones collaborated on numerous murals whose jazzy, Afrocentric collage technique helped expand the formal language of mural art. Their works—from 1979's **ANOTHER TIME'S VOICE REMEMBERS MY PASSION'S HUMANITY** to 1987's **BRIGHT MOMENTS, MEMORIES OF THE FUTURE** (New Regal Theater mural)—were among the benchmarks of the movement's maturing years, influencing many successive muralists with striking juxtapositions of volumetric, heroic figures and decorative flat patterning.

The late 1970s and early 1980s was a challenging period for the mural movement. In the increasingly conservative 1980s the grass-roots politics out of which the mural movement arose was on the wane. Competition for public art funding and the professionalization of arts administration made it more difficult to secure necessary resources. Muralists searched for new strategies for forming community partnerships and for funding.

Weber took leave of his directorship post at CMG in 1981 to concentrate on his own artwork and other projects. An influx of energetic and talented women into CMG during this time—among them Cynthia Weiss, Lynn Takata, Kathryn Kozan,

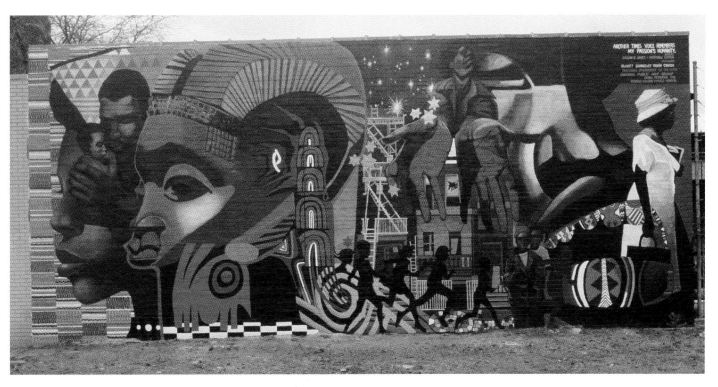

*Another Time's Voice Remembers My Passion's Humanity* by Mitchell Caton and Calvin Jones, 1979.

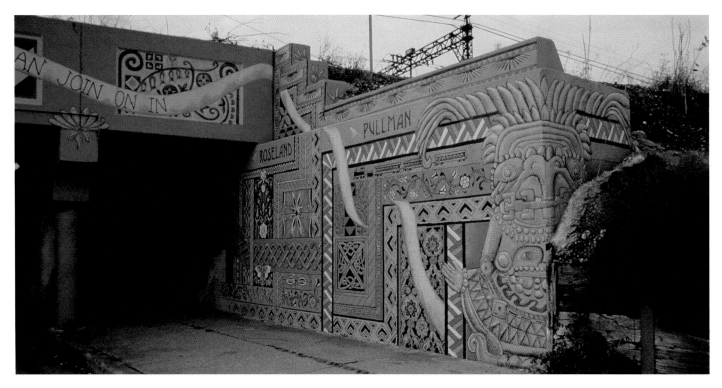

*I Welcome Myself to a New Place* by Olivia Gude, Marcus Akinlana, and Jon Pounds, 1988.

and Nina Smoot Cain—helped maintain the vitality of the community public art movement through their administrative skills and innovative work in mosaics, trompe l'oeil murals, and sculpted concrete.

In 1980 Weiss and Miriam Socoloff, assisted by more than fifty volunteers, created Chicago's first community mosaic, **FABRIC OF OUR LIVES**, at the Bernard Horwich Jewish Community Center in Skokie. Weiss continues to be an active mosaicist. Socoloff, a longtime teacher at Lake View High School, has led students in enhancing the site with numerous mosaic projects.

That same year Takata collaborated with Weber and Guerrero on **FOR THE PEOPLE OF THE FUTURE**, a groundbreaking concrete relief mural which incorporated mosaic and sgraffito. Through the 1980s she worked with schoolchildren and community residents to produce many concrete and mosaic benches and playsculptures.

Using Mexican icons to symbolize themes of cultural identity and community aspiration, Aurelio Díaz was the most visible muralist in Chicago's Mexicano neighborhoods throughout the 1980s. By mid-decade newly arrived muralist Hector Duarte—who had studied at the Siqueiros Workshop—also began painting walls in the Pilsen/Little Village area. He continues to be a committed painter and printmaker in the neighborhood. José Luis Berrios and Gamaliel Ramirez, of Puerto Rican heritage, were especially active with youths in the areas of Logan Square and Humboldt Park.

Reflecting its increased production of art in other media, in 1985 CMG renamed itself the Chicago Public Art Group (CPAG). Jon Pounds and Olivia Gude emerged as key members. With their roots in progressive social movements and in non-permission political street art as well as in art education, Pounds and Gude helped revitalize—and reinvent—the Chicago mural movement and the notion of collaborative, community-based art.

In 1988 the pair created **I WELCOME MYSELF TO A NEW PLACE (THE ROSELAND PULLMAN MURAL)**, with Marcus Akinlana and more than one hundred volunteers. The piece not only signified a return to monumental painted forms in Chicago; it renewed the possibilities of creating large-scale mural projects with complicated community involvement processes in design and execution.

Another key 1988 project was **PYRAMIDS OF POWER** by Cain and John Yancey, a work which sparked renewed interest in the mosaic form with its skillful utilization of commercial-grade ceramic tile to create a stylish tribute to the black family. That same year C. Siddha Sila, who worked with Walker and Caton in the 1970s, began leading Boulevard Arts Center youths in a series of murals, mostly along Garfield Boulevard. In the 1990s Boulevard Arts Center continued its commitment to neighborhood art at its permanent home in Englewood with pieces by well-known community artists from throughout Chicago.

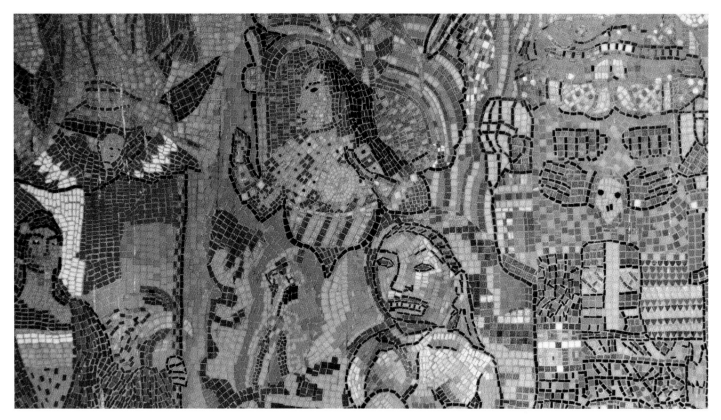

*Homage to the Women of Mexico* by Francisco Mendoza and youths, 1993.

THE CHICAGO MURAL MOVEMENT:
TOWARD A HISTORY

When Pounds became CPAG director in 1988, the group refocused its commitment to artist-member diversity, art education, mentoring, working in experimental media, fundraising, and cultivating new sponsorships. As community agendas became more complex, artists developed new strategies to engage various audiences. With the onset of the 1990s, multiracial, ethnic, and community revitalization themes predominated in murals and other community public art forms as a way to reflect the diversity and complexity of constituencies. Community artists also found themselves in greater demand in the Chicago Public Schools as the school reform movement empowered neighborhood residents and educators to shape their own school environments.

While Judeo-Christian-based spiritual themes and symbolism were a strong component of the early Chicago mural style, Akinlana's cycle of South Shore murals in the early 1990s, introduced African diaspora religious beliefs based on the *orisha* (a pantheon of West African deities) into the visual vocabulary of community public art. Other major influences in the design of Chicago murals in the late 1980s and 1990s included North and South American indigenous religions, the women's spirituality movement, and, especially in the case of the Mexican-American muralists, traditional Catholic iconography.

With Akinlana, Bernard Williams and Dorian Sylvain built upon the African-American mural tradition initiated by Walker and Eda, and extended by Caton and Jones. Their colorful works explore trans-African art, history, and culture themes in the black neighborhoods in which the mural movement has flourished. Such works include **THE GREAT MIGRATION** (Akinlana), the **MURAL OF ENGLEWOOD** (Sylvain), and **FEED YOUR CHILD THE TRUTH** and **TRIBUTE TO PULLMAN PORTERS** (Williams).

From 1989 to 1990 visiting sculptor Henri Marquet worked with Mirtes Zwierzynski, Weiss, and Cain to create the **JACKSON LANGUAGE ACADEMY PLAYSCULPTURES**. The project, which gave a number of CPAG artists the opportunity to experience the process of making a freestanding sculptural installation, stimulated interest in community-built artworks. During the early 1990s a series of projects at The Neighborhood Institute's One and Two Artist Row facilities in South Shore—mosaics, murals, and cast cement archways—also signaled the possibilities of creating dramatic artistic environments in urban spaces. Artists who collaborated on the various pieces include Akinlana, Cain, Gude, Sylvain, Yasko, Zwierzynski, Orisegun Olomidun, Phil Schuster, and Rene Townsend.

The Mexican Fine Arts Center Museum began sponsoring mural activity in Pilsen/Little Village in the early 1990s. Among its most notable projects are those in which art teacher Francisco Mendoza has led students and neighborhood residents on mosaic and mural projects highlighting Mexican culture, including the 18th Street el station, St. Vitus Plaza, and the ongoing epic mosaic cycle on Orozco Community Academy. The Taller Mestizarte print workshop has also functioned as a gathering place for neighborhood muralists in much the same way Casa Aztlán did years earlier.

Graffiti art (nonpermission and otherwise) has for two decades been a visible and vital presence in Chicago's public art and street-culture scene. By the early 1990s graf art was transcending its subway-evolved "wildstyle" roots and achieving mainstream recognition with gallery exhibits and community-based programs; several CPAG artists, including Gude and Williams, collaborated with Dzine and neighborhood youths on a series of innovative acrylic-and-spray-can murals. This brief period of official acceptance of the spray-can form led to a number of innovative graffiti- and hip-hop inspired murals sponsored by the Chicago Transit Authority and Gallery 37.

Although the city's ban on the sale of spraypaint is still in effect, permission pieces by a variety of crews in conjunction with community organizations continue to be painted. Many artists, such as Dzine, Mario Gonzalez, and Chris Silva, who got their start in the street-art underground, have continued to pursue successful artistic careers as studio artists and community muralists.

In the late 1980s and 1990s the resurgence of socially and politically engaged art as well as in art addressing issues of cultural identity led to a traveling retrospective in 1995 on the art of the Chicago community public art movement at the State of Illinois Art Gallery in Chicago and in Springfield. *Healing Walls*, curated by Judith Lloyd, featured drawings, photographs, and documents related to street murals and mosaics as well as their historical antecedents. Three years later the University of New Mexico Press republished the classic *Toward a People's Art* with additional essays documenting the movement in the 1980s and 1990s.

Postmodern sensibilities and experimental collaborative practices have become hallmarks of contemporary community muralism. Gude, using a more theoretically based approach to public art making, has explored notions such as heterogeneity, racial difference, and cross-cultural discourse in murals such as **WHERE WE COME FROM... WHERE WE'RE GOING** and, with Chávez, **FELLOWS & OTHERS**. Weber and Williams have made increasing use of cut paper to design innovative works such as **URBAN WORLD AT THE CROSSROADS**. Younger artists such as Kristal Pacheco, Tim Portlock, Beatriz Santiago Muñoz, and Robert Moriarty have been influenced by these approaches, and many have gone on to use collaborative collage techniques and various pictorial styles to portray complex visions of communities and culture.

Throughout the 1990s Chicago artists have continued to develop the form of community mosaicmaking. In works such as **JENSEN MOSAIC** by Chávez, **ROAD TO WISDOM** by Olomidun and Zwierzynski, and **PEACE BY PIECE** by Cain and Weber, artists have designed complex multisectioned compositions with innovative tessellation incorporating diverse tile shapes. Many artists have built on the elegant, linear style of working with 3/4-inch glass tile developed by Weiss and Zwierzynski in the 1980s. Recent works by Chávez, Gude, Julia Sowles, and Ginny Sykes include such elements as realistic imagery and intricate tile patterns.

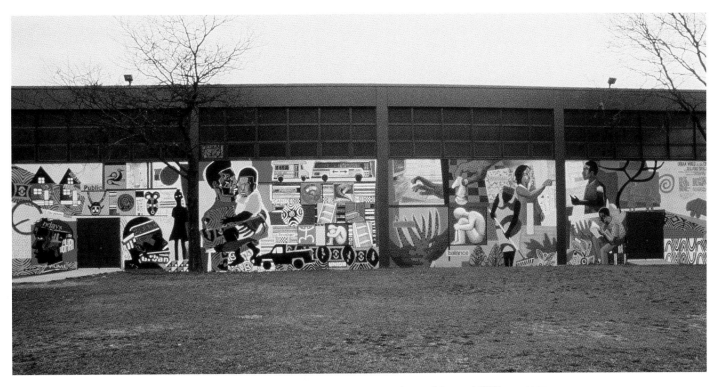

*Urban World at the Crossroads* by John Pitman Weber and Bernard Williams, 1997.

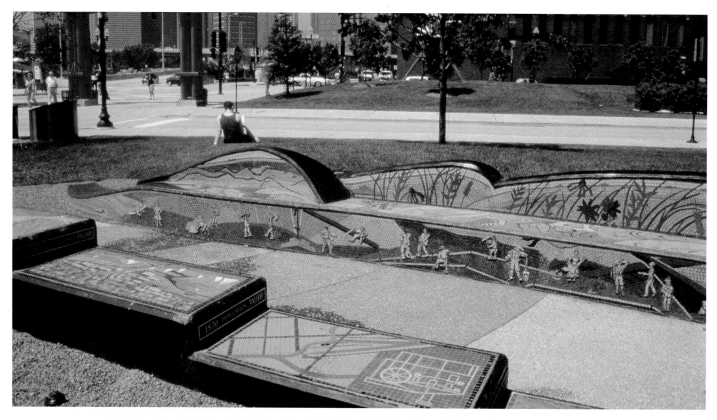

*Water Marks* by Olivia Gude, Kiela Songhay Smith, Cynthia Weiss, Mirtes Zwierzynski, and Jon Pounds, 1998.

An increasing number of artists and residents have worked with schools, community centers, and other institutions to reclaim and beautify public neighborhood spaces with community-built works—art parks and playlots, garden galleries, seating areas, and sculptural and space-design projects. This movement "off the wall"—pioneered by the freestanding, cast-and-sculpted-concrete pieces by Weber and Takata in the early 1980s and spurred by the City of Chicago's current emphasis on enhancing its public realm and aesthetic infrastructure—acknowledges that people need public spaces in which they can interact and thus create a sense of community.

Building on the precedents of individually created folk art gardens, community-designed parks and artspaces emerged on the city's South Side with the Boulevard Arts Center (1991), and several years later at the Donnelley Youth Center. Each site features an extensive (and evolving) collection of community public art, in a variety of media, that reflects African-American heritage and culture. Beginning in the mid-1990s archi-treasures, the Chicago Botanic Gardens, the Open Lands Project, and CPAG, partnering with a variety of city agencies and other nonprofit groups, have designed and built spaces involving elements of art, architecture, landscape design, and horticulture. These works include playful and innovative neighborhood spaces such as archi-treasures' **PULASKI COMMUNITY ACADEMY GARDEN GALLERY** and the Open Lands' **ABC YOUTH CENTER SCULPTURE GARDEN**—each featuring works by Schuster in a variety of media and materials.

CPAG's **FROM MANY PATHS WE COME** (the Sunnyside Mosaic Mall), by Sykes and Zwierzynski in collaboration with the Chicago Department of Transportation, and Zwierzynski's **NEW PATTERNS/FUTURE VISIONS** at Senn High School's Unity Garden, are innovative partnerships between community artists, urban designers, and city government. Still evolving sculpture and mosaic environments at Beth-Anne Life Center and at Lake View High School (whose outdoor art gallery was begun by teachers and students in 1984) highlight how community art can affect the ambience of urban space.

The most ambitious project to date is CPAG's intensively collaborative art and landscape design project **WATER MARKS**. These sculpted mosaic bench pieces, which brought community art into the city center, involved the work of 5 lead artists, 16 assistants, and 266 volunteers in 11 Chicago and Illinois communities as well as architects, designers, and engineers.

Outdoor murals, even those painted with high-quality acrylics, inevitably are threatened by Chicago's harsh climate or by urban redevelopment. With the whitewashing of Walker's landmark **PEACE AND SALVATION** in 1991, mural aficionados realized that many of the city's cultural treasures from the 1970s and 1980s were in danger of being lost. While some murals no longer speak to their communities, others continue to be socially relevant, aesthetically powerful, and deserving of restoration.

Unlike the cities of Los Angeles and San Francisco, which have established mural conservation funds, the City of Chicago has yet to initiate a maintenance program for its world-renowned street murals. Since 1993 CPAG, with the help of local sponsors, has been able to restore several fading murals, including works by Walker, Caton, and Jones, and has identified ten significant pieces that are endangered, such as **WALL OF DAYDREAMING AND MAN'S INHUMANITY TO MAN**, **BLACK WOMEN EMERGING**, and **ROOTS AND WINGS**.

Today there is an explosion of mural and other community public art activity by individual artists, cultural institutions, arts organizations, schools, city agencies, and community groups. The community arts movement is supported by longtime sponsors such as Youth Service Project (since 1978) and Chicago Youth Centers as well as by newer organizations such as Gallery 37, the City of Chicago's job training in the arts program. As community arts organizations have received more funding for art education, many artists have become increasingly sophisticated in using design methods that teach art fundamentals along with community art history.

In recent years a number of "new genre public art" practices have emerged nationally, many of them using methods of engagement and advocacy drawn from the traditions of the community mural movement. For example, Sculpture Chicago produced programs in 1993 and 1996 which resulted in innovative temporary, site-specific projects around the city.

Chicago Public Art Group, the only artist-run muralist collaborative in the country, has continued to be a place for community artists to share and develop technical, aesthetic, and organizing strategies. In 1999, to emphasize the potential of relationships between community art and urban design, CPAG and the University of Illinois at Chicago's Great Cities Institute cosponsored *Creating Places*, an invitational dialogue which brought together community artists, arts organizations, urban planners, and representatives of city and nonprofit service agencies. Like many organizations that emerged from the grass-roots political movements of the late 1960s, CPAG has sought to maintain its "street credibility" as it explores effective strategies and partnerships for shaping contemporary urban places and communities.

Building upon the rich legacy of the Chicago mural movement, the community public art movement continues to grow and change. Community artists revitalize neighborhoods through cultural activism and generate new styles of public art by, with, and for the people of the future. In the best community work, artists create works of affirmation and resistance which act as catalysts for individual and social change. As new artists are introduced to community art, they reinvent its traditions—and transform the communities by reflecting their images in art... an art, like the original **WALL OF RESPECT**, that aims to honor and beautify, educate and empower, inform and inspire.

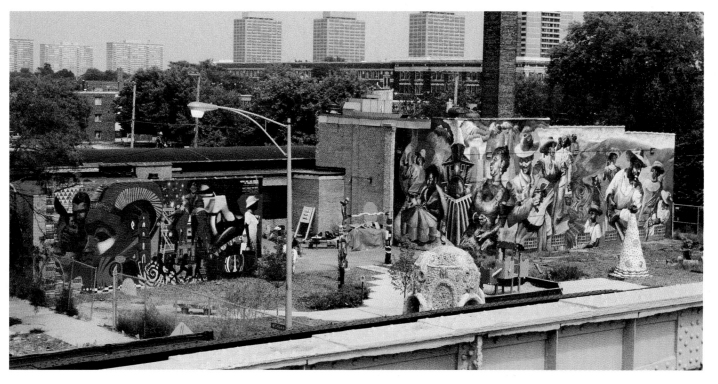

The Donnelley Center Community Art Garden, 1996.

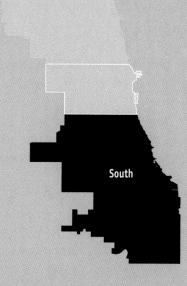

South

SOUTH

# SOUTH

*The South section in this guide is bounded on the north by Cermak Rd. (2200 S) and the Stevenson Expressway, the city limits on the south and west, and the lakefront on the east.*

The cradle of the community mural movement, the South Side is home to a wide variety of historically and aesthetically significant outdoor murals, many dealing with African-American and multiracial themes. Communities such as Hyde Park, South Shore, Bronzeville, Englewood, and Pullman have become well-known mural centers.

William Walker, a founder of the Chicago mural movement, painted most of his masterworks on the South Side. **WALL OF DAYDREAMING AND MAN'S INHUMANITY TO MAN**, painted with Mitchell Caton and Santi Isrowuthakul, is an important early work which presents a vivid picture of the challenges facing African-American communities in the 1970s. The carefully restored **HISTORY OF THE PACKINGHOUSE WORKER** shows Walker's commitment to themes of social justice and racial harmony.

The underpasses of Hyde Park were an important site for early Chicago murals by Walker, Caryl Yasko, and Astrid Fuller. Surviving classic Hyde Park murals include **ALEWIVES AND MERCURY FISH** and the recently restored **CHILDHOOD IS WITHOUT PREJUDICE** by Walker. **CIRCLE JOURNEY** by Beatriz

Santiago Muñoz, Stephanie George, and Ammar Tate and **WHERE WE COME FROM... WHERE WE'RE GOING** by Olivia Gude, brought the Hyde Park mural tradition into the 1990s.

Many of the Afrocentric and aesthetically influential murals of Mitchell Caton and Calvin Jones still exist on Chicago's South Side. Their unique style of combining realistic figures and decorative patterns can be seen in **A TIME TO UNITE** (with Justine DeVan), **ANOTHER TIME'S VOICE REMEMBERS MY PASSION'S HUMANITY**, **BUILDERS OF THE CULTURAL PRESENT**, and **BRIGHT MOMENTS, MEMORIES OF THE FUTURE** at the Regal Theater.

C. Siddha Sila, who got his start lettering spiritual text on early murals by Caton and Walker, has helped turn a drive to Midway Airport along 55th St. west of Interstate 94 into a mural tour featuring his colorful works composed of flat shapes, bold outlines, and mystical text.

1988 was a key year for Chicago Public Art Group—and for Chicago community art. Nina Smoot Cain and John Yancey created the first community mosaic on the South Side, **PYRAMIDS OF POWER; THE BLACK FAMILY**, which ushered in a decade of intensive mosaic collaborations. The 1988 **I WELCOME MYSELF TO A NEW PLACE (THE ROSELAND PULLMAN MURAL)** by Olivia Gude, Marcus Akinlana, and Jon Pounds

helped reinvigorate the mural movement with its use of intensive community involvement and monumental painted forms.

Gude, a white artist, painted several murals on the South Side during the 1990s exploring issues of race, difference, and heterogeneity. These include Where **WE COME FROM... WHERE WE'RE GOING** and, with Juan Chávez, **FELLOWS & OTHERS**.

While most significant Mexican murals are found in the Central Section, the southside Back of the Yards neighborhood is home to Chicago's largest outdoor mural, **LA LOTERÍA**, by Hector Duarte and Mariah de Forest.

In the late 1980s and early 1990s, the South Shore's Neighborhood Institute cosponsored a series of works with CPAG. Akinlana emerged as a major muralist working in a volumetric, dynamic figurative style to create a mural cycle dedicated to the African *orisha*, deities who represent aspects of nature and culture and act as personal guardians. These works include **SOUTH SHORE RESTS ON THE BOSOM OF OSHUN** and **BENU: THE REBIRTH OF SOUTH SHORE** with Jeffrey Cook.

Concentrated along 71st St., one can see many significant mural and mosaic works, including **WHERE THERE IS DISCORD, HARMONY; THE POWER OF ART** by Gude and Akinlana, **THE HOUSE POSTS** mosaic by Cain, other mosaic pieces at Two Artist Row, **BENU**, and the classic Caton and Jones work, **BUILDERS OF THE CULTURAL PRESENT**.

Bernard Williams's **FEED YOUR CHILD THE TRUTH** is an example of the strong influence Caton and Jones have exerted on succeeding generations of muralists. Williams's **TRIBUTE TO PULLMAN PORTERS** (and **URBAN WORLD AT THE CROSSROADS** in the Central section) show his emerging personal style.

The South Side is also home to the community art showcase, the Elliott Donnelley Youth Center, where one can see a wide range of sculptural, mosaic, and painted mural pieces, including Caton and Jones's **ANOTHER TIME'S VOICE REMEMBERS MY PASSION'S HUMANITY**, Akinlana's epic mural **THE GREAT MIGRATION**, and a grotto by Mr. Imagination. Another not-to-be-missed site is the still growing public art collection at the Boulevard Arts Center in Englewood, which features work by such artists as Akinlana, Yancey, and the sculptor Roman Villarreal.

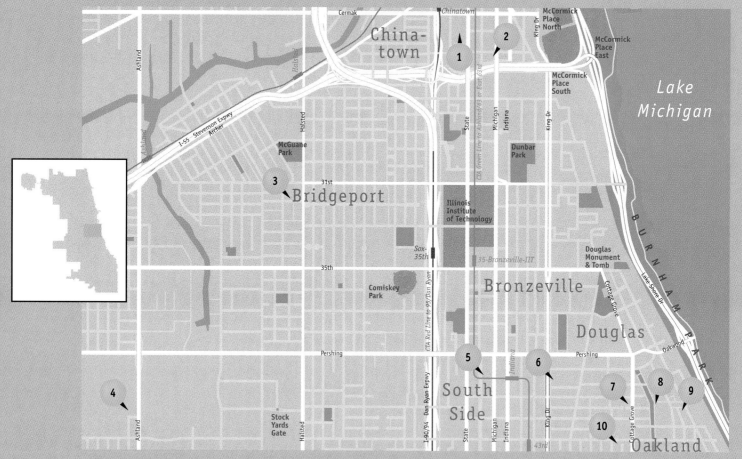

Cermak

Chinatown

McCormick Place North

China-town

McCormick Place East

McCormick Place South

Lake Michigan

Ashland

Halsted

I-55 Stevenson Expwy

Archer

Ashland

McGuane Park

Dunbar Park

State

Michigan

Indiana

King Dr

King Dr

CTA Green Line to Ashland/63 or East 63rd

31st

Bridgeport

Illinois Institute of Technology

Sox-35th

35th

35-Bronzeville-IIT

Douglas Monument & Tomb

Comiskey Park

Bronzeville

Douglas

Cottage Grove

Lake Shore Dr

B U R N H A M   P A R K

Pershing

CTA Red Line to 95/Dan Ryan

Pershing

Oakwood

South Side

Stock Yards Gate

Ashland

Halsted

I-90/94 Dan Ryan Expwy

State

Michigan

Indiana

King Dr

Cottage Grove

Oakland

43rd

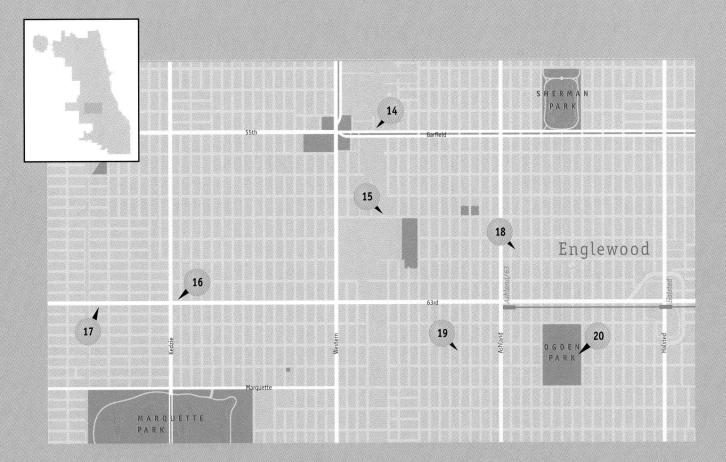

SHERMAN
PARK

14

55th                    Garfield

15

18                    Englewood

16

17

Kedzie                    Western                    63rd                    Ashland/63                    Halsted

19                    20
OGDEN
PARK
Ashland                    Halsted

Marquette

MARQUETTE
PARK

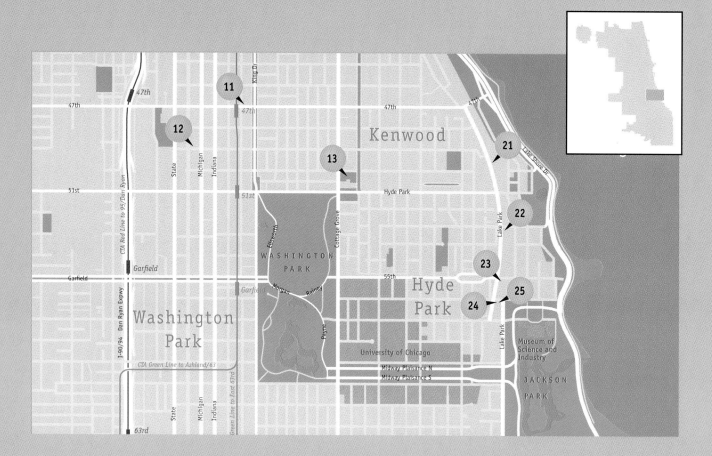

47th

47th

**11**

King Dr

47th

**12**

State

Michigan

Indiana

CTA Red Line to 95/Dan Ryan

51st

51st

**13**

Hyde Park

Ellsworth

Cottage Grove

WASHINGTON
PARK

Garfield

Garfield

Garfield

Morgan

Rainey

55th

Payne

I-90/94 Dan Ryan Expwy

Washington
Park

CTA Green Line to Ashland/63

Green Line to East 63rd

State

Michigan

Indiana

63rd

Kenwood

47th

**21**

Lake Shore Dr.

**22**

Lake Park

**23**

**25**

**24**

Hyde
Park

Lake Park

University of Chicago

Midway Plaisance N

Midway Plaisance S

Museum of
Science and
Industry

JACKSON
PARK

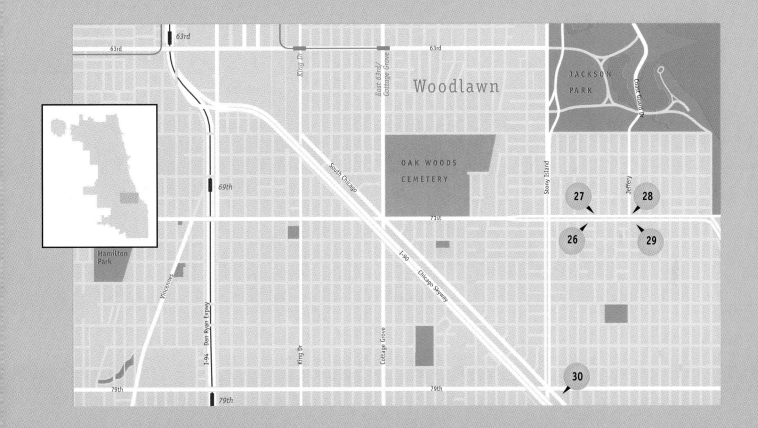

63rd

63rd

63rd

King Dr.

East 63rd/
Cottage Grove

Woodlawn

JACKSON
PARK

Coast Guard Dr

OAK WOODS
CEMETERY

Stony Island

Jeffery

South Chicago

69th

71st

I-90

Chicago Skyway

27

28

26

29

Hamilton
Park

Vincennes

Dan Ryan Expwy

I-94

King Dr

Cottage Grove

79th

79th

79th

30

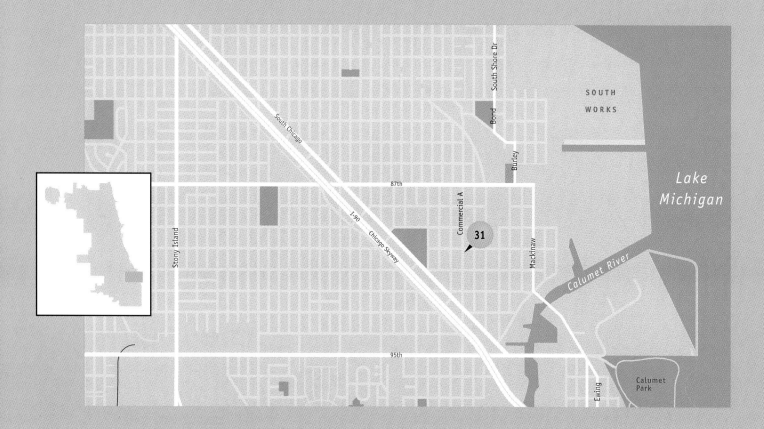

South Shore Dr

Bond

SOUTH
WORKS

Burley

South Chicago

87th

Commercial A

**31**

Mackinaw

Lake
Michigan

I-90 — Chicago Skyway

Stony Island

Calumet River

95th

Ewing

Calumet
Park

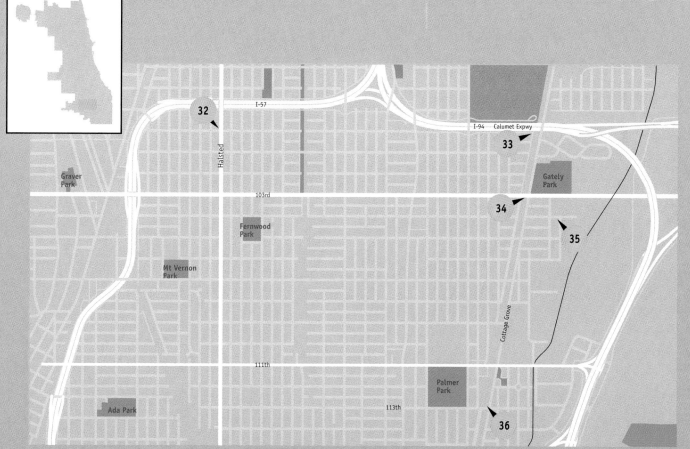

Graver
Park

I-57

**32**

Halsted

I-94   Calumet Expwy

**33**

Gately
Park

103rd

**34**

**35**

Fernwood
Park

Mt Vernon
Park

Cottage Grove

111th

Palmer
Park

Ada Park

113th

**36**

## PYRAMIDS OF POWER; THE BLACK FAMILY 1988

### NINA SMOOT CAIN AND JOHN YANCEY
### 2328 S. Dearborn St.

This ceramic-tile mosaic on the Henry Booth House, a community organization that serves the surrounding public housing, consists of three interlocking pyramids and other symbolic elements to suggest the stability, strength, and structure of family. While the piece honors single-parent households, it also affirms the need for men and women to work together to raise children.

The piece, which incorporates Cain's signature black-and-white right-triangle borders, was made through the "indirect method" in which shaped tiles are laid out face up on a full-scale drawing of the work. The tiles are held together with an adhesive paper on the surface until they are mounted on the wall with cement. (CPAG)

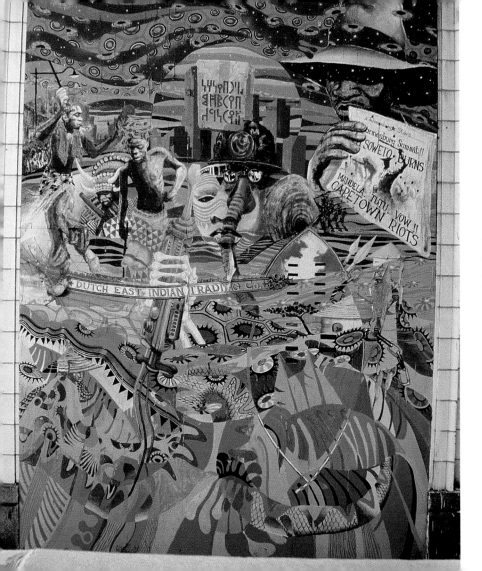

**2**

## CRY THE BELOVED COUNTRY—SOUTH AFRICA EXPOSED 1985

### MITCHELL CATON AND NII OTI ZAMBEZI
### 2400 S. Michigan Ave.

This mural is adjacent to the Chicago Daily Defender building, the home of one of the country's oldest and most respected black-owned newspapers. The mural is a montage of figures, designs, and text which dramatizes the richness of African history and culture. It was painted as an indictment of the then still extant apartheid regime in South Africa. The imagery also deals with the history of African-American journalism. (CPAG)

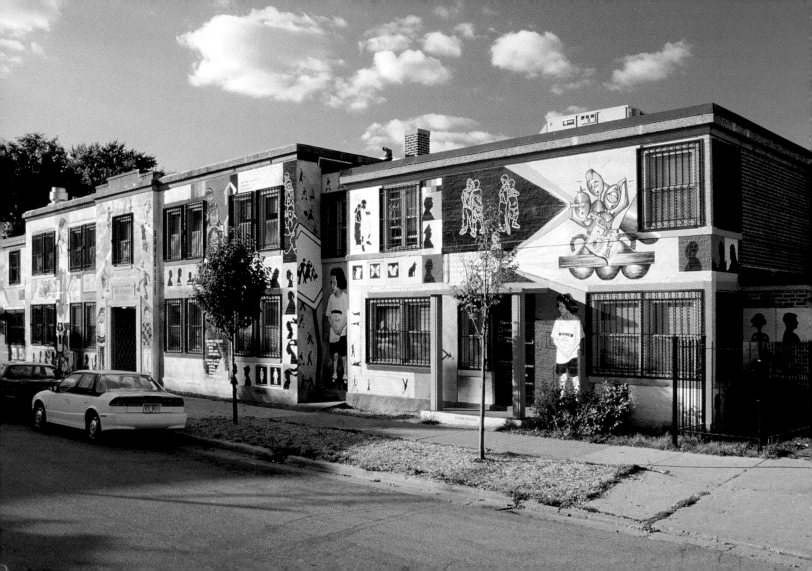

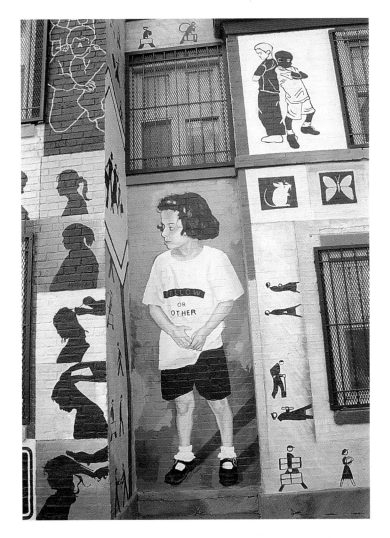

## FELLOWS & OTHERS 1997

### OLIVIA GUDE AND JUAN CHÁVEZ
### 844 W. 32nd St.

Enlivening the entire façade of Fellowship House, a Chicago Youth Center in Bridgeport, the mural addresses issues of racism and explores the question of how people decide whom they consider an "other" and whom they consider a "fellow." Although the mural deals with serious "adult" issues, only paintings of children are included because the artists wanted to create a wall that welcomed neighborhood youth to the center for fun and education.

Silhouettes of many community residents, youth artists, staff, and passersby are a unifying motif. The silhouettes are grouped in various ways to suggest the kinds of categorizations imposed on unique individuals.

A collage of images, styles, and text drawn from discussions with the community and youth participants, the mural includes a "culture machine," shown producing blocks of stereotypes, suggesting that "otherness" and "sameness" are cultural constructs which can be deconstructed. (CPAG)

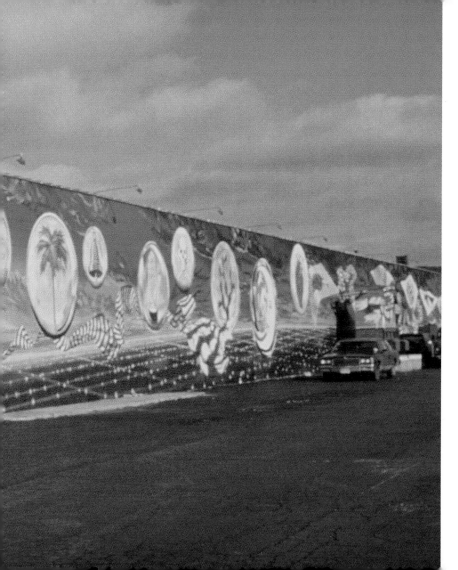

**4**

## HECTOR DUARTE AND
## MARIAH DE FOREST
## 4100 S. Ashland Ave.

The largest mural in the Chicago area, this nearly 500-foot-long piece, painted on the Swap-O-Rama Flea Market in the Back of the Yards area is dominated by images drawn from the traditional Mexican children's game, *Lotería*. Game cards with such symbols as *la bandera*, *la muerte*, and *el corazón* float against an aerial-view backdrop of city and sky. The mural is the best Chicago example of the dramatic spatial effects created by using the "dynamic symmetry" compositional method of the great Mexican muralist David Alfaro Siqueiros.

*The Great Migration* (detail)

# DONNELLEY CENTER COMMUNITY ART GARDEN

## 3947 S. Michigan Ave.

This Bronzeville Chicago Youth Center facility hosts what is perhaps the preeminent collection of public community art in the city. In 1991, encouraged by the Openlands Project, the center began transforming three vacant lots south of its building into a sculpture park, playground, and community garden.

As the first phase of this still evolving site, Mitchell Caton and Calvin Jones's classic mural, **ANOTHER TIME'S VOICE REMEMBERS MY PASSION'S HUMANITY** (1979) was restored by the Chicago Public Art Group. This jazzy montage of figures and textile patterning opens with the pairing of a wall-high African mask and the face of a contemporary woman, linking the African past with the present community. On the right, the striding figure of an elderly lady with her shopping bag honors the strength of the black matriarchy.

A new mural completed in 1995, **THE GREAT MIGRATION**, led by Marcus Akinlana, is a 2,700-square-foot historical narrative documenting the migration of African Americans from the South to Chicago, specifically to the Douglas Blvd./Grand Ave. area, after World War II. The mural contrasts a rural, agrarian past with the proliferation of urban industry and entertainment. Akinlana's masterwork in Chicago, the piece combines monumental scale and a painterly aesthetic. (CPAG)

Following the 1994 exhibit *Reclamation and Transformation: Three Self-Taught Chicago Artists* at the Terra Museum of American Art, the artists were commissioned in 1995 to create public pieces at the Donnelley: **CIRCUS SHRINE**, a whimsical cone-shaped cement and hubcap sculpture by Kevin Orth; **TOTEMS**, six carved ailanthus tree trunks by David Philpot created with Milton Mizenburg; and **MEDITATION GROTTO**, a cement structure embedded with modern debris and ancient fossils by Mr. Imagination . The grotto's seat is part of the old hotel that once stood on this site.

The art park also includes works made with neighborhood children, including two cast-concrete ceramic relief and stone benches by Phil Schuster; a mosaic-tile doorway by Kiela Songhay Smith, a sidewalk fresco by Smith and Rene Townsend, and entranceway concrete mosaic markers by Townsend.

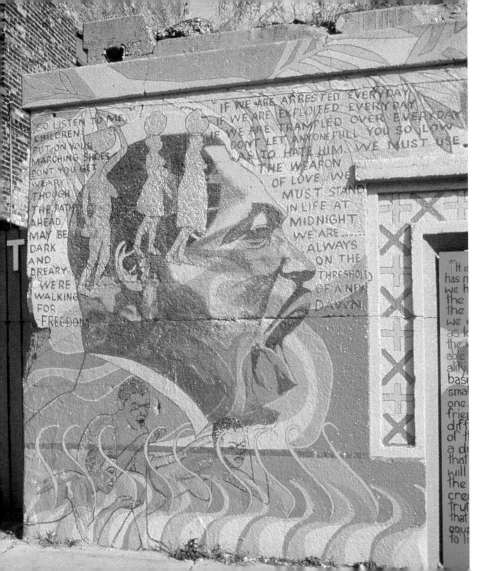

## HAVE A DREAM 1995

### C. SIDDHA SILA
### 40th St. and King Dr.

Commemorating Dr. Martin Luther King, Jr., as a religious and social leader, the mural uses Christian symbolism of the Father, Son, and Holy Spirit, as well as Dr. King's quotations, to emphasize different aspects of the King legacy. The predominantly purple-colored mural utilizes classic Siddha Sila techniques such as highlighting figures with strikingly colored outlines and hand-lettered poetic texts that read as "street prayers." (CPAG)

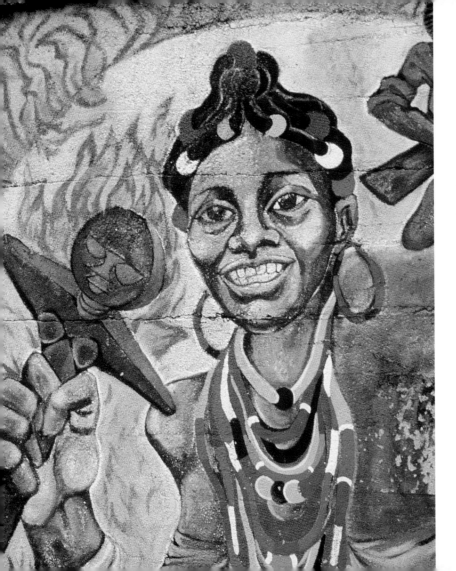

**7**

## BLACK WOMEN EMERGING
**1977**

**JUSTINE DEVAN**
## 4120 S. Cottage Grove Ave.

Created with the help of local residents by an artist seen as one of the mothers of the mural movement, the piece begins with images of an African dancer adorned with cultural emblems and a group of women (one bearing a rifle) rallying around a liberation flag. This mural calls on women to summon their ancestral strength in the struggle to gain access to all vocations, symbolized by a diploma, a caduceus, and scales of justice. Within a key representing domestic servitude, a woman breaks her broom, liberating herself from menial work in order to pursue higher goals. (CMG)

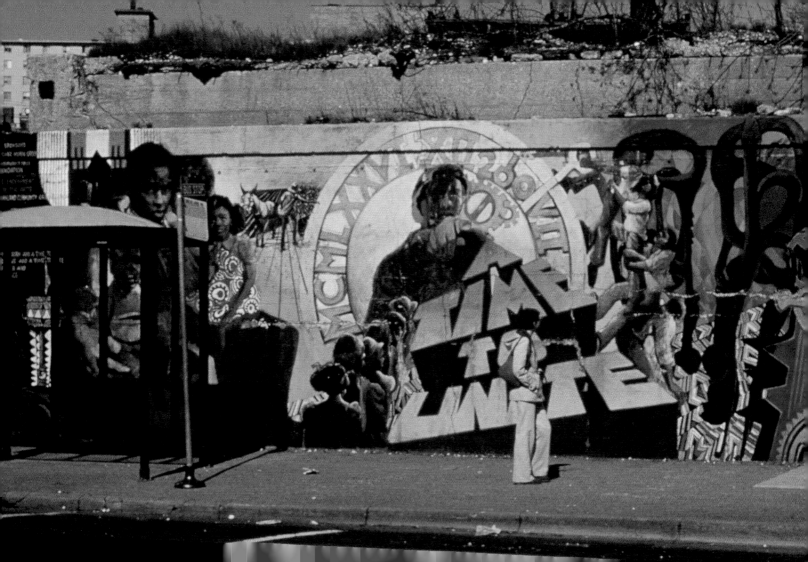

8

## A TIME TO UNITE 1976

### CALVIN JONES, JUSTINE DEVAN, AND MITCHELL CATON
### 41st St. and Drexel Ave.

This dramatic but fading mural in the Oakland area was a call for renewed racial solidarity during the bicentennial year, indicated by a clock. The work blends African styles and motifs with such painterly images as blues musicians, tribal drummers, and neighborhood residents to portray the historic unity of family, community, cultural heritage, and nation in the African-American tradition. This mural was the first of many significant works created by the collaboration of Caton and Jones. (CMG)

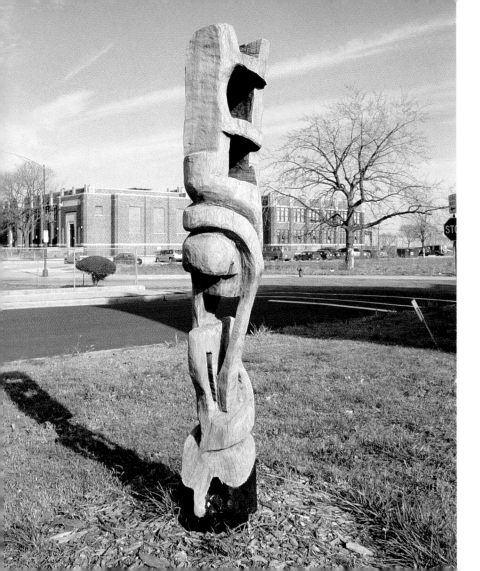

## OAKLAND MUSEUM OF CONTEMPORARY ART 1998

### MILTON MIZENBURG
### 41st Pl. and Lake Park Ave.

Over two years, neighborhood artist Mizenburg transformed five vacant lots into a unique sculpture garden near his home. City workers helped him install discarded tree trunks in upright positions. Mizenburg, occasionally assisted by David Philpot, used chainsaws and chisels to carve the thirteen totemlike figures in situ. Each piece is accompanied by a title and poem written by neighborhood poet Frank Duncan.

**10**

## MARTIN LUTHER KING, JR., MEMORIAL MURAL 1982

### EUGENE EDA
### 43rd St. and Langley Ave.

This freestanding sculptural mural work in durable porcelain enamel stands on the site of the **WALL OF RESPECT**, to which it is dedicated. Eda participated in painting the second version of the wall. Like the original mural the piece includes portraits of African-American leaders as well as images of slavery. Eda worked as an artist-in-residence with the Chicago Council on Fine Arts to create this four-winged piece for the King Community Services Center.

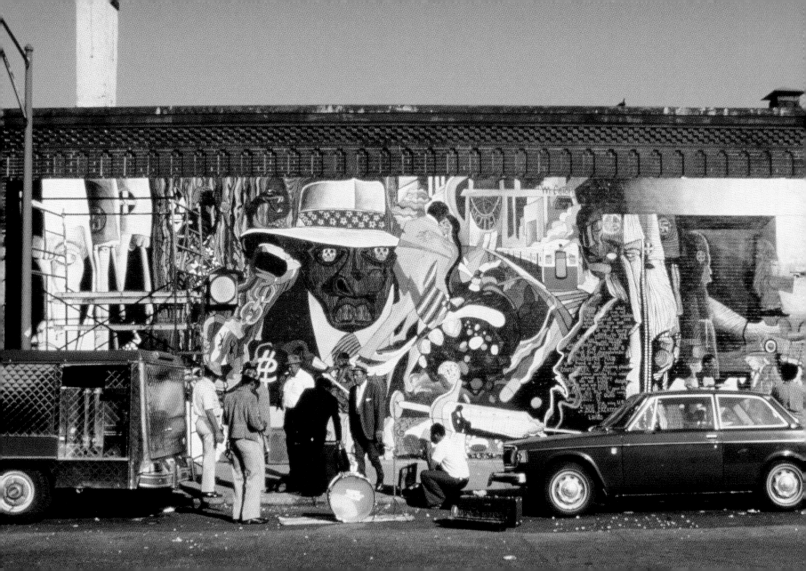

11

## WALL OF DAYDREAMING AND MAN'S INHUMANITY TO MAN 1975

### MITCHELL CATON, WILLIAM WALKER, AND SANTI ISROWUTHAKUL
### 47th St. and Calumet Ave.

Although fading, these thematically interrelated, side-by-side murals are aesthetically fresh and still speak to today's issues. Separate but equal, the murals use a richly symbolic language to indict a once-thriving black mecca as well as a racially divisive nation. On the right, Walker's piece deals with national political themes: the massive, carved faces of Klansmen and Black Muslims confront each other, while the smaller bodies of John Kennedy, Malcolm X, and Martin Luther King, Jr., lay dead on a chessboard among figures of greedy power brokers and starving children.

On the left, Caton's **WALL OF DAYDREAMING** depicts the style and vitality of street life while it points to the dangers of romanticizing an illicit economy based on drug pushing, prostitution, gang violence, and ill-gotten wealth. The murals' unflinching look at some grim social realities is leavened by the redemptive spirituality manifest in the positive, prayerful text of the poet Siddha: "Love will give us connection 2 the SOURCE."

The mural is an excellent example of the way in which the early street muralists spoke from the heart of the community, not feeling constrained to create only positive imagery but acting as prophetic and critical voices, exhorting the community to self-examination as well as personal and collective commitment to change. Even after twenty-five years the mural is free of graffiti—a sign of how the community accepts and values this historically important work. (CMG)

1998 restoration underway.

# HISTORY OF THE PACKINGHOUSE WORKER 1974

## WILLIAM WALKER
## 4859 S. Wabash Ave.

Chicago, "hog butcher for the world," has little public art dealing with its rich legacy of workers' movements. This artwork, among the nation's most powerful labor murals, depicts the history of the Amalgamated Meatcutters and Butchers Workmen Union. Painted on the former site of the union's Local office, the right side of the mural shows monumental workmen of all races going about their slaughterhouse jobs with a quiet dignity; the left side shows union representatives and workers confronting bosses, demanding a union contract. The scene takes place on a chessboard, a recurrent Walker motif for representing competing social forces.

Influenced by Diego Rivera's classical style of composition, it's a complex, compartmentalized work filled with incident and detail. Almost lost to Chicago's harsh weather, in 1998 CHA's Hayes Family Investment Center commissioned CPAG artist Bernard Williams to restore the work. (CMG)

13

FEED YOUR CHILD THE TRUTH 1994

## BERNARD WILLIAMS
## 50th St. and Cottage Grove Ave.

Located in the playlot across the street from Operation PUSH headquarters, this mural celebrates the accomplishments of Jessie "Ma" Houston, a veteran civil rights and prisoner rights activist and early supporter of Operation PUSH. An early major work by Williams, the juxtaposition of African patterning and volumetric figures is also an homage to the aesthetic influence of the Caton and Jones mural collaborations. The monumental size of this 99-foot-long work is characteristic of the ambitious scale of many community murals in the 1990s. (CPAG)

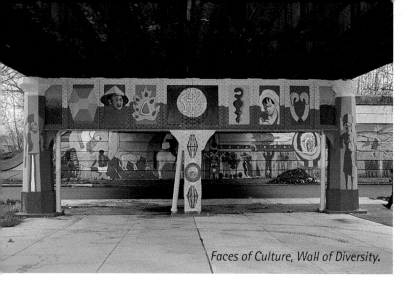

*Faces of Culture, Wall of Diversity.*

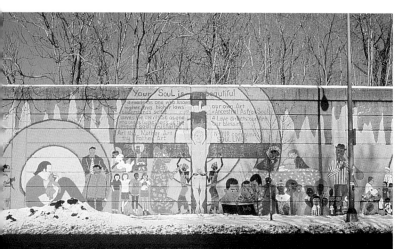

A playful, prayerful Siddha-led mural.

## GARFIELD BOULEVARD MURALS

### 55th and Leavitt St.

Exiting the Dan Ryan Expressway at Garfield (55th), and heading west from Halsted, one will see several murals by C. Siddha Sila and others. They culminate in a colorful ensemble of five works on the retaining walls and supports of a railroad bridge near Leavitt, serving as a western gateway to Englewood. On the south wall, **MAYA** (1987), by Mitchell Caton and Siddha, features a series of Meso-American and sun-god images as well as invocative text. The work is framed by the bifurcated **LIFE IS YOURS—STAND UP** (1989) by Siddha and youths.

On the north wall, Siddha-led art teams painted the companion pieces **FREEDOM 2 LOVE ALL LIFE** and **HAPPINESS IS THE ULTIMATE GOAL THRU SHARING ART** (1988). Each is a panoramic collage of images and words generated by Siddha's work with neighborhood youths. Most of the works were sponsored by the Boulevard Arts Center. On the central bridge supports, CPAG cosponsored John Yancey's **FACES OF CULTURE, WALL OF DIVERSITY** (1990).

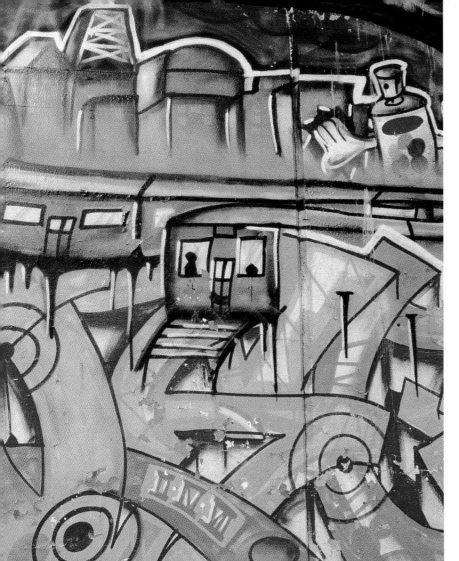

**15**

## PIECES OF CHICAGO 1996

### 59th St. between Hoyne and Oakley Ave.

This two-block-long, 12,000-square-foot series of spraypaint "burners" on two bridge retaining walls is the largest collection of graffiti art in Chicago. It was in the planning stages for more than a year. An ethnically diverse, city-wide group of about thirty graf writers united to create the pieces, which include "wildstyle" lettering as well as scenes depicting the history of Chicago; individual sections address civil rights, immigration, environmental, and other urban issues. The work was a project of the Southwest Community Congress and the Southwest Youth Service Collaborative and was organized by Joe Damal and Glenn Johnson.

## ARAB AMERICAN COMMUNITY CENTER MURAL 1994

### 63rd and Troy St.

This spraypiece, blending Arabic calligraphy, Old English lettering, and Pre-Columbian glyphs into graffiti-style lettering, quotes a proverb from the Koran: "Humankind was created as nations and tribes to know and celebrate each other, not to despise each other." This SWCC/SWYSC project was organized by Zore and Raven, who have developed many community graffiti projects, often with city funding, which have allowed youths from various cultural backgrounds to express themselves legally while also making creative, colorful contributions to their neighborhoods. These include impressive works at 47th St. and Lake Park Ave. and in the 58th St. underpasses between Racine and Ashland Ave.

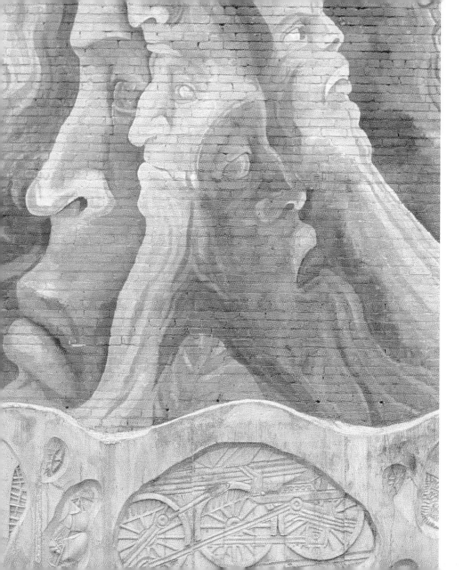

**17**

## ROOTS AND WINGS 1976

### CARYL YASKO AND LUCYNA RADYCKI
### 3543 W. 63rd St.

This massive (but very faded) mural in Chicago Lawn is believed to be the first community arts project in the nation to combine paint and cast concrete. Artists and local residents carved styrofoam which was then mounted in wooden forms into which concrete was poured. A painted tree bearing racially diverse faces appears to grow from the solid foundation composed of personal and neighborhood symbols. The inscription reads: "There are only two lasting bequests we can give our children—one is roots; the other, wings." Worth a visit to see the well-preserved, intricate concrete-work. (CMG)

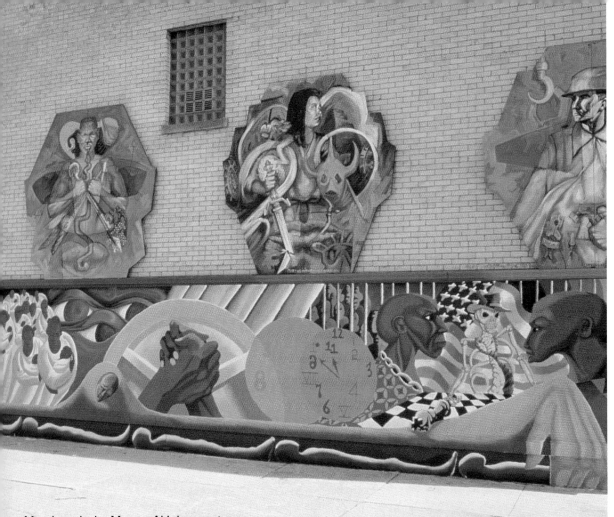

Mural masks by Marcus Akinlana rest on a
mural by John Yancey and neighborhood youths.

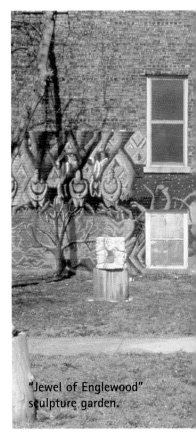

"Jewel of Englewood"
sculpture garden.

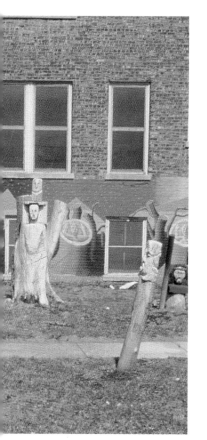

**18**

# BOULEVARD ARTS CENTER

## 6011 S. Justine St.

This Englewood cultural center features one of the most extensive and eclectic outdoor galleries in Chicago. Numerous artists have worked with the center's Gallery 60 students to create works that often reflect the need to reclaim African roots and culture. Still evolving, the sprawling site continues to annex new spaces.

**BOULEVARD ARTS CENTER** (1991), a mural on wood by John Yancey and **OUR KAMETIAN ROOTS** (1997), a mural by Jerry Pitman, are on the north side of the building; **MEMORY AND EMPOWERING MASKS** (1992), three mask-shaped panels by Marcus Akinlana, is on the west side; and **VISION AND AWAKENING** (1992) and **IMAGERY OF REALITY; BUILDING A UNIFIED FUTURE** (1993), murals by Yancey, surround the exterior.

The "Jewel of Englewood" sculpture garden features **TRIBUTE TO THE FAMILY** (1998), a limestone sculpture by Roman Villarreal as well as numerous small carved pieces by neighborhood youth. Also included are ceramic-tile mosaic benches (1996) by Dale Washington. The sports field is bordered by carved wood totems (1995) by Milton Mizenburg and David Philpot.

In the lot across Justine St. are two freestanding painted plywood installations, **THE SPIRITS OF OUR ANCESTORS** (1996) by Gamaliel Ramirez and **OUR COMMUNITY** (1996) by Gregg Spears. Roman Villarreal and youth artists contributed the 14-foot-high **URBAN TOTEM** (1999), a tribute to "Old Gods" of the Americas. The site is bordered by a unique assemblage fence mural by C. Siddha Sila and youths.

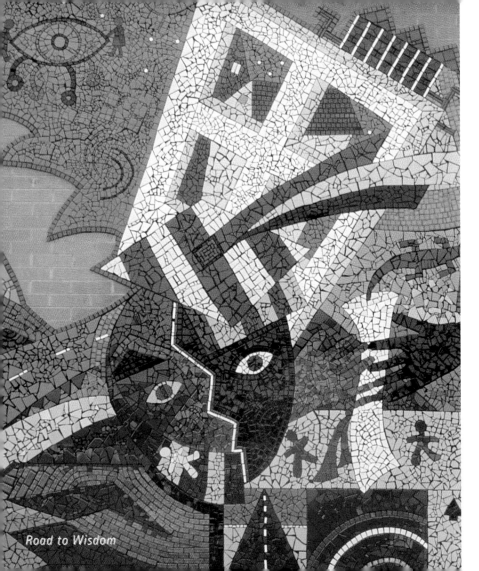

*Road to Wisdom*

## HARPER HIGH SCHOOL MOSAICS

### 6520 S. Wood St.

**EMPOWERED TO KNOW, GROOMED TO GROW** (1997), directed by Stephanie George and Nina Smoot Cain, consists of three panels of cracked-ceramic-tile mosaic representing the ancestral past, a present of effort and learning, and a future of hope and achievement. Mirtes Zwierzynski and Orisegun Olomidun's **ROAD TO WISDOM** (1999), created with Harper art classes, features some of Chicagoland's most innovative tilework. The mosaics form the foundation of a community art garden, an ongoing partnership of Harper High School and the GATX Corporation. (CPAG)

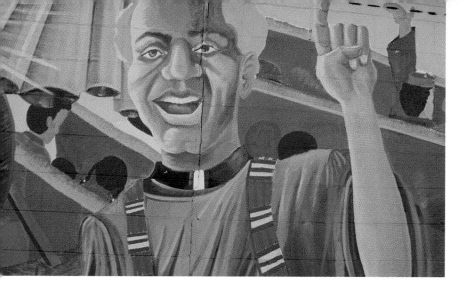

**20**

# MURAL OF ENGLEWOOD
## 1996

### DORIAN SYLVAIN
### 65th St. and Racine Ave.

This work on the Ogden Park pool house promotes a positive vision of a much-maligned African-American neighborhood by portraying the elements and institutions that help create a strong, viable community. Cosponsored by the Boulevard Arts Center and painted with Gallery 60 youths, the mural's images represent the values of work, leisure, church, family, education, and cultural heritage.

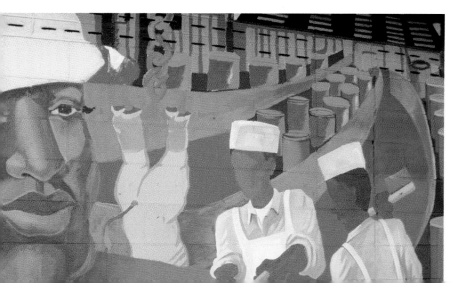

## NO FADS OR FRILLS 1980

### ASTRID FULLER
### Lake Park Ave., north of 51st St.

Painted on the wall of a Metra substation, this work, designed in classic Fuller style, is dense with symbolism and narrative detail. On the right, a teacher puts a monkey wrench into the tuxedoed powerbroker's school machine which is offering children only a limited curriculum devoid of the arts, thus turning them into lifeless products on an assembly line. On the left, the teachers' union confronts the machine bosses, bargaining not only for a labor contract but for decent schooling for all children.

Faded yet beautiful remnants of several works by Astrid Fuller, active as a muralist in the Hyde Park area during the 1970s, still exist. See **SPIRIT OF HYDE PARK** and **PIONEER SOCIAL WORK** at the 57th St. Metra underpass. Fragments of **REBIRTH** are visible on both sides of the 60th St. Metra underpass. (CMG)

22

## THE CIRCLE JOURNEY 1992

### STEPHANIE GEORGE, AMMAR TATE, AND BEATRIZ SANTIAGO MUÑOZ
### 53rd St. and Lake Park Ave.

The mural begins and ends with images of Elegba, the *orisha* of the crossroads. Its narrative illustrates a shaman's travels through a variety of natural environments; at the end of his pilgrimage he gives back to the community the wisdom he has acquired. Sponsored by the Blue Gargoyle and the Community Police Partnership for Youth, a program for at-risk kids. (CPAG)

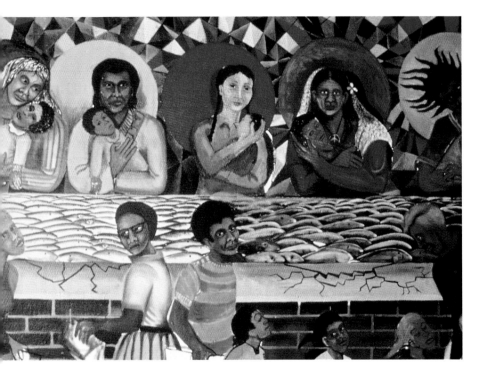

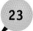

## ALEWIVES AND MERCURY FISH 1972

**ALBERT ZENO**
## 55th St. and Lake Park Ave.

This classic underpass mural was painted as an indictment of the industrial pollution of the Great Lakes, especially the consequence of the invasion of alewives into the freshwater lakes, an event here witnessed by a procession of local residents. Humans' subjugation of nature is thematically linked to scenes of shackled and liberated black people. The mural closes as mothers of all races nestle their infants and fish swim freely.

Across the street: Although badly damaged, Caryl Yasko's **UNDER CITY STONE** (1972), in which rushing neighborhood residents are oppressed by urban life, smoking factories, and military equipment, is still a dramatic and interesting mural.

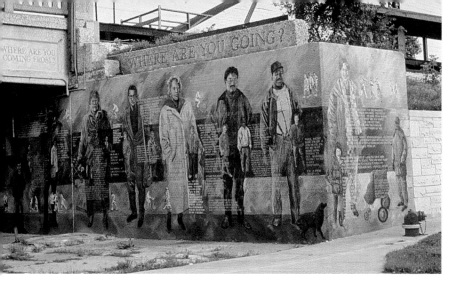

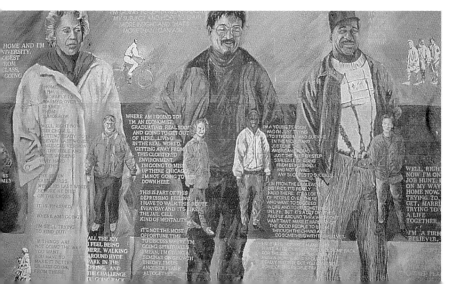

24

### OLIVIA GUDE
### 56th St. and Lake Park Ave.

For this oral history mural on the Metra underpass in Hyde Park, Gude asked various passersby, "Where are you coming from? Where are you going?" The images and words are drawn from photos of the people and their taped responses, which ranged from the mundane to the political to the metaphysical. The variety of quotations suggests that people within a given geographic area may not necessarily hear each other's voices—though the very act of pointing out these overlapping stories suggests the possibility of initiating conversation and creating a "community of discourse." (CPAG)

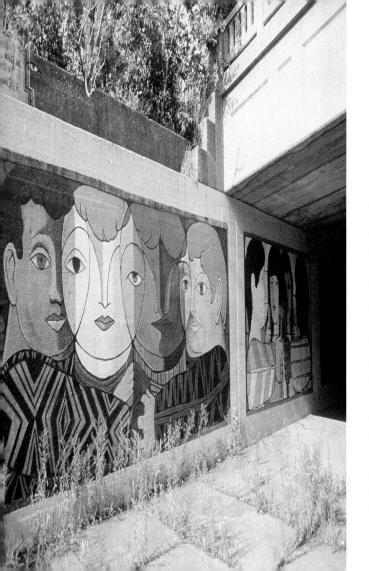

# CHILDHOOD IS WITHOUT PREJUDICE
## 1977

### WILLIAM WALKER
### 56th St. and Stony Island Ave.

Sometimes referred to as *Children of Goodwill*, Walker created this mural as a tribute to nearby Harte School. His daughter had attended school there and Walker wanted to express his appreciation for the school's promotion of racial harmony. The tripartite mural, Walker's personal favorite, includes a series of interlocking faces representing the potential unity of all races. Walker originally used interlocking faces in his work to symbolize brotherhood in the black community; in later works he painted faces of various hues and genders to challenge people to engage in the difficult task of forming interracial bonds.

Spending months at the 56th St. underpass in 1992 asking "Where are you coming from?" caused Gude to reflect on how the practice of contemporary muralists comes from the South Side street mural tradition. In 1993 she and Bernard Williams returned with Walker's permission to restore the work. This was the beginning of an ongoing effort by younger generations of CPAG artists to preserve significant early mural works.

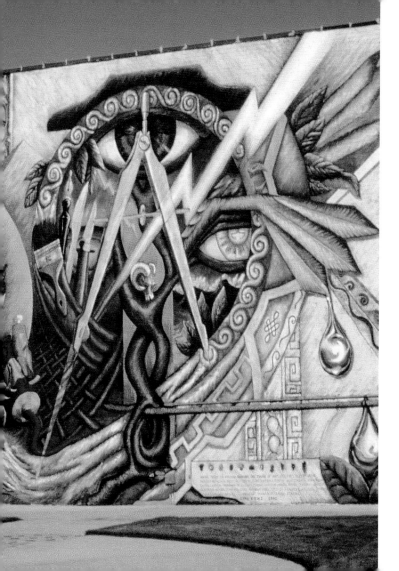

**26**

# WHERE THERE IS DISCORD, HARMONY; THE POWER OF ART
**1991**

## MARCUS AKINLANA AND OLIVIA GUDE
## 1801 E. 71st St.

Located at One Artist Row, an arts incubator building, this mural focuses on the healing role of the arts in an urban community. The monumental spiral that dominates the wall is a symbol of the cycle of death and renewed life in many cultures. Creating the spiral as well as emanating from it are the tools of the visual art trade. Note in the left corner the discarded fine-art frame and the burning billboard with cigarette and alcohol ads. The three eyes of the spiral allude to artistic vision; the third eye is the spiritual insight needed to make art relevant to the community. The work broke new aesthetic ground in that it eschewed the traditional use of human figures and an obvious narrative structure. (CPAG)

See also, in front of the mural, the colored-cement **PATTERNED PLAZA** (1990), created by CPAG artists in a workshop led by Caryl Yasko and Gude.

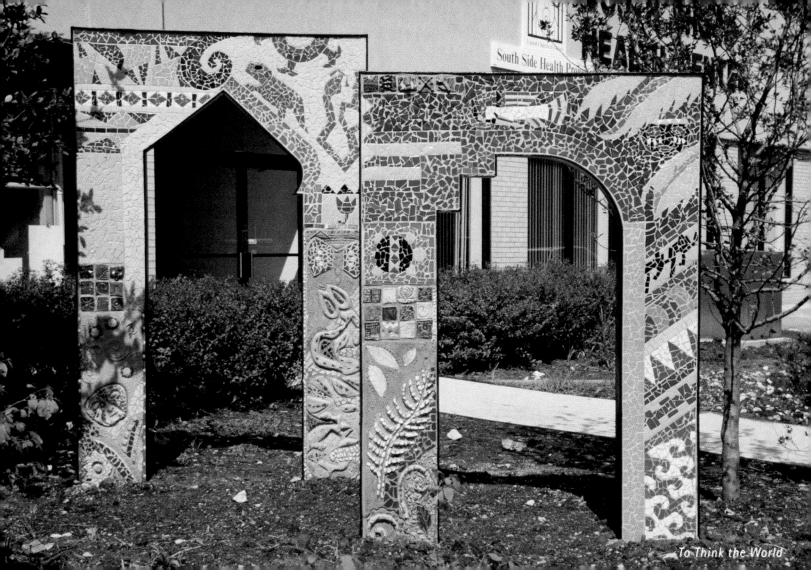

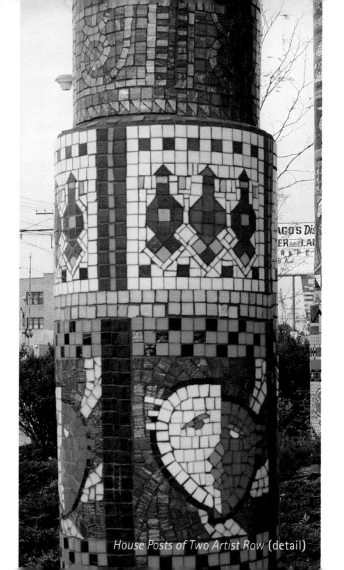

*House Posts of Two Artist Row* (detail)

27

## TWO ARTIST ROW

### 1818 E. 71st St.

This arts-turned-business incubator building is enlivened with a variety of visually striking mosaics. All were created by CPAG artists with youths at Gallery 71. **HOUSE POSTS OF TWO ARTIST ROW** (1992), by Nina Smoot Cain, consists of two columns covered with bands of pattern drawn from various African nations. The artist and teen workers created each mosaic band separately and then at project's end laid out the entire piece on the studio floor to determine the final arrangement before installation.

**TO THINK THE WORLD** (1993), by Mirtes Zwierzynski, Orisegun Olomidun, and Phil Schuster, is a pair of cast concrete archways with ceramic tile, reliefs, and stones. With techniques learned from the New York artist Lilli Ann Rosenberg, who is often referred to as the "mother of community public art," the artists created the pieces using the "reverse cast" method. Tiles and other objects are embedded in the wet clay that forms the bottom of the shaped mold into which the concrete is poured.

The *orisha*-themed **SONG OF ENLIGHTENMENT** (1994), by Zwierzynski, Olomidun, and Rene Townsend, consists of seven mosaic panels on the west façade. (CPAG)

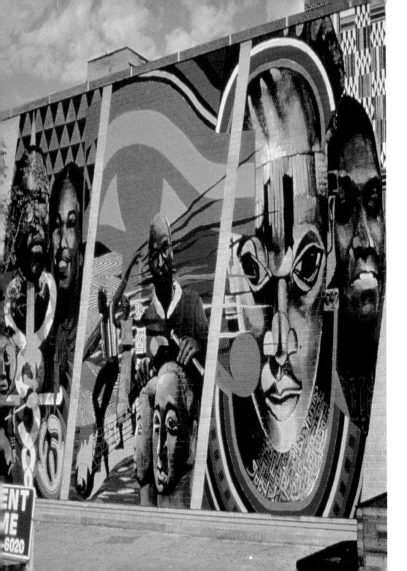

## BUILDERS OF THE CULTURAL PRESENT 1981

### MITCHELL CATON AND CALVIN JONES
### 71st St. and Jeffery Blvd.

Combining Caton's complex graphic style with Jones's naturalistic figuration, this mural celebrates the kinship between traditional African and African-American aesthetic expression. Layered on a backdrop of African patterns and symbols, a Benin ceremonial mask, and portraits of Chicago African-American artists—poet Gwendolyn Brooks and sculptor Marion Perkins—suggest how today's creators continue to shape and be shaped by the materials of their cultural heritage. Perkins, one of the founders of the legendary South Side Community Art Center, advocated the importance of reconnecting with Africa in order to create a black aesthetic not dominated by Eurocentric standards.

Another significant Caton/Jones innovation to mural composition was the use of an irregular outer shape to contain the mural design, thus creating an interesting spatial relationship between the painted surface and the entire wall. (CMG)

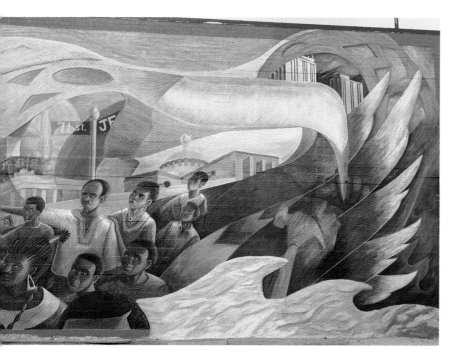

**29**

## MARCUS AKINLANA AND JEFFREY COOK
### 71st St. and Jeffery Blvd.

Incorporating concrete relief, this mural on the back of the Walgreen's building uses Benu, the golden phoenix of ancient Egypt, as a metaphor for the economic and cultural revival of the South Shore community. A Moses-like figure leads the people through parted, concrete waves of water.

All eyes are turned to the dynamic figure of Oya, the woman warrior *orisha* who symbolizes revolutionary change. Interwoven with the wings of Benu are images of local landmarks as well as street signs prescribing self-pride, respect for others, and cultural awareness as the route to community strength and vitality.  In 1995 the mural, cosponsored by The Neighborhood Institute, was restored by the artists. (CPAG)

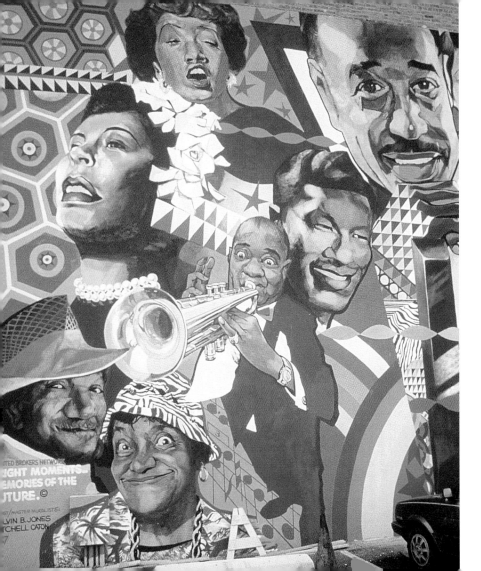

## BRIGHT MOMENTS, MEMORIES OF THE FUTURE
**1987**

### MITCHELL CATON AND CALVIN JONES
### 79th St. and Stony Island Ave.

This vibrant, monumental mural on the New Regal Theater, in typical Caton/Jones fashion, employs a collage of painterly figures and African-inspired designs to depict the contributions of blacks to the entertainment industry. Featuring blues and jazz musicians, actors, dancers, and comedians, most of whom performed at the cultural landmark in its heyday on 47th St., the work's compositional style reflects its subject matter—rhythmic and improvisatory. Drawn without a grid or projection, the artists developed the work directly from sketches on scraps of paper to its whopping scale.

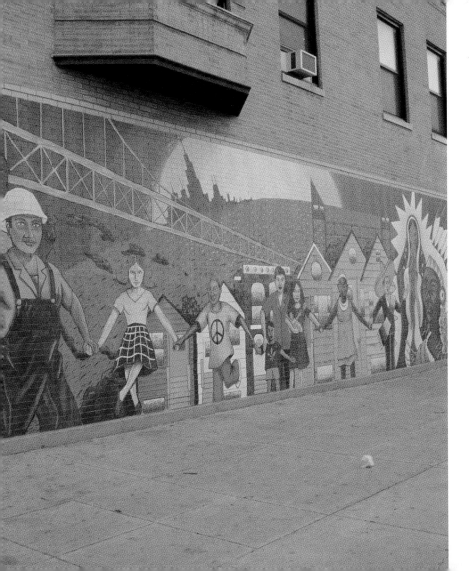

31

## SOUTH CHICAGO WE ALL COME TOGETHER AS ONE
**1999**

### GAMALIEL RAMIREZ
### 90th St. and Commercial Ave.

Highlighted by an orange glow, citizens of different cultures and classes join hands to protect their neighborhood homes; South Chicago and city skyline landmarks serve as a backdrop. The work was sponsored by a variety of community organizations and painted with the assistance of local youths. South Chicago was a center of Latino mural activity in the 1970s; Ramirez's commitment to community public art and his recent relocation to the neighborhood suggests the possibility of a mural renaissance there.

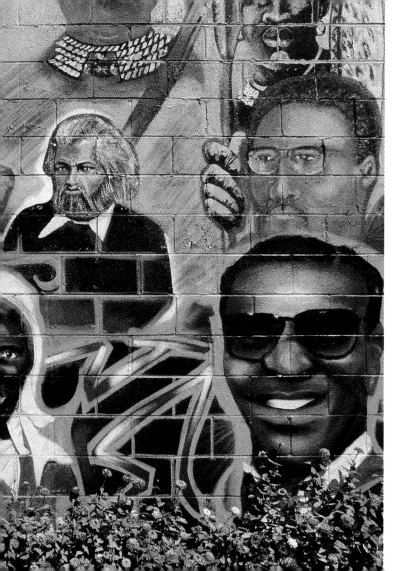

## OUR BROTHERS AND SISTERS DOWN FROM DAY ONE 1984, 1998

**DON RODGERS, GLENN JONES, AND
RAHMAAN BARNES
100th and Halsted St.**

Everything old is new again in this intriguing piece, which deftly blends the street styles of succeeding generations of muralists. In 1984 Rodgers painted a series of portraits of African and black American figures, from ancient Egyptian and Muslim sources to jazz musicians to such heroes as Marcus Garvey and Harold Washington. Fourteen years later, spraycan artists Jones and Barnes of Righteous Kreativity Productions "refinished" the deteriorating mural, adding fresh images such as that of Louis Farrakhan and a clock to signify the passage of time. Around the corner in the alley, see RK's piece on African-American sports legends.

**UNITY** by RK Productions and youths, sponsored by Project Artreach, is located at 87th St. and Anthony Ave. in South Chicago. It's the first of a series of planned pieces to adorn the walls of a Chicago Skyway underpass.

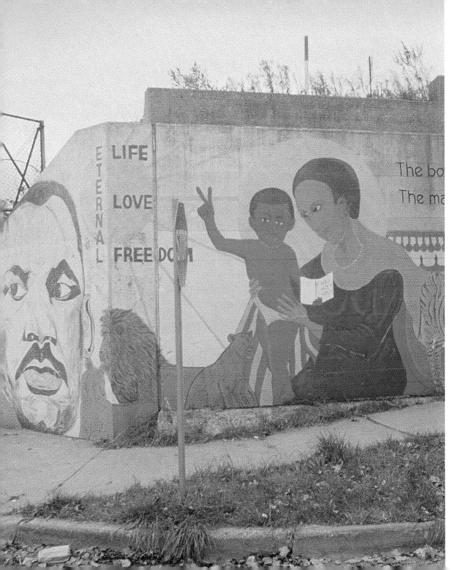

**33**

## ETERNAL LIFE LOVE FREEDOM 1991

### C. SIDDHA SILA
### 100th St. and Cottage Grove Ave.

Fusing spiritual texts with images of such figures as Martin Luther King, Jr., Malcolm X, and the Madonna and child, this mural is an offering in remembrance of those who sacrificed their bodies and blood to the dreams of love, freedom, peace, and justice—"the eternal life values worth living & dying for."

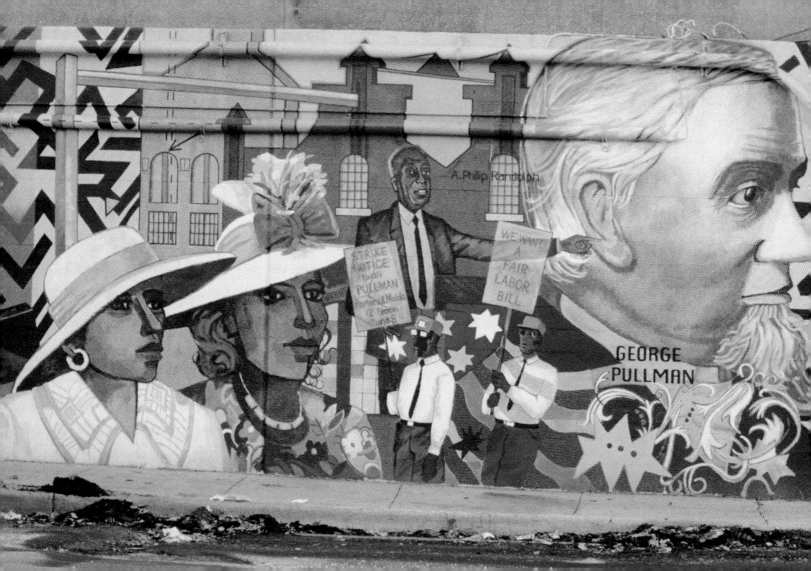

A. Philip Randolph

STRIKE NOTICE to all PULLMAN Porters & Maids 12 Noon June 8

WE WANT A FAIR LABOR BILL

GEORGE PULLMAN

34

## TRIBUTE TO PULLMAN PORTERS 1995

### BERNARD WILLIAMS
### 103rd St. and Cottage Grove Ave.

Aptly sited on either side of a train underpass in North Pullman, this mural honors the Brotherhood of Sleeping Car Porters, the nation's first black labor union, as well as its spirited leader A. Philip Randolph. It also includes portraits of Milton Webster, director of the Chicago Local, and (not too flatteringly) George Pullman, founder of the sleeping-car factory and company town that bears his name.

Williams makes dramatic use of the facing walls to symbolize the face-off between labor and management. A powerful locomotive decorated with African patterns symbolizes the role of the railroad in disseminating the cultural heritage of black America and in introducing African Americans to the urban, industrial North. (CPAG)

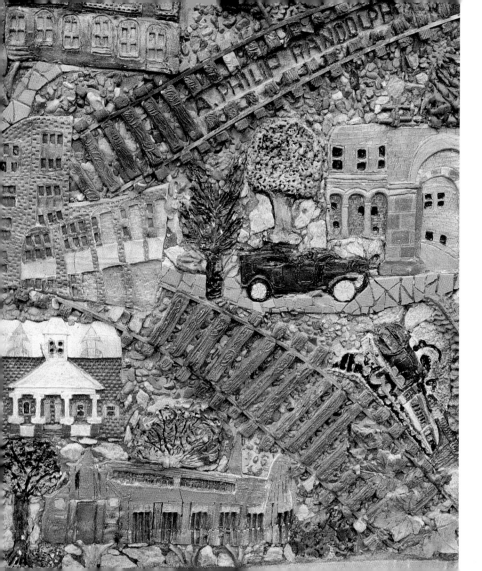

# RANDOLPH REMEMBERED
## 1995

### RENE TOWNSEND AND PHIL SCHUSTER
### 10406 S. Maryland Ave.

Located at the A. Philip Randolph Museum Gallery, this freestanding concrete relief sculpture created with area youths uses clay relief and ceramic mosaic to document the history of the Pullman area. It emphasizes the accomplishments of A. Philip Randolph, Milton Webster, and the Pullman porters. (CPAG)

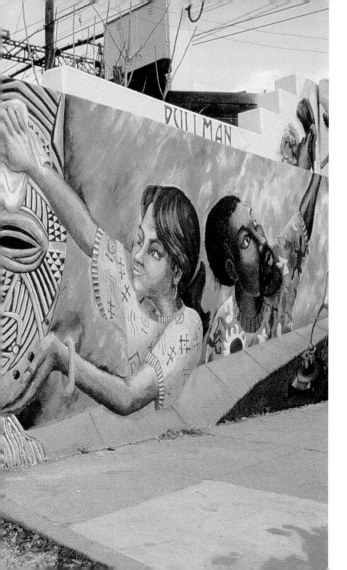

**36**

## I WELCOME MYSELF TO A NEW PLACE
### 1988

### OLIVIA GUDE, MARCUS AKINLANA, AND JON POUNDS
### 113th St. and Cottage Grove Ave.

One of the largest community murals in Chicago, this 7200-square-foot work encompasses an entire railroad underpass. Designed and created by more than one hundred neighborhood residents, the mural symbolically and literally "bridges the gap" between the neighborhoods of the predominantly African-American Roseland and the predominantly white and Latino Pullman.

The Pullman (north) wall is an intricate patchwork of decorative patterns incorporating designs used in the ancestral art of area residents. Other images include an art fair to which residents bring portraits of George Pullman, A. Philip Randolph, and Eugene Debs, founder of the American Railway Union and the American Socialist party, and leader of the Pullman Strike. On the Roseland side, neighbors work together to preserve their homes and heritage. (CPAG)

Nearby: Three blocks east, at 113th St. and Langley Ave., see the **PULLMAN PLAYGROUND SCULPTURE**, a 55-foot-long redwood train built in 1985 by Jon Pounds, Olivia Gude, and community residents.

Central

# CENTRAL

*The Central section is bounded by Division St. (1200 N) on the north, Cermak Rd. (2200 S) and the Stevenson Expressway on the south, the lakefront on the east, and the city limits on the west.*

Pilsen, historically one of most preeminent pockets of contemporary outdoor Mexican mural art in the U.S., is located here. Other highlights in this section include the **MILE OF MURALS**, African-American-themed murals on the West Side, the Gateway Park mosaics, and works in the Little Village area.

Inspired by such Mexican muralists as Diego Rivera, José Clemente Orozco, and David Alfaro Siqueiros, and spurred by the Chicano movement, Pilsen artists have filled the barrio walls with images of culture, history, identity, and protest. Although many of the notable outdoor murals from the late 1960s and 1970s are lost, Pilsen and the adjacent Spanish-speaking Little Village (South Lawndale) are still vital, evolving mural centers.

Founded in 1970, the Casa Aztlán community center became a base for Chicago's Mexicano mural movement. Raymond Patlán, the facility's first artist-in-residence, covered its walls with murals from 1970 to 1972; new and restored works by Marcos Raya, Salvador Vega, and Aurelio Díaz—all of whom had studios and led workshops at the center—followed.

Patlán's **REFORMA Y LIBERTAD** is the only outdoor work in Pilsen that survives from this early period.

Beginning in the mid-1970s Díaz was one of the most prolific muralists in Chicago, leading or participating in dozens of works. Many remain in the Pilsen/Little Village area; these include the stunning Latino Youth, Inc., murals, 16th St.'s **GALERÍA DEL BARRIO**, and works for St. Pius V Parish. St. Pius's commitment to the mural form has continued into the 1990s with **INCRÉIBLES LAS COSAS QUE SE VEN** and **FAMILIAR**, by Jeff Zimmerman.

In 1975 the Pilsen-based activist arts organization MARCH began sponsoring mural activity. It was through MARCH's efforts in the late 1970s that **A LA ESPERANZA** was painted on the newly built Juárez High School.

Ricardo Alonzo and José González were among a changing collective of mostly Latino artists who during the 1970s directed the **MILE OF MURALS** project on the Hubbard St. railway retaining wall; it featured panels representing endangered species and ethnic cultures. More politically provocative collective mural projects are the 1980 **PREVENT WORLD WAR III** and the 1998 **PROTECT PILSEN**. Another significant anti-gentrification mural is **ALTO AL DESPLAZAMIENTO URBANO DE PILSEN** led by Hector

Duarte, one of the most important Pilsen muralists of the 1990s.

Beginning in the early 1990s, several public artworks in Pilsen have been sponsored by the Mexican Fine Arts Center Museum, including those at the 18th St. CTA station and the **OROZCO SCHOOL MOSAICS** by Francisco Mendoza and his art students.

Many murals have also been painted in predominantly African-American communities on the West Side. Among the earliest is 1973's **BREAK THE GRIP OF THE ABSENTEE LANDLORD**, the only extant outdoor work by members of Mark Rogovin's Public Art Workshop. CPAG has led several works in the 1990s, including the spray-mural collaborations **HOW TO BUILD A BRIGHTER FUTURE** and **STILL DEFERRED; STILL DREAMING**, by Olivia Gude and Dzine which were funded by a National Endowment for the Arts—Art in Public Places grant. Youth Service Project, Gallery 37, and CPAG sponsored a monumentally scaled mural at Orr High School, bringing together master muralists John Pitman Weber and Bernard Williams to paint **URBAN WORLD AT THE CROSSROADS**.

In the late 1990s artists, arts organizations, and community organizations teamed to create a number of community art gardens. Concrete guru Phil Schuster and youths constructed an impressive snake sculpture (replete with mosaic baby snakes) for the **ABC YOUTH CENTER SCULPTURE GARDEN**. In 1998 Schuster joined CPAG director Jon Pounds and veteran concrete sculptor Weber to build a gateway sculpture for the Creative Reuse Warehouse's garden in the Maxwell St. area.

Bethel New Life is developing one of the most significant community public art collections in the city. C. Siddha Sila, an artist whose works go back to the earliest days of Chicago's mural movement, began the transformation of the Beth-Anne Life Center complex with the 1996 painting of **NEW LIFE, NEW LOVE**. Weber, Nina Smoot Cain, and neighborhood teens have created a series of stylish mosaics for the walls, courtyard, and gateposts of the center.

Gateway Park at the entrance to Navy Pier is the site of Chicago Public Art Group's most complicated—and intensively collaborative—mosaic project to date. **WATER MARKS** is an installation of sculpted concrete benches inset with community-made ceramic pieces interspersed in glass-tile mosaic. The project brought the artistic and organizational talents of the community art movement to a downtown location.

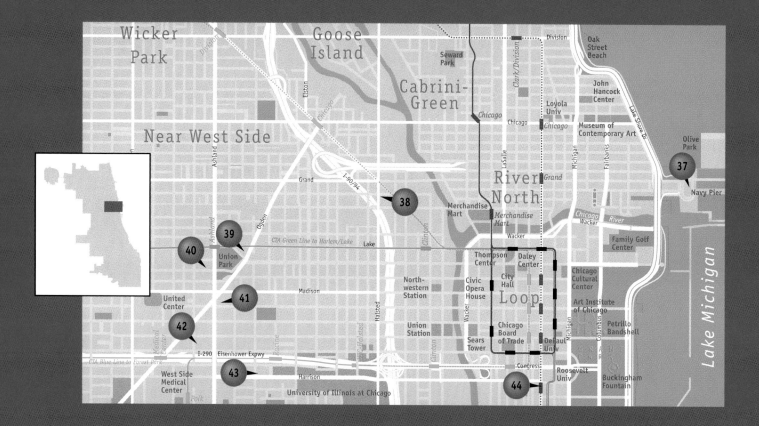

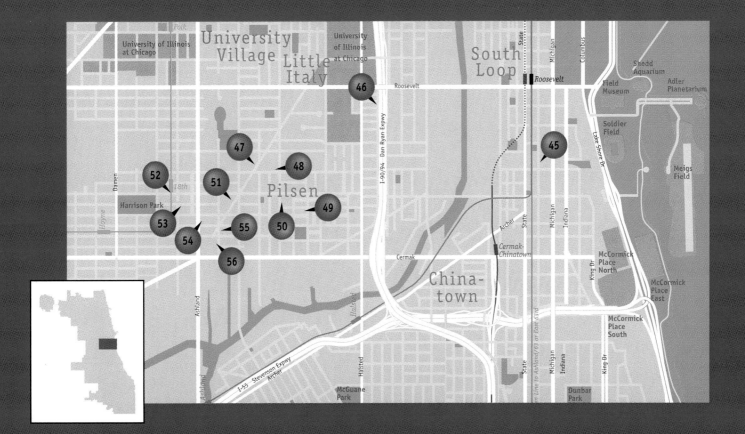

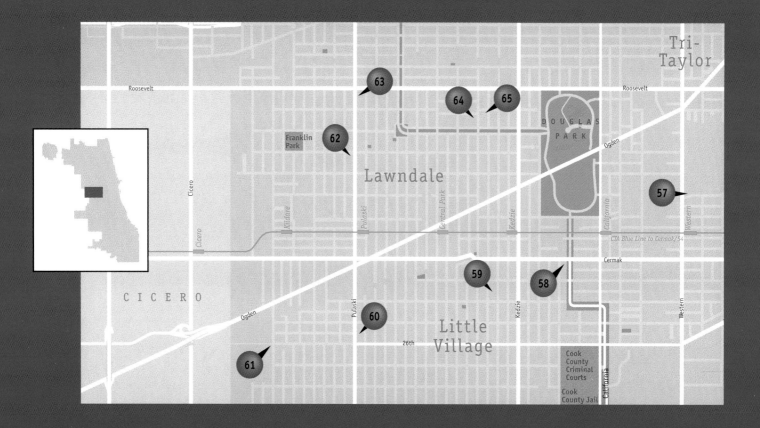

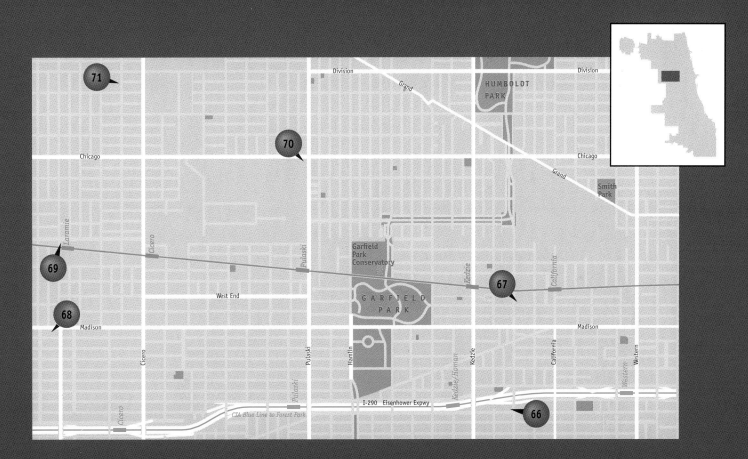

71

70

Division

Grand

HUMBOLDT
PARK

Division

Chicago

Chicago

Grand

Smith
Park

Laramie

Cicero

Pulaski

Garfield
Park
Conservatory

Kedzie

California

69

67

West End

GARFIELD
PARK

68

Madison

Cicero

Pulaski

Pulaski

Hamlin

Kedzie/Homan

Kedzie

California

Western

Madison

Pulaski

Cicero

I-290   Eisenhower Expwy

CTA Blue Line to Forest Park

66

# WATER MARKS 1998

## OLIVIA GUDE, KIELA SONGHAY SMITH, CYNTHIA WEISS, MIRTES ZWIERZYNSKI, AND JON POUNDS
### Navy Pier, Gateway Park

**WATER MARKS** is one of the country's most monumental community public artworks. The four cast-concrete and mosaic benches nestled in landscape berms, as well as a multicolored terrazzo path, commemorate the 150-year history of the Illinois and Michigan Canal and the way the canal has shaped the history of the region. The canal linked Lake Michigan to the Illinois and Mississippi rivers—ultimately linking the Atlantic Ocean to the Gulf of Mexico—spurring unprecedented commerce and population growth in the mid-nineteenth century. Gateway Park is the entry point of the I & M Canal National Heritage Corridor.

Much like the canal itself, **WATER MARKS** was also the result of a great collaboration of individuals and organizations. Four years in the making, CPAG and the Canal Corridor Association orchestrated a complex collaboration consisting of the artist team and sixteen assistants as well as landscape architects, engineers, fabricators, historians, and community residents. Two hundred sixty-six volunteers from 11 sites from Bridgeport to LaSalle-Peru, Illinois contributed the 941 handmade ceramic elements interspersed among the 125,000 glass-mosaic tiles.

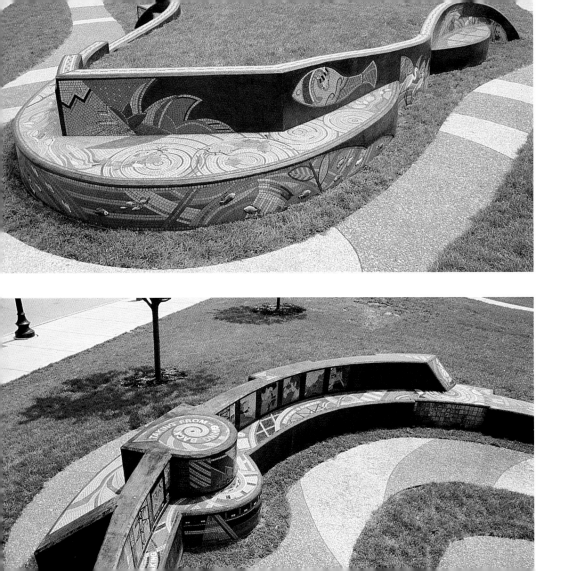

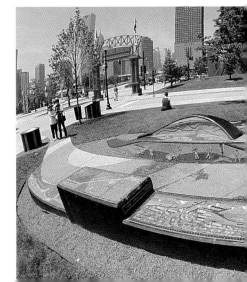

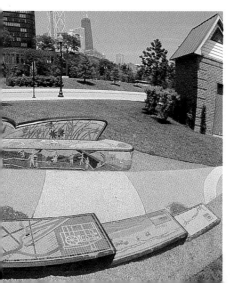

37

## WATER MARKS (CONTINUED)

The terrazzo pathway linking the sculptures represents a map of the I & M Canal as it connected to the Chicago and Illinois rivers and then on to Lake Michigan. Each sculpted bench has its own title and tells a piece of both the canal's and Chicago's history.

The **SILURIAN SEAT** depicts the Chicago area 425 million years ago, when it was under the sea, as well as the native prairie landscape. The bench's skirt shows the history of human occupation from the Native Americans to the immigrant workers who dug the 97-mile-long canal by hand.

The **LOCK BENCH** shows the workings of a canal. Each horizontal step is a map or a picture, marking a moment in the history of the land that became Chicago, from 1673 to the present.

The **WATER BOAT BENCH** represents the flow of water through the region, the seasons, and the lives of those who settled alongside Illinois's inland waterways. The sculptural forms of the bench reference a canal boat and a dugout canoe.

The **TURNING BASIN BENCH** wraps around the spiraling path, suggesting the water basins at each end of the canal. Grain, raw materials, and energy flow from one end of the bench to the other by water, rail, and truck. The bench's outer walls are covered with handmade ceramic tiles in shifting hues reminiscent of an Illinois field. The words and images on this bench speak of finding a balance between human productivity and nature. (CPAG)

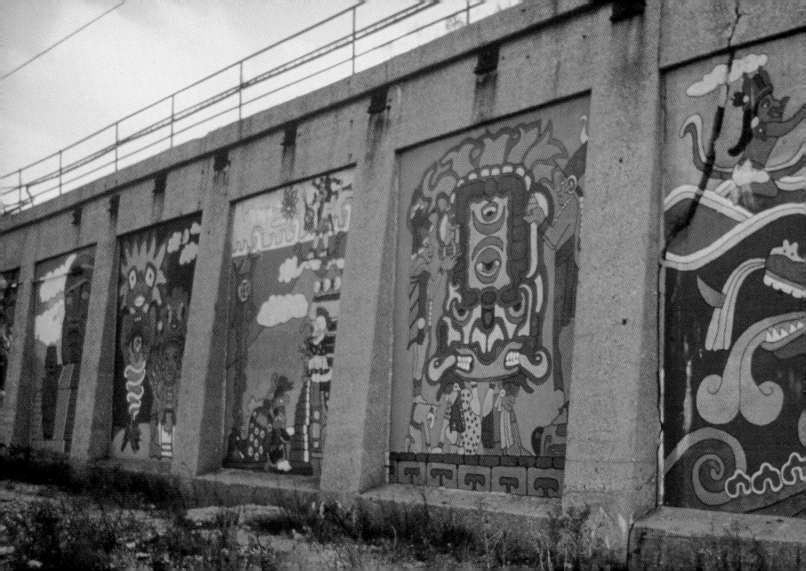

38

# MILE OF MURALS

## Hubbard St. between Ogden Ave. and Desplaines St.

Not quite a mile long, this series of murals on the railroad embankment retaining wall along Hubbard St. is composed of 11 separate "galleries" painted throughout the 1970s. More than 170 panels of wildlife, ecological themes, city scenes, folk art, and Native and Latin American design motifs help to humanize a drab, industrial corridor.

Beginning at Milwaukee Ave. and going west, **SAY GOOD-BYE GALLERY**, **CHICAGO GALLERY I AND II**, and **STOP NOW GALLERY** (1971–1974) were directed by Ricardo Alonzo and painted by students of the West Town Community Youth Art Center. The **ETHNIC CULTURES: USA** sequence (1975) consists of: **AZTLÁN GALLERY**, directed by José González; **THE NORTH AMERICAN INDIAN FOLK ART GALLERY**, by Aníbal Rojas; **THE MUSEUM OF AMERICAN AND EUROPEAN FOLK ART**, by Rose Divita; and **UPENDO NI PAMOJA (LOVE IS TOGETHER)**, about African cultures, by Terry Irwin. **1976 GALLERY** (1976) and **SPECIAL SPECIES GALLERY** (1977) were directed by Alonzo. (Unfortunately concrete wall resurfacing in 1999 destroyed the May to Racine block of **SPECIAL SPECIES GALLERY** and several panels from the **1976 GALLERY**.)  In 1979 an untitled section was added to the wall east of Milwaukee Ave. to Desplaines St. by Alonzo, Fred Montano, and youths of the West Town Community Fine Art Center.

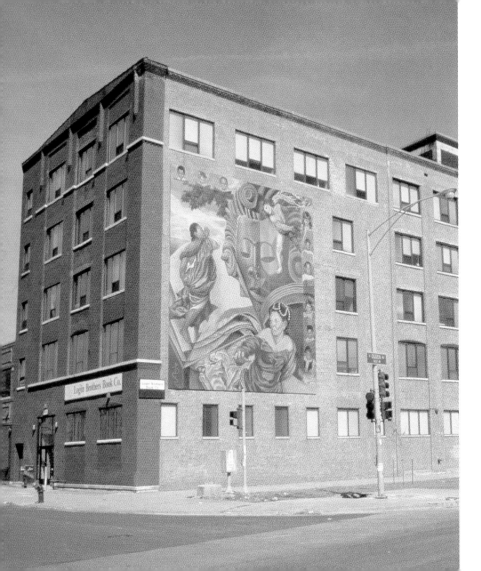

**39**

## BOOKS, IMAGINATION, AND CULTURE 1995

**KATHLEEN FARRELL AND
KATHLEEN SCARBORO**
**Ogden Ave. and Randolph St.**

Located on the side of the Login Brothers Book Co., this mural explores learning about world cultures through reading. It shows African, Mexican, Greco-Roman, and biblical characters as well as famous writers such as Maya Angelou, emerging from literary works. Figures of youths—drawn from neighborhood and employees' children—study reading materials through the ages, from cuneiform to electronic texts.

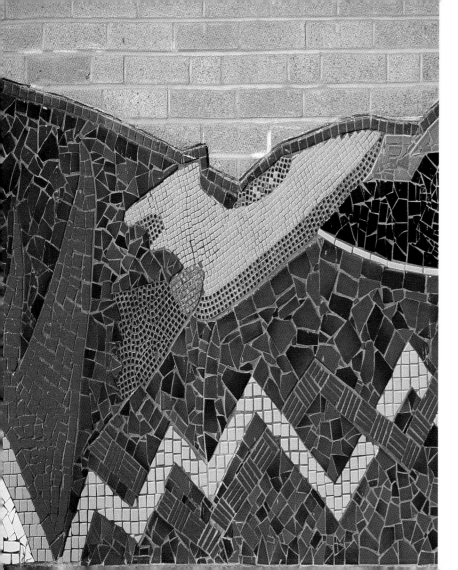

## THE SHAPE OF OUR DREAMS 1996

**KRISTAL PACHECO AND ROBERT MORIARTY**
**1628 W. Washington St.**

This organic, free-flowing mosaic framing the entrance of Spalding High School developed out of a thematic curriculum based on the question, "Are you most free when you dream?" The artists designed the project to include students with varying degrees of disabilities. There is an interesting variety of tile work in the mosaic, including sections in which the tessellation team arranged larger ceramic tiles in the linear, swirling patterns usually associated with glass-tile mosaic. (CPAG)

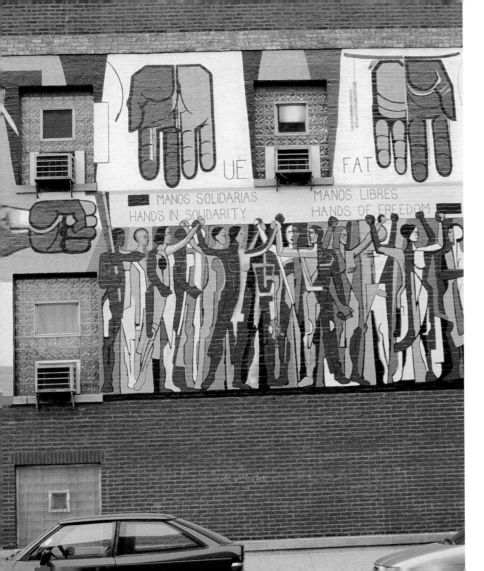

# HANDS IN SOLIDARITY, HANDS OF FREEDOM 1997

## DANIEL MANRIQUE ARIAS
## 37 S. Ashland Ave.

This work on the United Electrical Workers Union Hall by a Mexican muralist and community activist was inspired by the ongoing organizing alliance between the United Electrical Workers and Frente Auténtico del Trabajo (FAT, the Authentic Workers' Front), a Mexican labor federation that unites unions, cooperatives, and peasant and neighborhood organizations. A companion piece to the mural painted by Mike Alewitz in FAT's Mexico City headquarters, this work demonstrates that *"la solitaridad obrera no tiene fronteras"*—labor solidarity has no borders—and that workers' and immigrants' rights must be vigorously defended in the NAFTA (North American Free Trade Agreement) era. Manrique's artistic integrity and political commitment inspired the young Chicago artists who acted as his assistants. (CPAG)

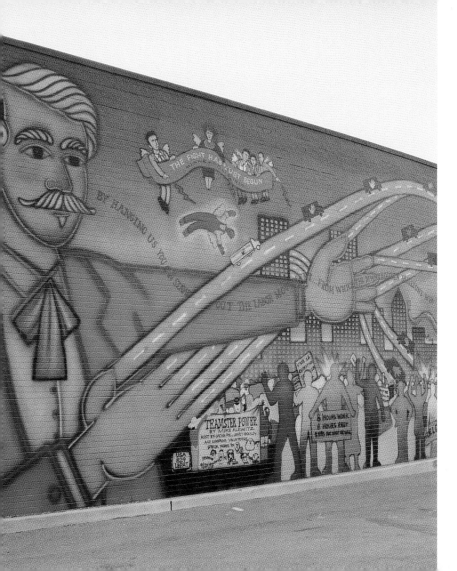

42

## TEAMSTER POWER 1997

### MIKE ALEWITZ
### 300 S. Ashland Ave.

New Jersey–based muralist Alewitz and Chicago volunteers created this mural in the Teamster City complex to celebrate the 1997 United Parcel Service strike victory. Alewitz, following David Alfaro Siqueiros's dictate to employ industrial materials to make "multi-instructional" art for the masses, used airbrush techniques to paint images of labor activist Lucy Parsons and her husband, Haymarket martyr Albert Parsons. Also included are images of leaders of the 1934 Minneapolis Teamster strike and a renegade Teamster truck breaking free of bloody UPS tentacles, representing the "monster of capitalism."

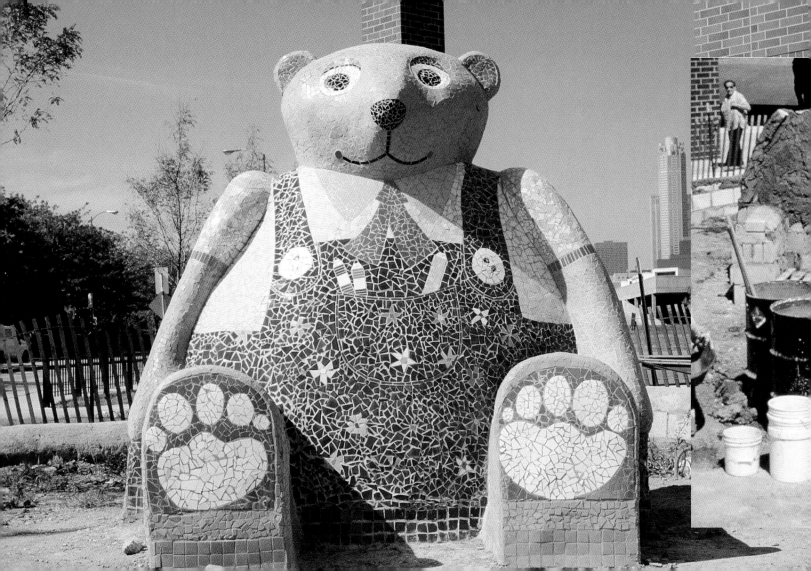

43

# ANDREW JACKSON LANGUAGE ACADEMY PLAYSCULPTURE 1990

## HENRI MARQUET, CYNTHIA WEISS, MIRTES ZWIERZYNSKI, AND NINA SMOOT CAIN
## 1340 W. Harrison St.

Marquet, a visiting French sculptor, teamed with CPAG artists, schoolchildren, and parents to create a fanciful play space with a climbable bear, tiger, and coiled snake. The bear, in its brightly patterned overalls, is a typically American teddy bear; the tiger is a whimsical recreation of the Egyptian sphinx; and the snake with its yellow ochre stucco finish recalls the architecture of Latin America. The multilingual art team demonstrated for students the value of learning several languages.

Marquet introduced to CPAG artists the solid masonry construction method. The basic form was roughed in with cinder blocks and mortar and then concrete and progressively smaller cut masonry pieces were used to sculpt the final contours of the animals. The bear is covered with ceramic mosaic. The tiger, in a Chicago first, is finished with colorfully glazed commercial brick. The cement snake is embedded with mosaic designs by the schoolchildren. (CPAG)

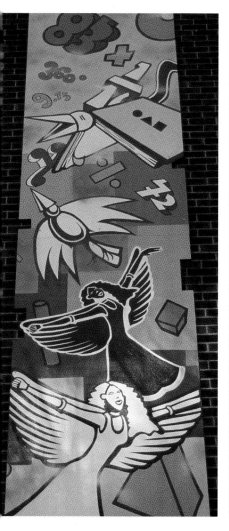
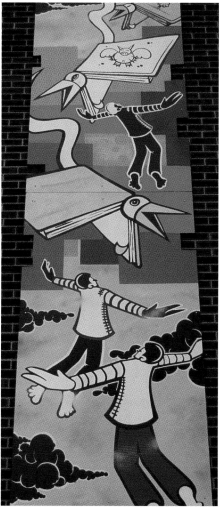

**44**

# SOARING TOWARD EXCELLENCE 1999

## CHRISTOPHER TAVARES SILVA
## 606 S. State St.

Silva and assistants worked with fifteen incoming freshman students to create their high-flying vision of learning and human evolution. Panel murals can feel like relatively small, temporary paintings lost on a large wall. Silva's innovative shaping and placement of the panels utilizes the entire wall for its amusing and whimsical composition. Students developed drawings in Silva's signature hip-hop-influenced cartoonlike style to represent their goals as trying to achieve flight. Birds, hybrid birdbooks, and angels frolic against a colorful geometric backdrop.

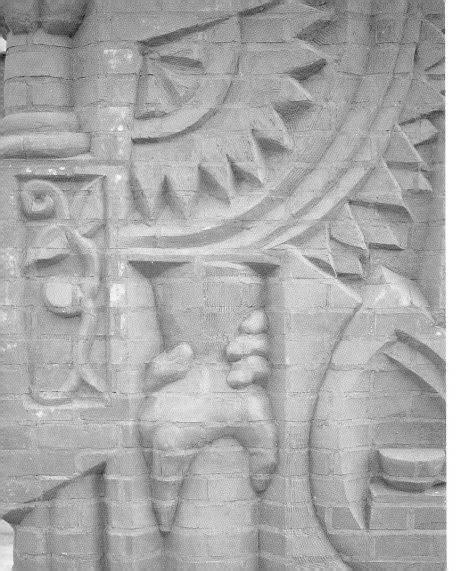

**45**

# MEMORIAL WALL 1999

### JOHN PITMAN WEBER AND
### MIRTES ZWIERZYNSKI
### 1521 S. Wabash Ave.

This freestanding carved brick wall at the Lakefront SRO is one of the few works in this demanding medium in the Chicago area. Commissioned by the AIDS Foundation, the symbolism of the wall (columns, a mask, wings) memorializes those who have died; it also evokes the eternal rebirth of nature (sprouting seed, uncurling leaf, sun, water) and the solidarity of people helping others (arms grasping each other in the lifesaving hold, a cup).

In the studio the artists constructed a wall of wet clay bricks interspersed with thin slabs of wet clay temporarily taking the place of the mortar joints. After carving the artwork, the artists meticulously unstacked the wall, numbering each piece for firing and eventual reassembly by a mason. (CPAG)

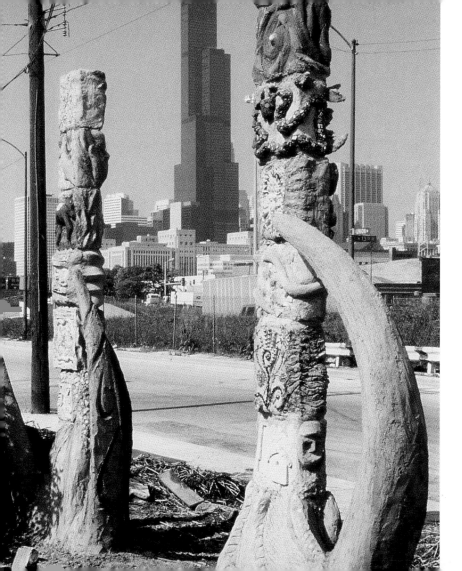

46

## REUSE/RECYCLE 1998

**PHIL SCHUSTER, JOHN PITMAN WEBER, AND JON POUNDS**
**13th St. and Union Ave.**

These freestanding concrete sculptures, collaboratively created with fifteen participants in an International Sculpture Conference seminar, form a gateway to the 13th St. Garden, a reclaimed vacant lot adjacent to the Creative Reuse Warehouse in the Maxwell St. area. The work is a useful compendium of cast and hand-sculpted concrete techniques. Also on view are a concrete relief water cistern by Schuster and other changing art and garden installations. (CPAG)

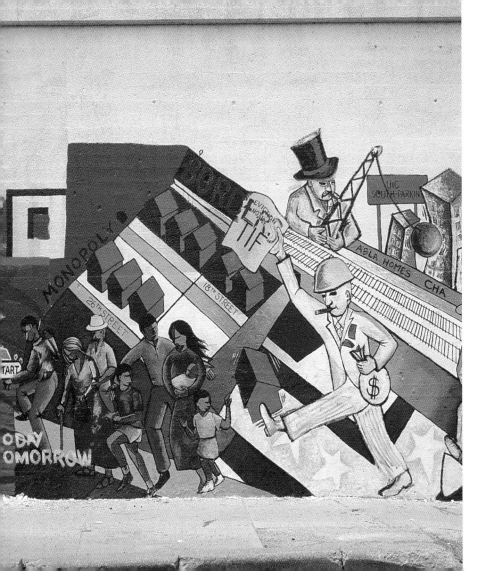

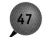

## PROTECT PILSEN 1998

### ARTIST COLLABORATION
### 16th St. and Blue Island Ave.

A variety of activist artists from throughout the city joined Pilsen muralists in commandeering an underpass wall to create this multisectioned mural that protests the feared gentrification of this predominantly Mexican-American community. In the lead image a Monopoly game board with figures of politicians and real estate speculators symbolizes the threat of the neighborhood's planned designation as a TIF (Tax Increment Finance) District. The multifarious work includes spray pieces, collage, and amusing expressionistic twists on the convention of using ancient Mexican imagery in community murals.

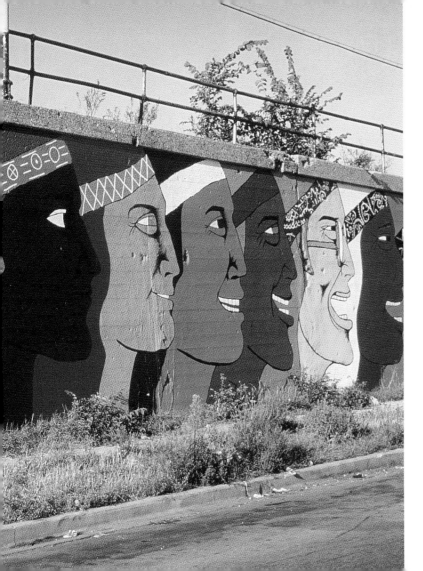

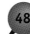
**48**

# GALERÍA DEL BARRIO

**AURELIO DÍAZ**
**16th St. between Racine and
Blue Island Ave.**

Beginning in 1976 Aurelio Díaz directed groups of Pilsen residents—first students and then other neighborhood people—in the painting of this series of murals stretching for several blocks along the retaining wall of the railroad embankment on 16th St. Panels (some of which are now badly faded) include images and designs devoted to the diverse heritages of La Raza—Aztec, Olmec, and Spanish as well as other symbolic assertions of Chicano, Mexicano, and Latino power. Particularly striking is a series of wall-high overlapping profiles representing the many facets and expressions of a contemporary Chicano.

In the late 1970s El Hogar del Niño (a Pilsen day-care center), Pros Arts Studio, Casa Aztlán, and Mujeres Latinas en Acción (Latin Women in Action) worked with youths to extend the murals eastward. Beginning in 1996 Oscar Romero, Gustavo Rodriguez, and others added works.

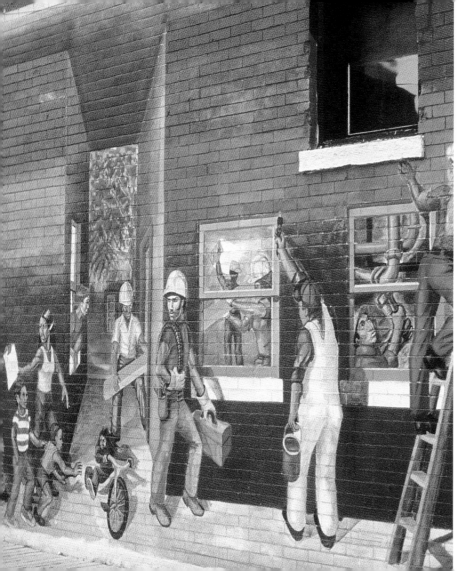

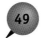

## UNTITLED 1983

### BILL CAMPILLO
### 1900 S. Carpenter St.

This mural is a true street survivor—a testament to the popular support for the creating, maintaining, and renewing of community depicted in the piece. On one side, neighborhood residents with tools and other construction materials literally build their homes, school, and community; the other side shows them celebrating the birth of a child and the planting of a tree. The two scenes are cleverly linked by an image of two workmen carrying a window—the building's actual window. In 1997 the project was restored by Campillo and Pilsen artists.

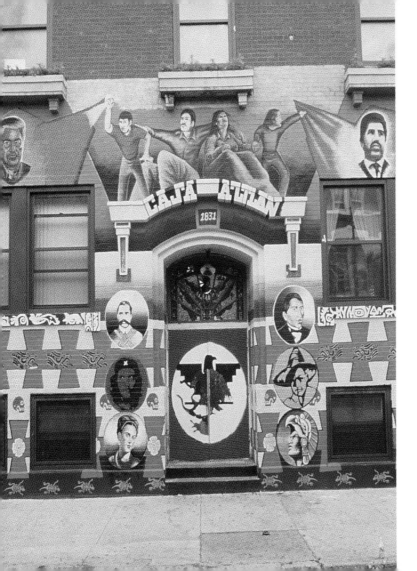

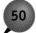

## CASA AZTLÁN

### 1831 S. Racine Ave.

From 1970 to 1973 resident artist Raymond Patlán and local youths covered the interior and exterior walls of this legendary community service center with a cycle of murals on Mexican historical and cultural themes, emphasizing Chicano and Mexicano struggles for justice. The walls facing the courtyard were decorated with brightly colored Pre-Columbian designs and architectural patterns.

After a fire in 1974, Marcos Raya, Salvador Vega, Aurelio Díaz, Carlos Barrera, and others reworked the exterior (1975–1979). They continued the tradition of the patterned courtyard murals and renewed the façade, including more portraits of Latino political and cultural heroes as well as of neighborhood residents.

Raya and Vega restored the mural in 1994, adding new figures. The current roster of heroes depicted on the façade are Benito Juárez, Augusto Sandino, Cuauhtemoc (the last Aztec king), Emiliano Zapata, Che Guevara, Frida Kahlo, Cesar Chávez, and local activist Rudy Lozano.

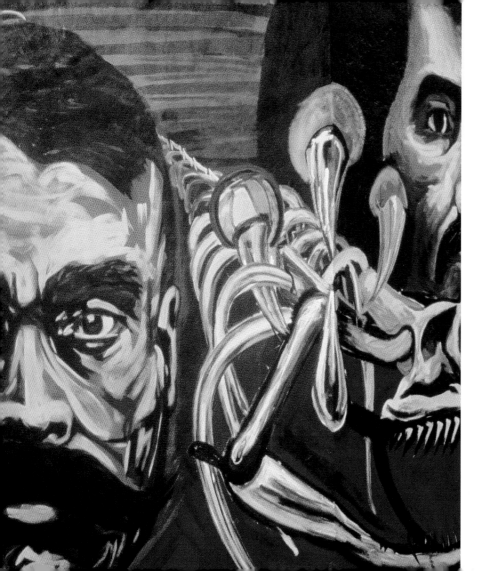

## ALTO AL DESPLAZAMIENTO URBANO DE PILSEN— STOP GENTRIFICATION IN PILSEN 1997

### ARTIST COLLABORATION
### 1805 S. Bishop St.

This mural addresses urgent issues in this working-class neighborhood. Against a backdrop of the United Farm Workers' eagle symbol, the piece depicts the people organizing and marching to maintain their jobs and housing despite the clawing threat of real estate speculators and city bureaucrats. One area highlights the plight of *eloteros* (pushcart vendors) whose livelihoods are threatened by increasing city restrictions.

Organized by Hector Duarte, the mural utilizes the classic David Alfaro Siqueiros method of composition. It was painted by Duarte and other artists connected to Taller Mestizarte—José Guerrero, Jesús Gonzalez, Luis Montenegro, Jose Piño, Mariah de Forest, and others.

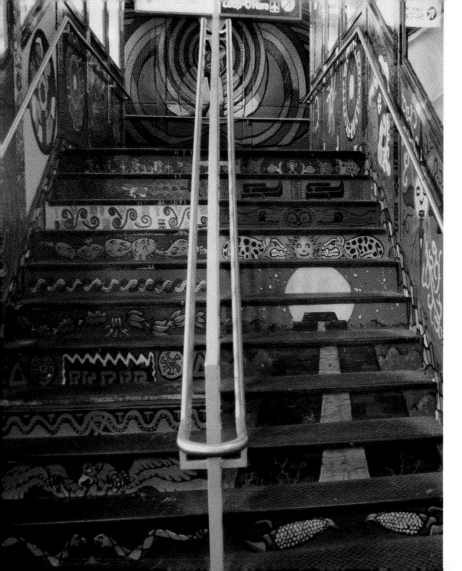

52

# 18TH STREET CTA STATION

## 18th and Paulina St.

No other rapid transit facility in Chicago is enlivened with as much mural art as this Blue Line el station in the heart of Pilsen. From 1993 to 1995 Francisco Mendoza, Joy Anderson, other artists, and area youths—working with the support of the Mexican Fine Arts Center Museum and the CTA's Community Stations Program—transformed the station's platform and stairway areas into a brilliant ethnic gallery. Almost every available surface has been covered with Pre-Columbian as well as traditional and contemporary Mexican designs and images highlighting Latino pride and culture.

**HOMAGE TO THE WOMEN OF MEXICO** (1993), a glass-tile mosaic at the station's entrance, was created by Mendoza with local youths and the support of the CTA and the MFACM.

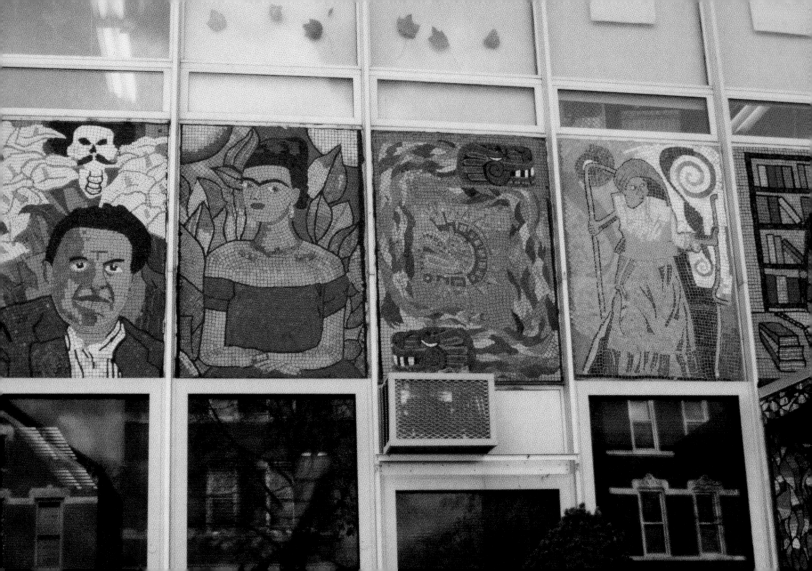

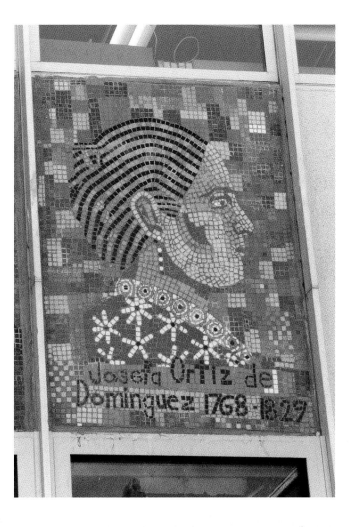

## OROZCO COMMUNITY ACADEMY MOSAICS

### FRANCISCO MENDOZA
### 1645 W. 18th Pl.

Named for the great Mexican muralist, this Pilsen elementary school is fittingly embellished with public art. Since 1991 art teacher Francisco Mendoza has led students in covering the façade with a series of glass-tile mosaics. Many honor well-known Mexican and Chicano figures—including local artists Carlos Cortez and Maria Enriquez Allen—while others are on arts and sports themes. Sponsored by the Mexican Fine Arts Center Museum and Gallery 18, the project continues to add new mosaics each year.

Across the street at 1818 S. Paulina St.: Mendoza also led local youths in the creation of the **ST. VITUS MURALS** (1992), a series of vibrant paint and spraycan works in and around the plaza of the old St. Vitus Church building, now the Resurrection Project's Instituto Cultural Guadalupano. On the wall behind the church, Mendoza and Salvador Vega created an Aztec sports-themed mural.

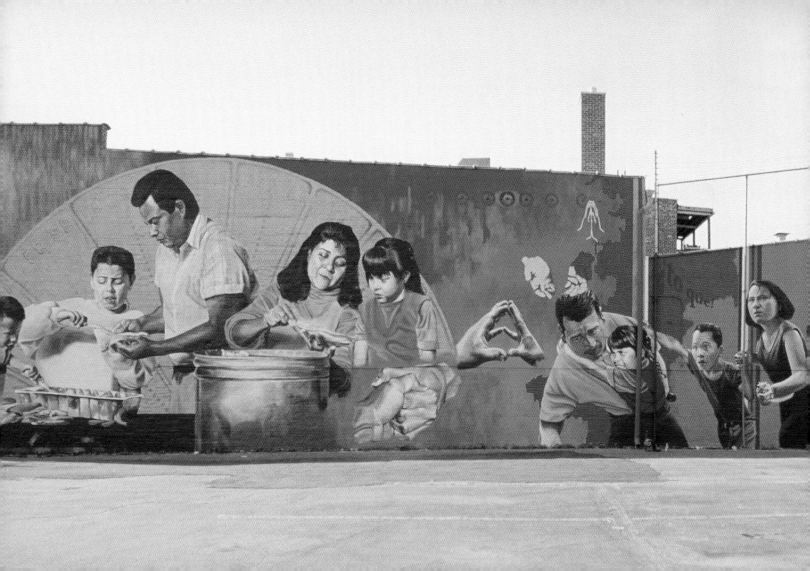



## ST. PIUS V PARISH AND SCHOOL

### 1919 S. Ashland Ave.

This Pilsen parish has sponsored several murals as part of its ongoing commitment to bring its spiritual message to the community through art. **INCREÍBLES LAS COSAS QUE SE VEN—INCREDIBLE THE THINGS YOU SEE** (1997), by Jeff Zimmerman, is located across the street above the lavandería at 1858 S. Ashland Ave. The mural shows a Mexican immigrant family struggling to cross the Rio Grande while a miraculous apparition of the Virgin of Guadalupe serves as their guide.

To the south at 1910 S. Ashland Ave. on the St. Jude Gift Shop, Zimmerman painted **FAMILIAR** (1999), depicting Mexican families in conflict and in harmony. Unlike many contemporary murals addressing family themes, where idealistic images of unity and togetherness predominate, this mural aims to illustrate that creating strong nurturing families, especially in immigrant communities, can often be a difficult process that involves working through problems by open communication and understanding.

Featuring real-life Pilsen parents and youth, the right side shows isolated family members confronting each other with accusatory gestures; the larger left side, the part most visible from the street, shows a reconciled family making tamales together.

*Familiar*

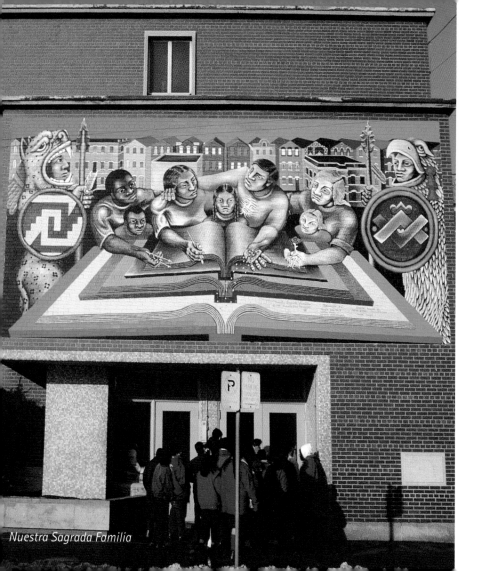
Nuestra Sagrada Familia

## ST. PIUS V PARISH AND SCHOOL (CONTINUED)

Above the doorway on the south side of the school is **NUESTRA SAGRADA FAMILIA—OUR SACRED FAMILY** by Aurelio Díaz; in a classically composed work in a style reminiscent of Rivera, parents and children peruse a gigantic book, symbolizing knowledge of–and pride in–their heritage. **NUESTROS SAGRADOS ALIMENTOS— OUR SACRED FOODS**, a scene of families harvesting and sharing the land's bounty, also by Díaz, adorns the north wall of the parish (both 1989).

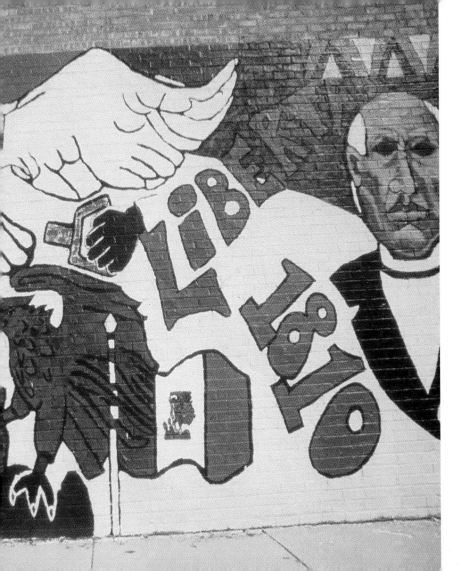

55

## REFORMA Y LIBERTAD 1971

### RAYMOND PATLÁN
### 2013 S. Laflin St.

Linking past struggles for independence and social justice to today's, this historic Pilsen mural was painted with local youths in honor of Miguel Hidalgo y Costilla (1753–1811), the father of Mexican independence and Benito Juárez, the great Mexican reformer (1806–1872). The two, considered the George Washington and Abraham Lincoln of Mexico, are surrounded by symbols of ancient Aztlán. The mural was reworked by Pátlan and crew in 1974 and was repainted in 1985 by Dulce Pulido and her students. (CMG)

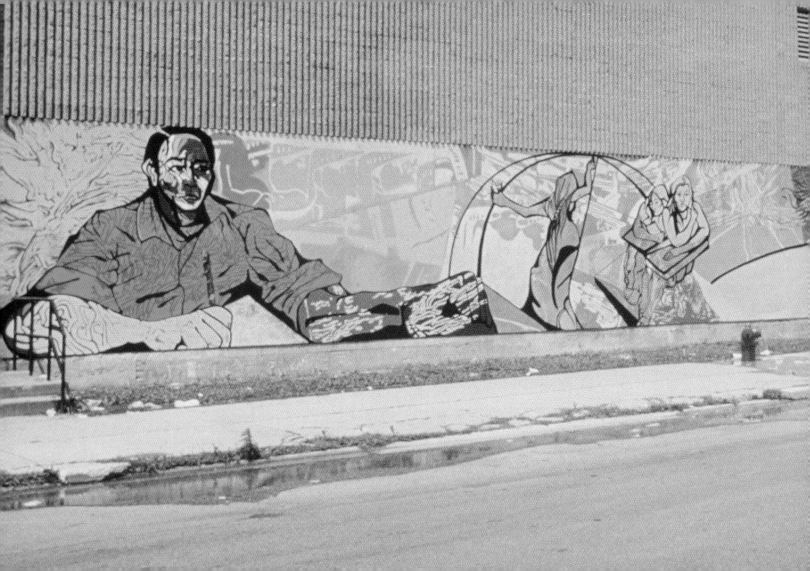

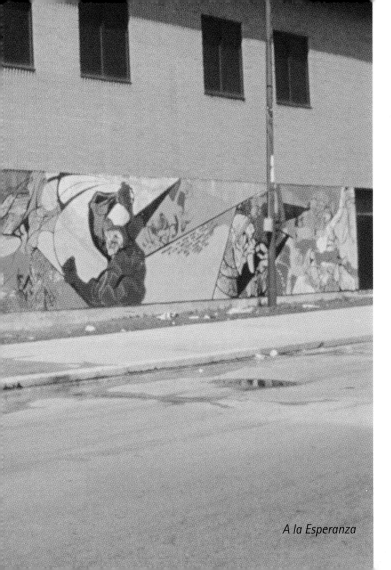

*A la Esperanza*

56

# BENITO JUÁREZ HIGH SCHOOL

## 2150 S. Laflin St.

**A LA ESPERANZA—TO HOPE** (1979), a mural on the east side of the building, was commissioned for the newly built Pilsen high school as the result of a design contest won by Jaime Longoria. Codesigned with Malú Ortega y Alberro, and painted by them, Marcos Raya, Salvador Vega, Oscar Moya, José González, and Roberto Valadez, the 2,000-square-foot work uses a unique graphic style and subtle color scheme to honor Benito Juárez, a nationalist hero. The mural also depicts themes related to local problems, education, and achievement. The mural was the first large-scale commission awarded to Mexicano muralists in Chicago. Unlike many previous Pilsen works, it was well funded, painted on an ideally prepared surface, and planned as part of the original architectural design. In 1994 the mural was restored by Raya and Vega.

    **KANTO A LOS 4 VIENTOS—CANTO TO THE 4 WINDS** (1983), a series of murals by Aurelio Díaz on the school's west side, stresses the right of Mexican people to reclaim their cultural heritage through bilingual education.

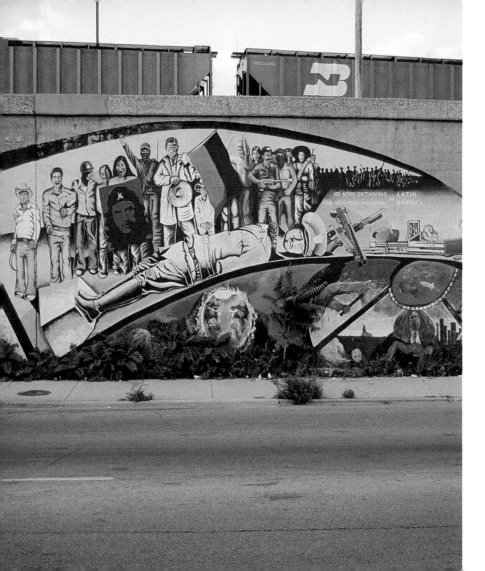

# PREVENT WORLD WAR III
## 1980

### ARTIST COLLABORATION
### 18th St. and Western Ave.

The dawn of the Reagan era—and with it, the looming specter of nuclear warfare—prompted this protest mural along the railroad embankment retaining wall at 18th St. and Western Ave. The project, also known as the *Anti-World War III* mural, was organized by John Pitman Weber, who did not paint due to a broken arm. It was designed and painted by a group of muralists including Marcos Raya, Celia Radek, Mark Rogovin, Rich Capalbo, Caryl Yasko, José Guerrero, Roman Villarreal, Rey Vasquez, and Carlos Cortez.

Mujeres Latinas en Acción added a panel in 1983. In 1997 Raya retouched and updated his panel entitled *Dedicated to the People of Central America*, which shows the people stepping over a fallen statue of a Latin American dictator.

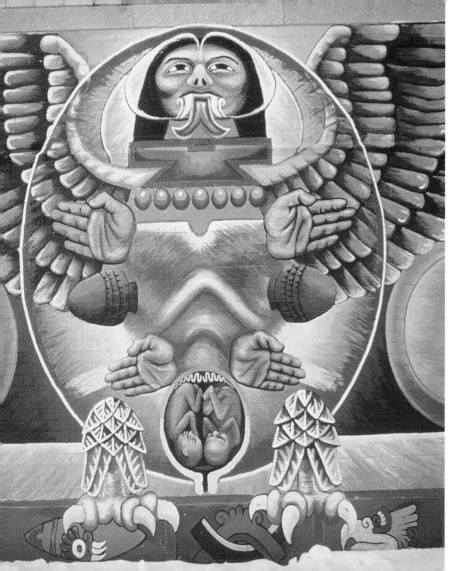

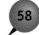

58

# LATINO YOUTH, INC. MURALS

## AURELIO DÍAZ
## 2206–2208 S. Marshall Blvd.

The courtyard of this alternative high school and social service center in the Marshall Square area features an impressive cycle of three murals, created by Aurelio Díaz with Latino Youth participants. **DANDO Y MANTENIENDO LA VIDA—GIVING AND MAINTAINING LIFE** (1990), painted around the lower portion of the courtyard, is dedicated to mothers in the barrio as well as to Mother Earth. The two vertical murals, **EL AMANECER DE LA JUVENTUD—THE DAWN OF YOUTH** to the south and **RESPETO A NUESTRO ORIGEN ES EL BIENESTAR DE NUESTRO PRESENTE—RESPECT FOR OUR ORIGIN IS THE WELL-BEING OF OUR PRESENT** (1989) to the north urge children and youths to educate themselves about their cultural heritage as a firm foundation for future achievement.

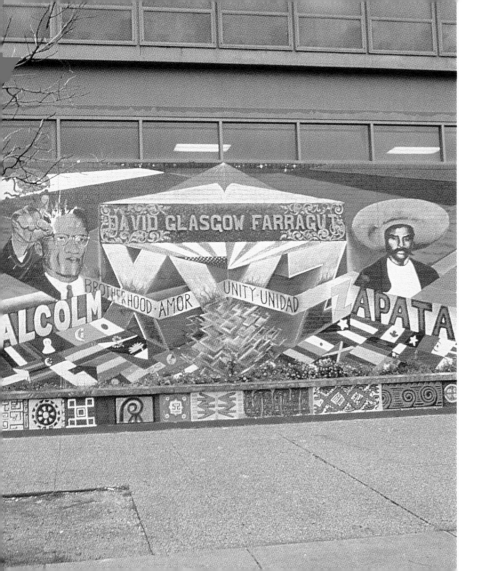

## X y Z 1993

### DORIAN SYLVAIN AND SALVADOR VEGA
### 2345 S. Christiana Ave.

"X" stands for Malcolm X; "y" is the Spanish "and"; and "Z" stands for Zapata. This mural at Farragut Career Academy, sponsored by the Mexican Fine Arts Center Museum, brought together an African-American and a Mexican-American artist to promote interracial cooperation in the school because of tensions between the two communities. The mural honors several African-American and Mexican heroes and heroines, urging brotherhood and unity between blacks and Latinos. It features flags from countries around the world.

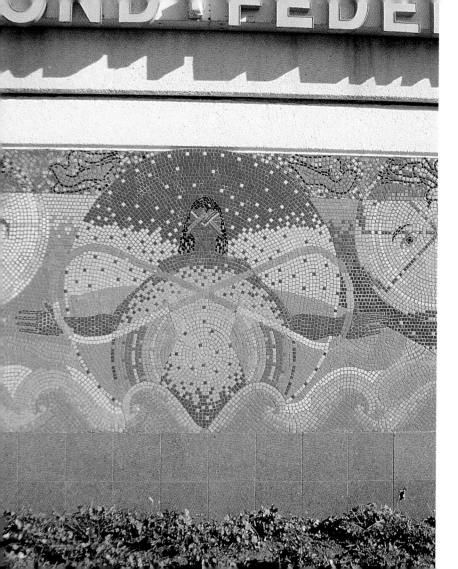

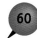

## OUR ENVIRONMENT, OUR COMMUNITY 1993

### ROBERTO VALADEZ, JOSÉ GUERRERO, AND MARGARET GUERRERO
### 3960 W. 26th St.

This glass-tile mosaic mural on the drive-in facility of the Second Federal Savings Bank in Lawndale shows Pachamama, the Incan Earth Mother, flanked by the sun and the moon, and bordered by birds, fish, amphibians, and Aztec symbols. The project was cosponsored by United Neighborhood Organization and created with area youths.

Also see the mural painted by Vicente Mendoza on the back of the bank (1985).

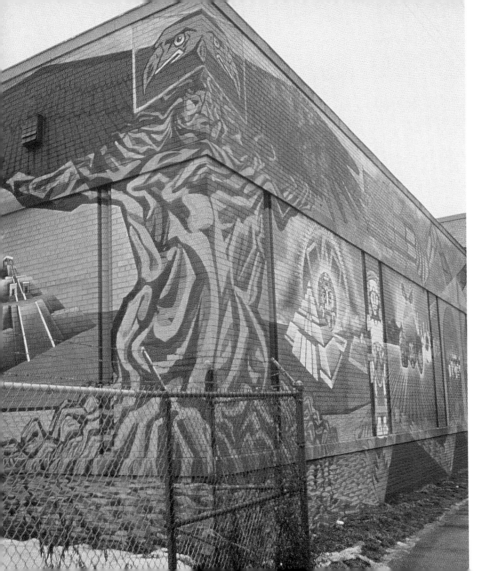

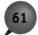

**61**

## OUR ROOTS, NEW HORIZONS 1985

**HECTOR DUARTE, AURELIO DÍAZ, AND ALEJANDRO NAVA**
**26th St. and Kostner Ave.**

Wrapping around the corner of a Chicago Central Industrial Park structure in the predominantly Latino Little Village neighborhood, this mural consists of the usual Mexican cultural symbols—among them eagles, pyramids, and sun gods—that connect the ancient past of La Raza to the present. It also features such emblematic figures as Cuauhtemoc, Emiliano Zapata, and Cesar Chávez.

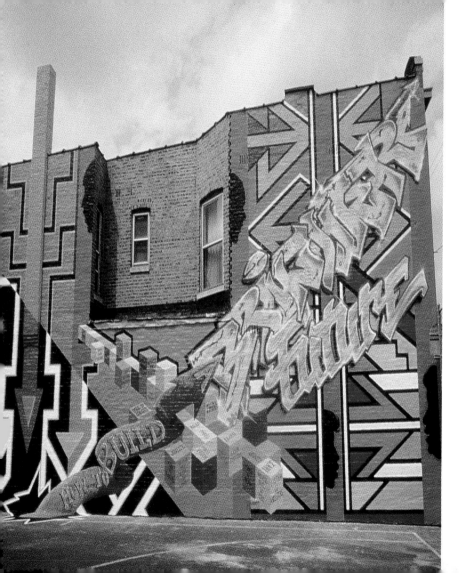

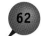

# HOW TO BUILD A BRIGHTER FUTURE 1993

### DZINE AND OLIVIA GUDE
### 1512 S. Pulaski Rd.

One of the three pieces created by the muralist/spraycan artist collaboration in the summer of 1993, this 25-foot-tall spray and acrylic paint mural on a Better Boys Foundation facility combines Ndebele mural designs from southern Africa, graffiti "wildstyle" lettering, and huge, carefully rendered building blocks. The design incorporates the building's chimney—turning it into a vivid pink arrow shooting downward, creating a painted explosion on the ground at the foot of the mural. The texts on the blocks are quotes from North Lawndale residents about what it takes to create a better future. "Respect your elders." "Fight racism." "If you say, 'can't,' you won't." (CPAG)

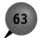
## COMMUNITY CHRISTIAN ALTERNATIVE ACADEMY

### 1231 S. Pulaski Rd.

This North Lawndale school is enlivened with a series of murals that combine folk art, traditional mural, and hip-hop styles. Focusing on the African-American heritage of the surrounding neighborhood, **IT TAKES A WHOLE VILLAGE TO RAISE A CHILD** (1996), by art teacher Elyn Koentopp and her students, provides a colorful backdrop for the developing community garden beautified by cast-concrete and glass-mosaic benches. Bordered by vibrant Ndebele designs, the mural proclaims, "I am from the great role models that I will one day be." They include Harold Washington, Rosa Parks, and Thurgood Marshall. In another section, colorful symbols and text delineate the seven principles of Kwanzaa.

The school's courtyard also features a series of smaller murals by art teachers Koentopp, Valerie Brodar, Brian Pyle, and students.

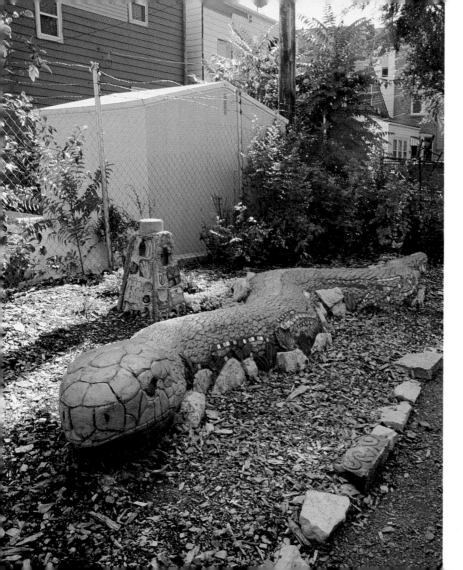

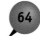
64

## ABC YOUTH CENTER SCULPTURE GARDEN 1996

### PHIL SCHUSTER AND MARVA JOLLY
### 3415 W. 13th Pl.

"Flowers flowers in the ground/Leaves growing all around/Make Chicago a better town." This mosaic text on a sculpted bench could just as well apply to this playful, imaginative neighborhood space, a creation of the Open Lands Project with the North Lawndale community. Schuster, a concrete sculptor, and Jolly, a ceramicist, worked with landscape designers and local children to transform a woodlot into an art garden abloom with whimsy and wonder.

Six separate artworks—three bird baths by Jolly, and Schuster's "river bench," triangular planter bench, and, the pièce de résistance, his 23-foot-long writhing snake—are all decorated with glass mosaic, cracked-ceramic tile, handmade clay relief tiles, stones, and other bric-a-brac. A Dzine spraypiece from 1993 forms a backdrop for the garden.

# I DARE TO DREAM 1995

## PAUL THOMAS MINNIHAN
## 3353 W. 13th St.

This mural, overlooking the Storybook Reading Garden adjacent to the Douglass Branch of the Chicago Public Library, depicts a fanciful *Wizard of Oz* scene in vivid color; inset at the pictures' edges are black-and-white portraits of African-American heroes and heroines, including Frederick Douglass, abolitionist and orator; Ida B. Wells, equal rights crusader; and Mae Jemison, the Chicagoan who was the first black woman in space. These figures, like Dorothy and her cohorts, have dared to dream. The project was sponsored by the Chicago Botanic Garden and the Blue Skies for Library Kids.

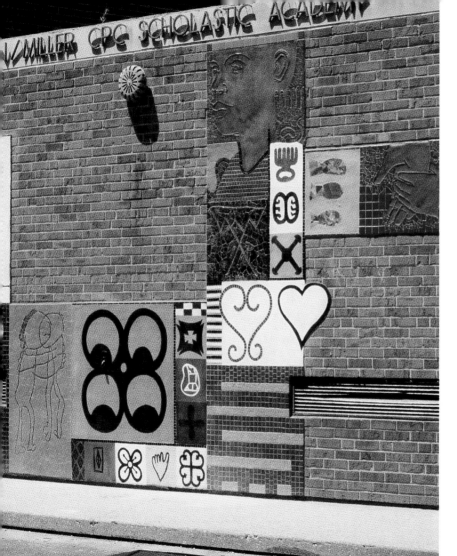

**66**

# JENSEN ACADEMY MOSAIC MURAL 1998

## JUAN CHÁVEZ
## 3030 W. Harrison St.

Combining mosaic and painted mural techniques, this influential work uses Adinkra symbols from West Africa to represent the qualities of wealth, love, hope, strength, forgiveness, patience, resilience, and defiance. Among the piece's innovations is the use of separate rectangular areas to organize the composition and the creation of imagery with tile "line drawings" in beds of colored stucco. (CPAG)

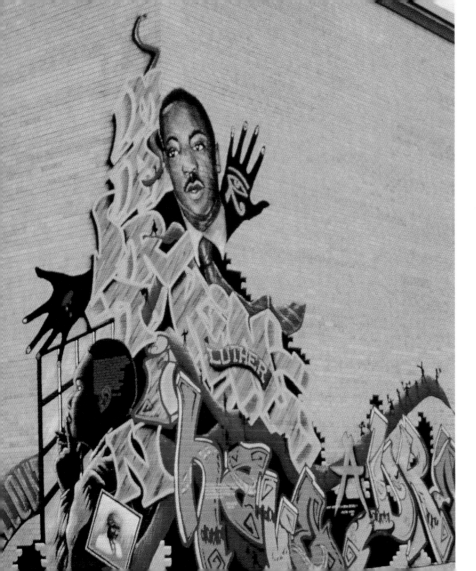

## STILL DEFERRED; STILL DREAMING 1993

### OLIVIA GUDE AND DZINE
**Washington Blvd. and Sacramento Ave.**

The first in a series of collaborations between Gude and spraycan artist Dzine, the piece appears to cling to the corner of the Martin Luther King, Jr., Boys and Girls Club. Celebrating the thirtieth anniversary of King's "I have a dream" speech, the mural also asks Langston Hughes's question, "What happens to a dream deferred?" The work includes graffiti-style lettering, naturalistic portraits of King and Gandhi, and quotes by many Africans and African Americans on dreaming and living. Tiny silhouettes of civil rights advocates designed by neighborhood teens and children march throughout the work. Pearl Cleage's question, "What do you pack when you pursue a dream and what do you leave behind?" suggests that each person must learn how to honor cultural legacy and be open to new ideas and new values. (CPAG)

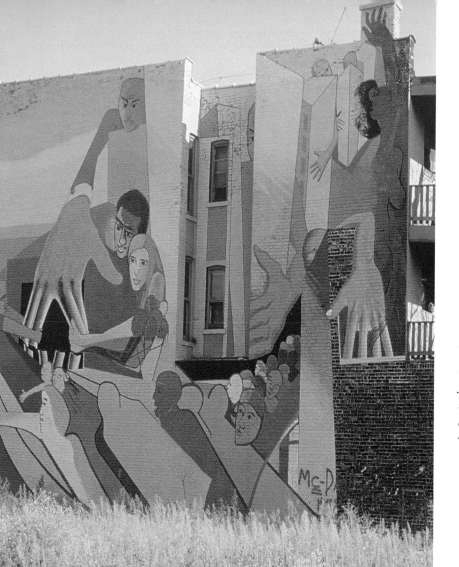

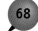

## BREAK THE GRIP OF THE ABSENTEE LANDLORD 1973

### MARK ROGOVIN
### 5219 W. Madison St.

A fading yet still relevant classic filling the entire side of a three-story building, this is the sole surviving outdoor mural of the Public Art Workshop, which had been based in this West Side Austin community. It depicts a black woman in her burning flat while menacing slumlords greedily grasp their rundown tenements. A group of racially mixed tenants is shown prying open a slumlord's jailbar-like hand. The mural incorporates the architecture of the actual wall—real windows, for example, are made part of the painted building. The project was painted with local youths.

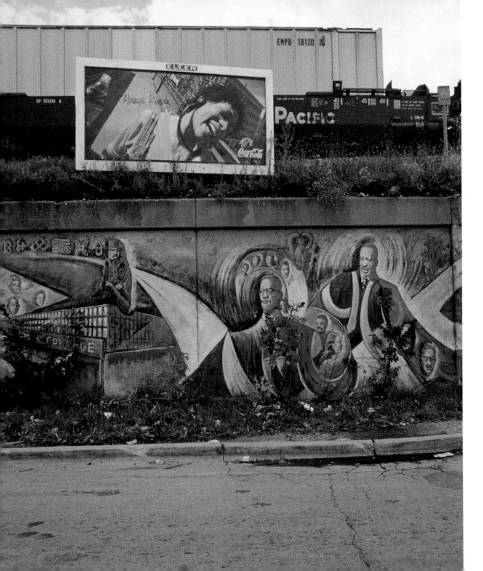

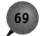

## LEGACY 1996

### EUGENE EDA
### Kinzie St. and Laramie Ave.

In his first outdoor mural in many years, Eda—among Chicago's first muralists—features portraits of notable African Americans from politics and the visual and performing arts, along with African and ancient Egyptian motifs on a Metra retaining wall. Portraits include Josephine Baker, Jacob Lawrence, and Sidney Poitier. The mural incorporates an image of Malcolm X College, the sponsor of the piece.

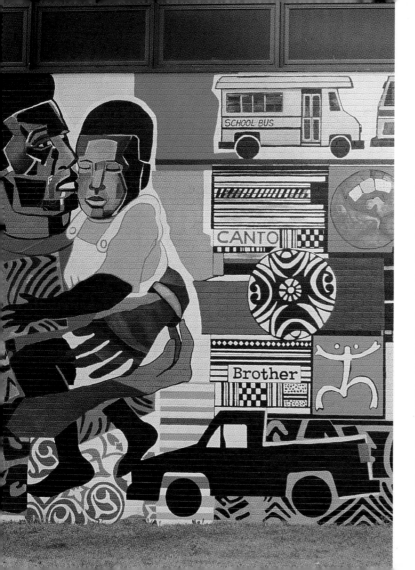

## URBAN WORLD AT THE CROSSROADS 1997

### JOHN PITMAN WEBER AND BERNARD WILLIAMS
### Chicago Ave. and Pulaski Rd.

This dynamic mural at Orr Academy High School transformed a formidable blank wall into a jazzy collage of color, pattern, and realistic rendering. Echoing the modernist architecture of the building, the mural is loosely arranged in a rectangular grid which contains images related to family, culture, education, and community development. The inclusion of many images of transportation highlights one of the mural's themes—the literal and metaphorical coming and going of people at the crossroads of urban life in this west Humboldt Park neighborhood.

Working together for the first time, the two master muralists incorporated their individual studio styles into the monumentally scaled work. They led a team of Youth Service Project/Gallery 37 teens in designing the piece, using a cut-paper collage technique inspired by the work of Romare Bearden. (CPAG)

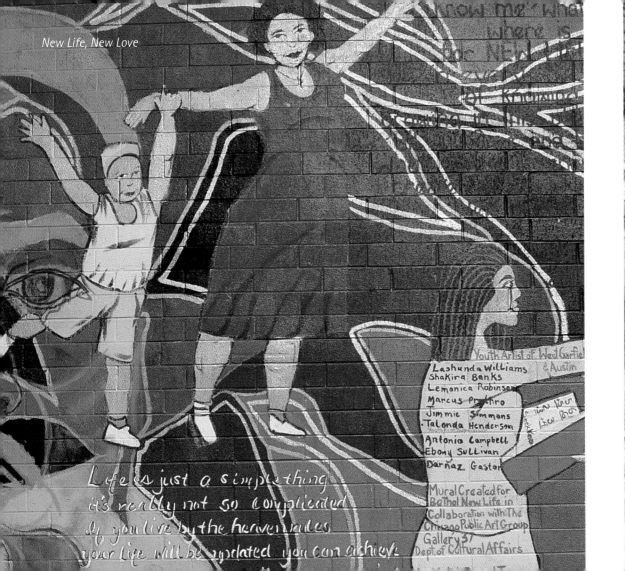

*New Life, New Love*

Youth Artist of West Garfield & Austin

Lashunda Williams
Shakira Banks
Lemonica Robinson
Marcus Prothro
Jimmie Simmons
Talonda Henderson
Antonio Campbell
Ebony Sullivan
Darnaz Gaston

Mural Created for
Bethel New Life in
Collaboration with The
Chicago Public Art Group
Gallery 37
Dept. of Cultural Affairs

Life is just a simple thing
it's really not so complicated
if you live by the heaven rules
your life will be updated you can achieve

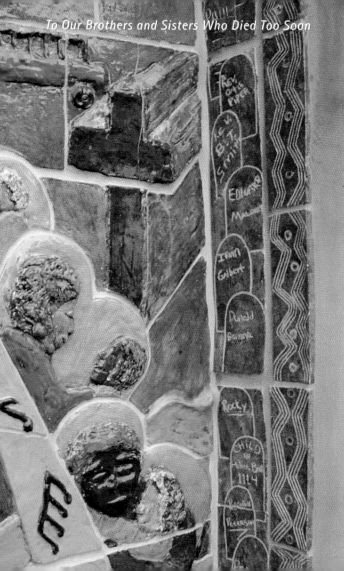

## BETH-ANNE LIFE CENTER

### 1140 N. Lamon Ave.

Bethel New Life, an Austin-based community development agency, has been transforming the grounds of an old hospital into a vital center for social services and, with CPAG artists and Gallery 37 youths, a showcase for community public art. The campus includes a day-care center, a small business center, an auditorium, a chapel being converted to a performing arts center, and a senior citizens' housing complex.

C. Siddha Sila's mural **NEW LIFE, NEW LOVE** (1996), on the day-care center, celebrates family unity with images of children and elders sharing mutually loving and learning relationships. On a vivid purple backdrop, the work's spiritual theme is enhanced by golden angelic figures and religious texts. Nearby, Corinne Peterson led **TO OUR BROTHERS AND SISTERS WHO DIED TOO SOON** (1997), a ceramic relief mural that commemorates the untimely deaths of neighborhood youths as well as the passing of the loved ones of the apprentice artists; the piece urges viewers to "increase the peace."

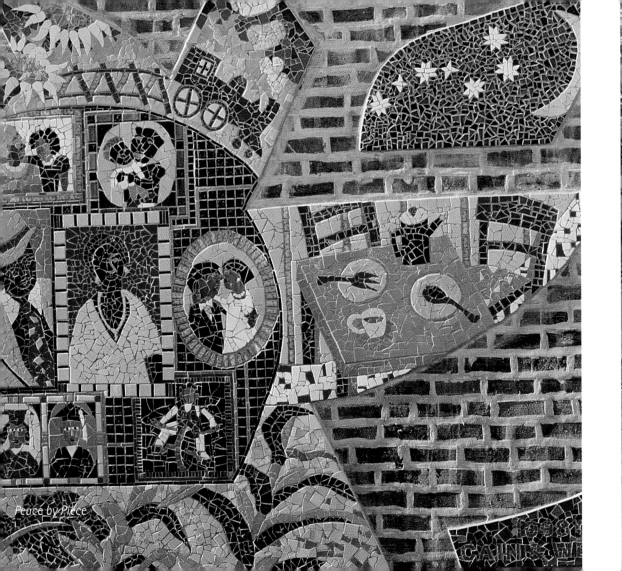

*Peace by Piece*

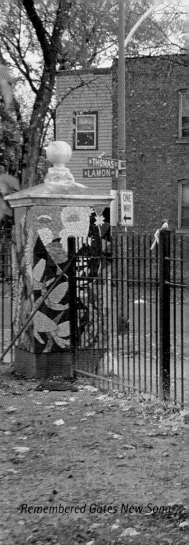

*Remembered Gates New Song*

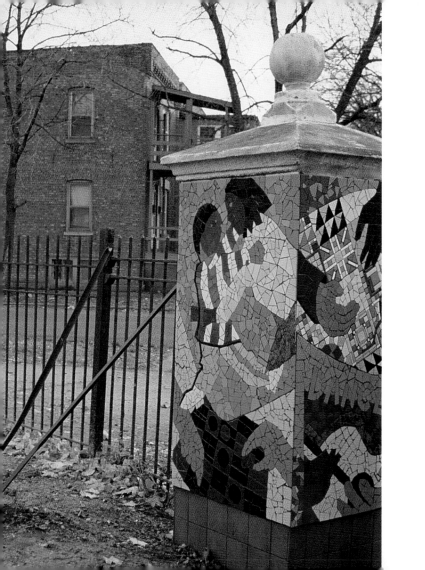

# BETH-ANNE LIFE CENTER
## (CONTINUED)

**PEACE BY PIECE** (1998), by John Pitman Weber and Nina Smoot Cain, is a courtyard installation in which neighborhood youths celebrated the strengths and rituals of African-American life through interpreting community photographs in cracked-ceramic mosaic. Discussions with youths about how their families came north yielded images of the Big Dipper which guided runaway slaves and a train engine representing the Great Migration. A set table and a frieze of collard greens recall shared family traditions.

Cain and Weber returned in the summer of 1999 to create **REMEMBERED GATES NEW SONG**, ceramic mosaics for the center's historic entry posts at the corner of Lamon Ave. and Thomas St., and two wall pieces—**READING TOGETHER** and **GARDEN OF TIME**.

Weber, debuting in his first all-mosaic work, and veteran mosaicist Cain broke new ground in their varied and playful tile work. The mosaics incorporate multicolored sections, whole-tile decorative borders, and skillfully nipped tiles which mimic sunflower seeds and leaf veins. (CPAG)

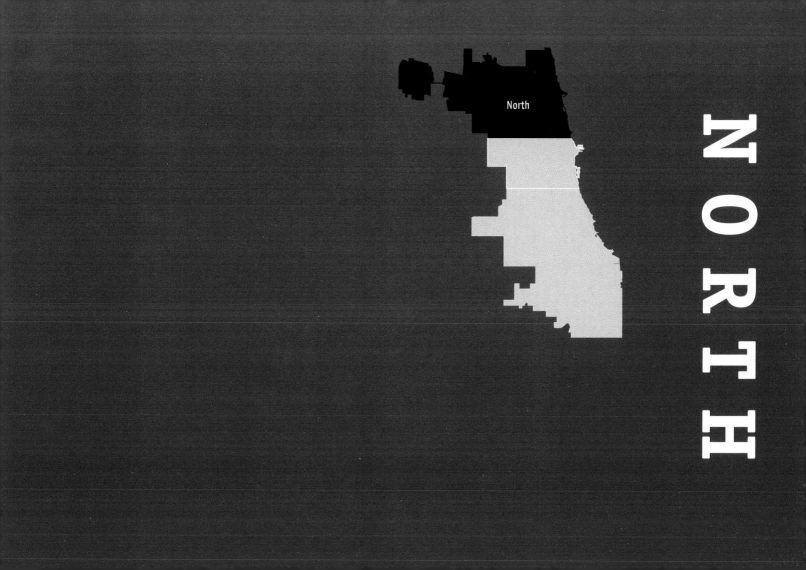

North

# NORTH

*The North section is bounded by Evanston on the north, Division St. (1200 N) on the south, the lakefront on the east, and the city limits on the west.*

Because of its diverse neighborhoods, community artworks in this section are the most heterogeneous and thematically varied of those in any part of the city. The North Side also is home to the city's oldest extant outdoor murals, dating from as early as 1971.

In the early 1970s William Walker, a founder of Chicago Mural Group, was very active in the Cabrini-Green public housing complex on the Near North Side. The eerily beautiful church façade, **ALL OF MANKIND**, survives from this period.

At the same time CMG cofounder John Pitman Weber was working with the Puerto Rican community in West Town to create **UNIDOS PARA TRIUNFAR** and **ROMPIENDO LAS CADENAS**, believed to be one of the oldest extant outdoor community murals in the United States. Other surviving important pieces of Weber's early work include **FOR A NEW WORLD** and **TILT**.

West Town and Humboldt Park, on the Near Northwest Side, have historically been centers of the Puerto Rican nationalist movement; many murals in these communities pay homage to *independentista* heroes and heroines—from

historical figures, such as in 1971's **LA CRUCIFIXIÓN DE DON PEDRO ALBIZU CAMPOS**, by artists of the Puerto Rican Art Association, to more recent works, such as those on the Puerto Rican Cultural Center.

Many North Side murals are based on themes of the celebrations and struggles of immigrant peoples, including Sun Yun's Korean-themed **MOUNTAINS + WATER + WE THE PEOPLE**, in Albany Park, **CHANGING HOME** by Juan Chávez in New Chinatown, and Lothar Sanchez-Speer's German mural in Lincoln Square.

It was on the North Side that some veteran CMG/CPAG artists began experimenting with other materials and techniques. In 1980 Weber teamed with José Guerrero and Lynn Takata in Humboldt Park to create **FOR THE PEOPLE OF THE FUTURE**, which used concrete relief, mosaic, and sgraffito. Such works as Takata's **WINDFORM** and Weber and Catherine Cajandig's **ARBOL DE VIDA** continued the experimentation with sculptural concrete. More recently Phil Schuster has created significant concrete works such as his **STORYTELLING THRONE** in Uptown and, with Robert Moriarty, **THE NATURE OF EDUCATION** at Ames Middle School.

The North Side is also home to several experiments in combining community art and gardening. Archi-treasures

has developed sites on Division Street—the Albizu Campos Casita Garden Gallery and the grounds of Clemente High School. CPAG and archi-treasures artists worked with parents and children to turn the unremarkable front lawn of Pulaski Community Academy into a remarkable folk art–like garden. Waters Elementary School and Stone Community Academy have each developed stunning gardens and have begun to enhance them with student-created public art.

**FABRIC OF OUR LIVES**, a 1980 work by Cynthia Weiss and Miriam Socoloff, wasn't only Chicago's first Jewish history–themed mural; it was also the city's first community mosaic. Socoloff, then a teacher at Lake View High School, and various visiting artists have led students in transforming the grounds around the school with wall mosaics, freestanding sculptures, and mosaic benches.

Since 1978 CMG/CPAG has worked each year with teen artists from Youth Service Project in the West Humboldt Park area. The partnership has produced more than twenty murals and mosaics. Among the significant murals created by this collaboration are **URBAN WORLD AT THE CROSSROADS** and **ES TIEMPO DE RECORDAR.**

YSP has been a major supporter of innovative mosaic works, including such pieces as **SUNRISE OF ENLIGHTENMENT** by Nina Smoot Cain and Mirtes Zwierzynski at Nobel School and **WHAT DO YOU NEED TO KNOW**? by Olivia Gude and Juan Chávez at Lowell School.

The North Side is home to many 1990s projects that continued to develop the visual style and experimental collaborative techniques of community murals. These include Jeff Zimmerman's innovative **PAID PROGRAMMING**, Beatriz Santiago Muñoz and Tim Portlock's **FISHING IN HOGARTH'S HEAD BAY**, Gude and Dzine's **AREN'T I A WOMYN?** and **ARTS FOR ALL**, a collaboration of muralists and spraycan artists. Also located here are two CPAG/CTA/Gallery 37 collaborations in which teens and muralists teamed up to create hip-hop-inspired imagery in Joshua Sarantitis's **TELL ME WHAT YOU SEE** and Joe Matunis's **I'VE GOT A FEELING ABOUT THE WHIRL'D.**

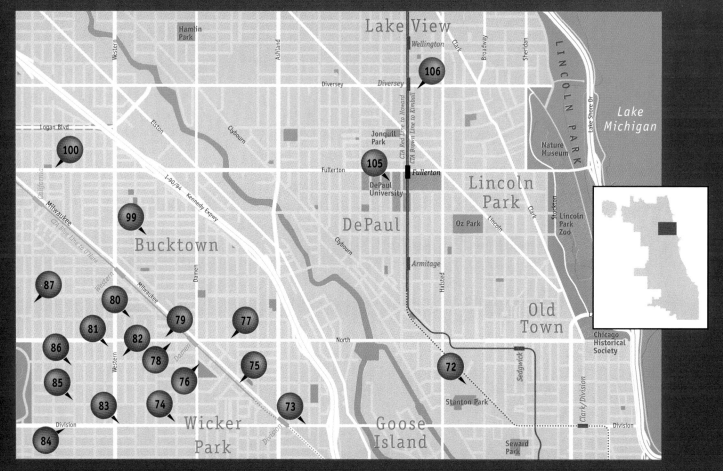

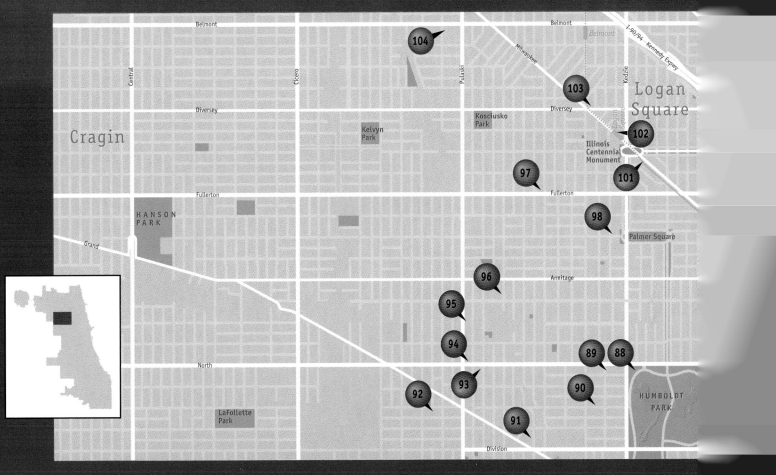

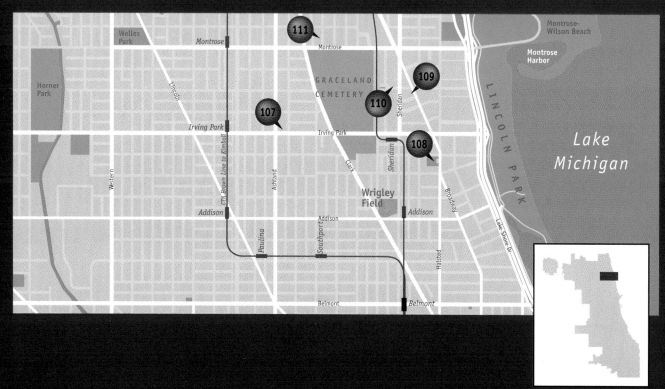

Welles Park

Montrose

Horner Park

Lincoln

Irving Park

111

Montrose

GRACELAND CEMETERY

107

Irving Park

109

110

Sheridan

108

Western

CTA Brown Line to Kimball

Ashland

Clark

Sheridan

Wrigley Field

Addison

Paulina

Addison

Southport

Addison

Broadway

Halsted

Belmont

Belmont

Montrose-Wilson Beach

Montrose Harbor

LINCOLN PARK

Lake Michigan

Lake Shore Dr

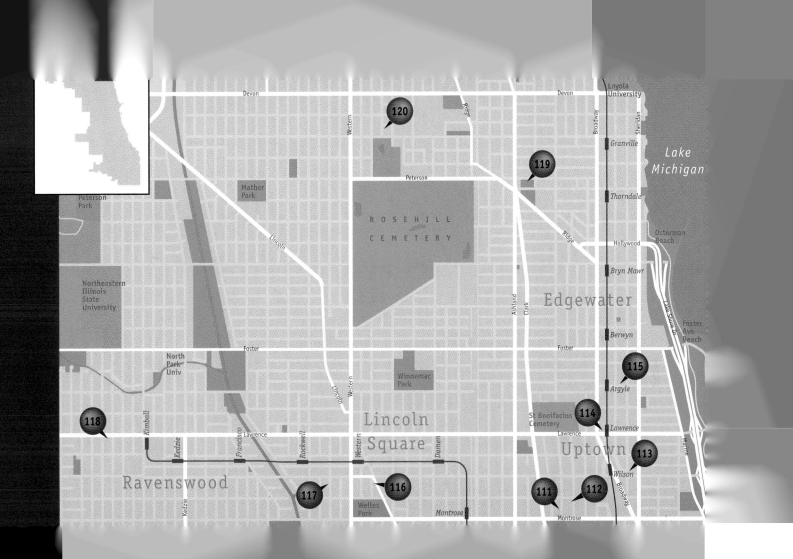

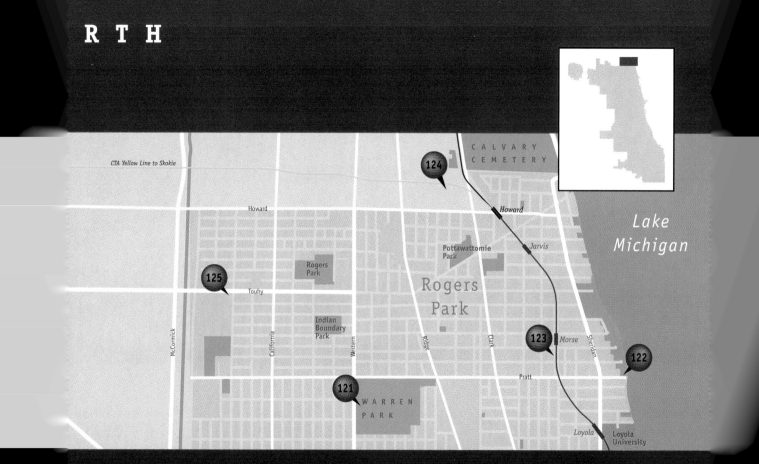

CTA Yellow Line to Skokie

CALVARY CEMETERY

**124**

Howard

Howard

Pottawattomie Park

Jarvis

Lake Michigan

**125**

Rogers Park

Rogers Park

Touhy

Indian Boundary Park

California

McCormick

Western

Ridge

Clark

Morse **123**

Sheridan

Pratt

**122**

**121**

WARREN PARK

Loyola

Loyola University

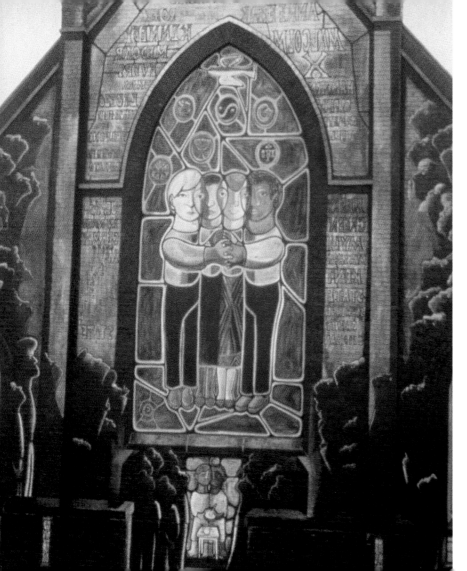

## ALL OF MANKIND 1973

### WILLIAM WALKER
### 617 W. Evergreen Ave.

Walker spent three years covering the exterior and interior of the San Marcello Mission Church with murals about the unity—and disunity—of the human race. Located at the edge of the Cabrini-Green public housing complex, the church façade features one of Walker's recurring motifs: four heads, representing different races, interlocked in a symbol of brotherhood and goodwill. Around the window is a list of civil rights–related martyrs and events, including Dr. King, Medgar Evers, the My Lai Massacre, and the shootings at Kent State. The future of Chicago's "little Sistine Chapel," now the Strangers Home Missionary Baptist Church, is uncertain due to the intensive redevelopment of the area. (CMG)

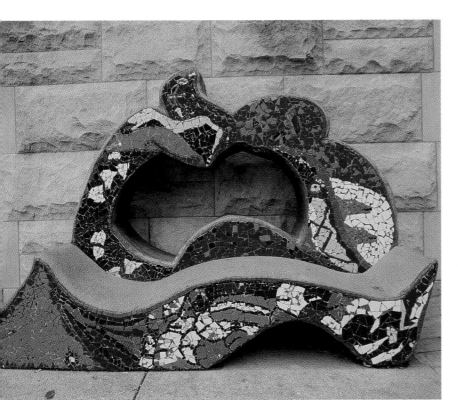

## NEAR NORTH MONTESSORI SCHOOL

**LYNN TAKATA**
**1434 W. Division St.**

In 1986 Takata and children created four "interactive" concrete and ceramic-tile bench sculptures for this Near Northwest Side school. The fanciful **FLOATING THING #6** is located on Cleaver St. Three animals from successive evolutionary stages—a nautilus, a reptile, and a tiger—are in the playground off of Division St. (CPAG)

**74**

## UNIDOS PARA TRIUNFAR— TOGETHER WE OVERCOME
**1971**

**JOHN PITMAN WEBER**
**2100 W. Division St.**

A true street survivor, this early CMG work sought to defuse tensions among black, Latino, and white gang members in the West Town community. It depicts youths fighting beneath a death's head, contrasted with a unity march in which participants wear tams representing various street clubs. The center of the mural is dominated by the brotherhood clasp of black and brown hands. When Weber restored the mural in 1974, he added images of a coffin and a cop firing his gun, references to a Puerto Rican youth worker who had been slain the previous year by a policeman, sparking anti-brutality marches in the area. (CMG)

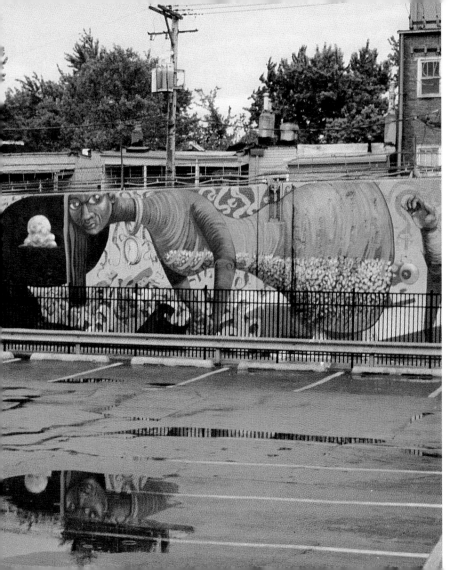

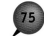

75

# I'VE GOT A FEELING ABOUT THE WHIRL'D 1997

## JOE MATUNIS
## 1372 N. Milwaukee Ave.

Matunis, a Brooklyn artist, and a team of Gallery 37 youths painted this 150-foot-long mural on a retaining wall behind the Walgreen's building parking lot with symbolic figures representing virtues (patience, wisdom, pride, charity, love) and vices (sloth, greed, duplicity, vanity, anger). For example, a gigantic Patience, an hourglass figure with a numberless clock, bides her time on the wall. A small portion of the mural is done in spray-paint, an homage to the wall's previous life as a CTA permission graffiti site. (CPAG)

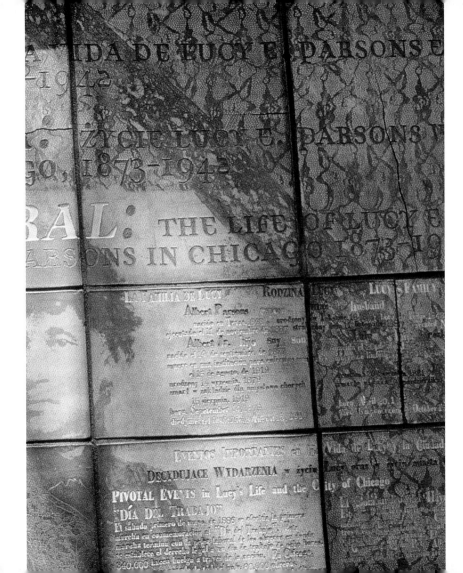

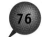

## SPIRAL: THE LIFE OF LUCY E. PARSONS IN CHICAGO, 1873–1942 1995

**MARJORIE WOODRUFF**
**1425 N. Damen Ave., Wicker Park, northwest corner**

This is one of the few monuments in the city to honor Chicago's nineteenth-century radical labor movement which was centered in this neighborhood. The installation consists of a spiraling park bench with ceramic tiles, with texts in English, Spanish, and Polish highlighting important themes in the life of the multiracial labor activist. A "conversation box" on the site invites visitors to deposit written comments about their reaction to the piece. Originally planned as a temporary installation, in 1997 the Chicago Park District accepted ownership of the artwork.

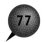

## PAID PROGRAMMING 1997

**JEFF ZIMMERMAN**
**North Ave. and Honore St.**

Using English and Spanish wordplay, references to corporate logos, a bar-code flag, and portraits of local people, this aesthetically innovative "anti-billboard" mural is a meditation on the commercial forces that shape our lives and public space. The mural's provocative juxtaposition of consumer abundance and stark poverty is especially relevant in this rapidly gentrifying West Town neighborhood.

# ARBOL DE VIDA—LIFE-TREE 1989

**CATHERINE CAJANDIG AND
JOHN PITMAN WEBER
2125 W. North Ave.**

At the Center for Neighborhood Technology, Weber and Cajandig led a youth team in the creation of a hand-sculpted polychrome concrete relief with sgraffito as well as painted wood panels with images which depict CNT's programs and values— clean water, solar power, recycling, jobs, housing, gardens, and multiracial communities. Each teen artist created a clay model for the relief sculpture and then combined the best parts of each piece into the final model for the tree. (CPAG)

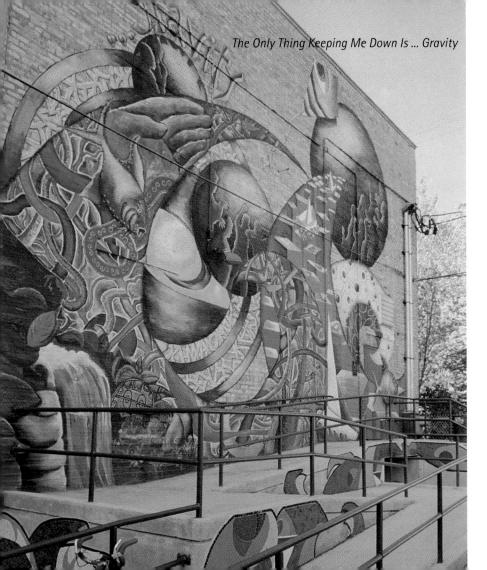

**79**

# ASSOCIATION HOUSE OF CHICAGO

## 2150 W. North Ave.

Serving the West Town community since 1899, Association House has helped generations of immigrants—now mostly Latino—make a meaningful life for themselves in Chicago. **BREAKING BARRIERS— ROMPIENDO BARRERAS** (1994), by Turbado Marabou and Veronica Werckmeister, highlights the importance of cultural awareness, education, the arts, and the struggle for justice through images of Puerto Rican masks, Aztec figures, and African patterns as well as texts by Ernesto "Che" Guevara, Jose Marti, and Frederick Douglass.

Kristal Pacheco and Werckmeister worked with Gallery 37 youths to extend the wall with **THE ONLY THING KEEPING ME DOWN IS ... GRAVITY** (1997). The combined mural and cracked-ceramic mosaic work features abstract and symbolic imagery on the theme of breaking barriers—whether of culture, race, language, or politics. (CPAG)

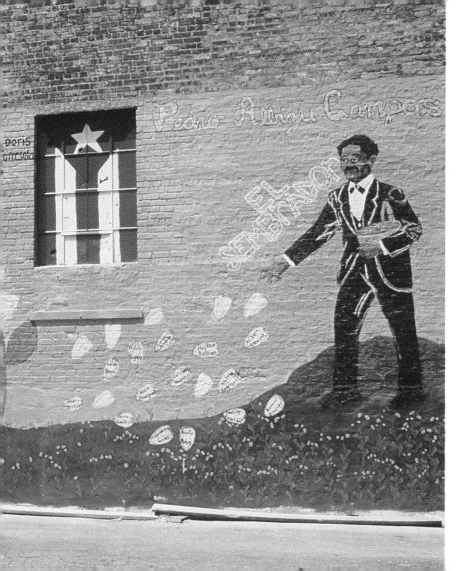

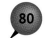

# JUAN ANTONIO CORRETJER PUERTO RICAN CULTURAL CENTER 1994

## 1617 N. Claremont Ave.

The façade of this West Town community center, named for the national poet of Puerto Rico, is adorned with patriot-themed murals. In 1987 and in 1992 Marcos Vilar worked with area teens to create murals related to the island's independence movement. Pablo Marcano Garcia painted the thirteen window-portraits of imprisoned (now recently released) *independentistas*.

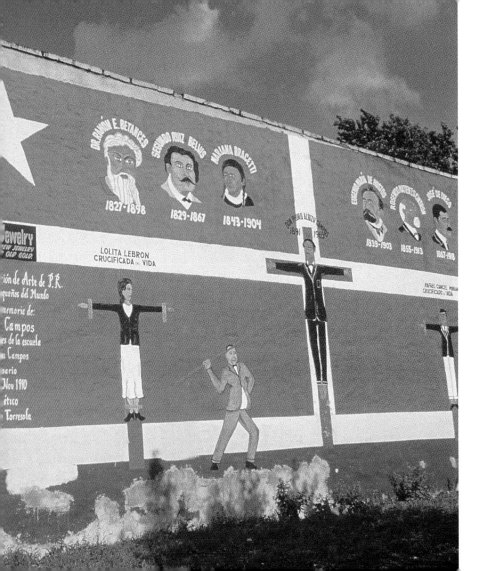

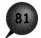

## LA CRUCIFIXIÓN DE DON PEDRO ALBIZU CAMPOS
### 1971

**MARIO GALÁN, JOSÉ BERMUDEZ, AND HECTOR ROSARIO**
**North and Artesian Ave.**

Painted by members of the Puerto Rican Art Association, this mural pictures Pedro Albizu Campos, leader of the Puerto Rican Nationalist party during the 1930s, hanging from a cross and awaiting the spear thrust of Luís Muñoz Marín, the governor of the island who revoked his pardon. Overlaid on a backdrop of a huge flag, the "Tiger of Liberty" is flanked by crosses upon which hang the important Nationalist figures of Lolita Lebron and Rafael Cancel Miranda. Across the top is a series of portraits of other great Puerto Rican patriots. In 1990 the mural was restored.

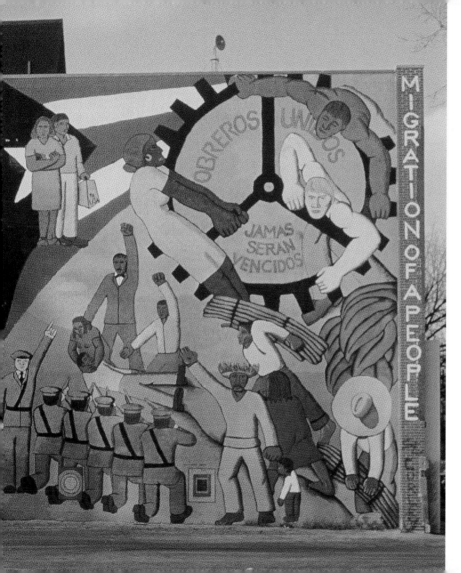

# MIGRATION OF A PEOPLE
## 1974

### ED MALDONADO AND BOB SOLARI
### 1516 N. Claremont Ave.

This mural, on the St. Aloysius Church Service Center, was painted when the building briefly housed the Puerto Rican High School. It depicts exploited workers and persecuted people leaving their homelands for a better life in the U.S. The Spanish text translates as "Never again will the workers of the world be overcome."

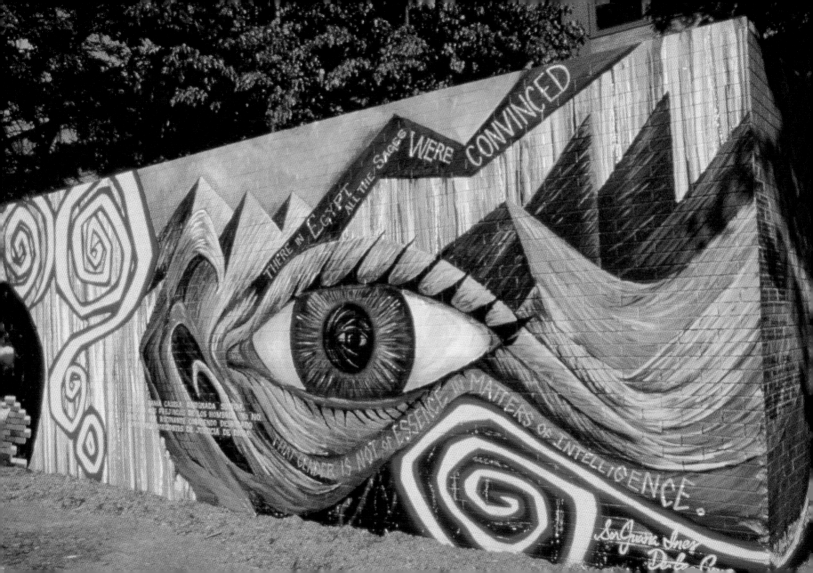

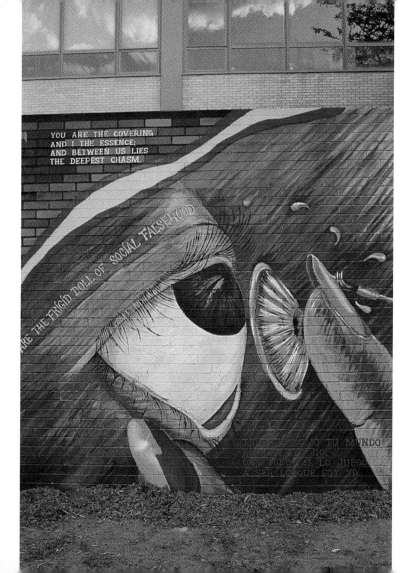

YOU ARE THE COVERING
AND I THE ESSENCE;
AND BETWEEN US LIES
THE DEEPEST CHASM.

ARE THE FRIGID DOLL OF SOCIAL FALSEHOOD

83

# AREN'T I A WOMYN? 1993

## OLIVIA GUDE AND DZINE
## 1147 N. Western Ave.

This spraypaint and acrylic mural on Clemente High School celebrates the strengths and contributions of Third World women. The 107-foot-long work, combining Dzine's graffiti lettering with Gude's painterly images, was inspired by the words of Julia de Burgos, the noted Puerto Rican poet; Sor Juana Inés de la Cruz, the seventeenth-century Mexican nun and poet who is often referred to as the "first feminist of the Americas"; and Sojourner Truth, the African-American liberationist. The CPAG mural, painted with youths from the Puerto Rican Cultural Center, does not show the women at all; instead, their large eyes gaze back at the viewer.

Nearby: Around the corner on a wall facing south toward Division St., see the large portrait of Roberto Clemente by Pablo Marcano Garcia. See also the sundial, sculptures, tables, and chairs on the east and west sides of the building by archi-treasures artists and teens.

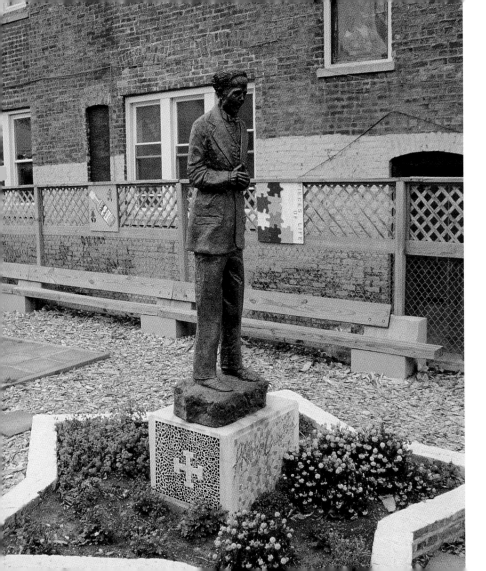

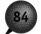
84

# ALBIZU CAMPOS CASITA GARDEN GALLERY 1997

## 2625 W. Division St.

Students from the Dr. Pedro Albizu Campos Puerto Rican Alternative High School and community members worked with Neil Gaffney of archi-treas-ures, an organization which involves artists, architects, and youth in designing and creating unique urban spaces featuring art and horticulture. They transformed a vacant lot into a landscaped mini-plaza featuring a *casita* (a small guest house or community center common in Puerto Rican culture). The site includes tiled retaining walls and seats, a concrete stage, and flags in tile and paint. The neighborhood gathering place, located in the heart of the W. Division St. Puerto Rican commercial district, is also home to a statue of the independence leader Albizu Campos. Originally intended to be installed in Humboldt Park, it was rejected as too politically controversial by the Chicago Park District.

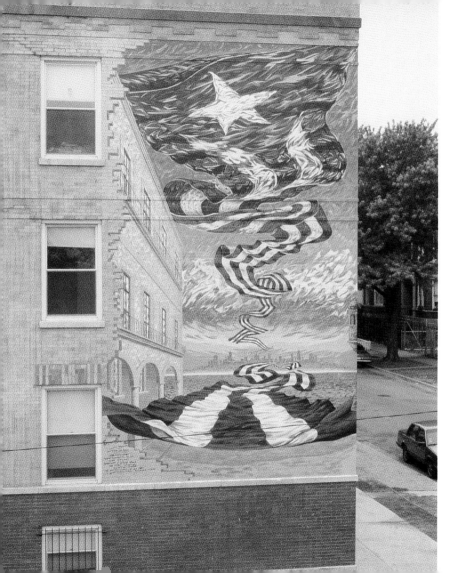

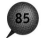
# HONOR BORICUA 1992

## HECTOR DUARTE
## 1318 N. Rockwell St.

Honoring Humboldt Park's predominantly Puertorriqueño heritage (*Boriquen* is the island's original Arawak Indian name), this mural depicts the Puerto Rican flag flying from the island, across the sea, and into the Chicago skyline. In turn the flag unfurls from Chicago and returns to the island. The circle of flags suggests the ongoing exchange of culture and ideas between the two communities. The mural is a project of LUCHA, the Latin United Community Housing Association (*lucha* means "struggle"). (CPAG)

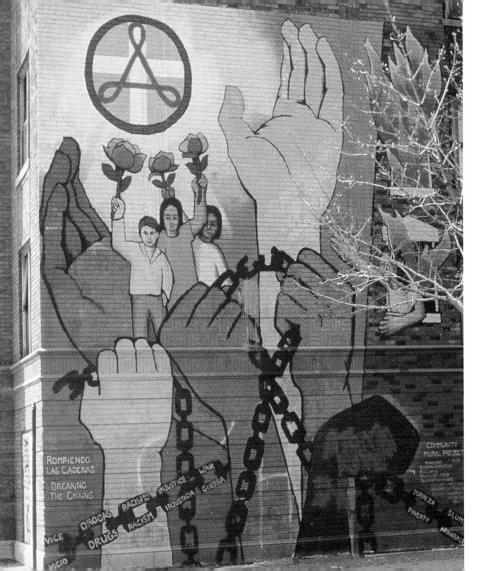

## BREAKING THE CHAINS— ROMPIENDO LAS CADENAS
### 1971

**JOHN PITMAN WEBER**
## Rockwell and LeMoyne St.

Although this CMG work is believed to be the old-est community mural in the U.S. that survives in its original form, it remains relevant to the neighbor-hood's struggles. The hands of the people—black, white, and brown—break the chains of injustice, poverty, and drug addiction to create a bright future, symbolized by children carrying roses. A woman crying from the window of a burning building is a reference to the arson that plagued this Humboldt Park neighborhood in the 1970s. Also included is the symbol of the cosponsor, the Latin American Defense Organization, which fought for racial justice and better housing in the area. Many of the building's residents participated in the painting of the mural. (CMG)

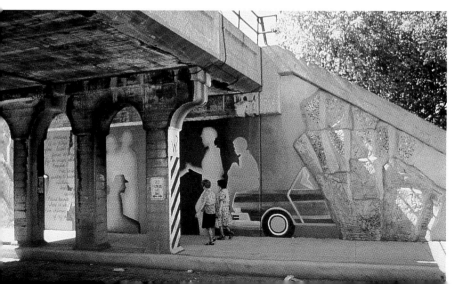

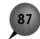

# CHILDREN ARE OUR FUTURE—NUESTROS NIÑOS SON NUESTRO FUTURO 1979

## CELIA RADEK, CATHERINE CAJANDIG, AND JOHN PITMAN WEBER
## California and Bloomingdale Ave.

A gift from one generation to another during the International Year of the Child, this mixed-media work on a Humboldt Park viaduct was CMG's first piece to use hand-built cement relief. The facing murals also incorporated mosaic and sgraffito (a method of producing designs by incising the surface layer of the concrete to reveal a ground of a different color).

The work is a hybrid—combining paint, concrete, mosaic, and text. It contrasts beautiful abstract sculptural forms with the stark statistics on local school dropouts and youth unemployment. Along with the collaborative visual art, it includes a collective poem in Spanish and English.

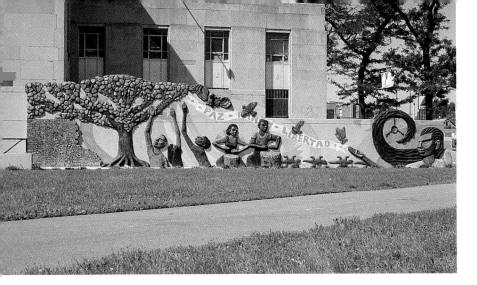

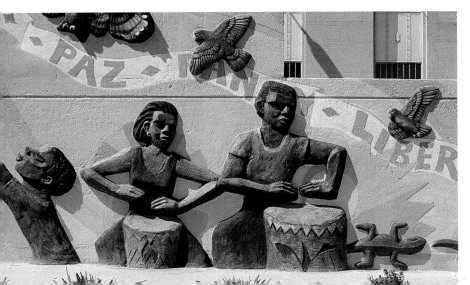

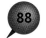

# CALLING FORTH THE SPIRIT OF PEACE 1993

### JEFFREY COOK AND PHIL SCHUSTER
## North and Kedzie Ave.

The 46-foot-long concrete relief mural depicts two conga players invoking the spirit of peace, personified by a Taino figure. (The Taino are the indigenous people of Puerto Rico.) The lizards, as in many African cultures, are symbolic intermediaries between the physical and spiritual worlds. The mural has a double message: its location in a gang-plagued neighborhood, as well as its placement on a wall of the National Guard Armory, inspired the artists and the Youth Service Project team to reflect on the theme of peace. The banner, *Paz, Pan, y Libertad*" translates as "Peace, Bread, and Liberty." (CPAG)

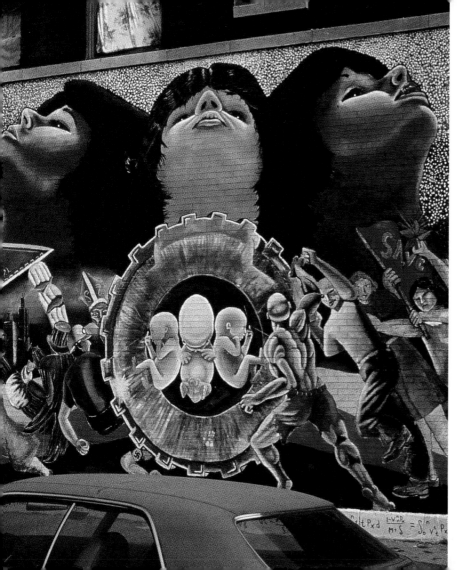

## SMASH PLAN 21 1978

### OSCAR MARTÍNEZ, JOSÉ GUERRERO, AND JUDITH MOTYKA
### Spaulding and North Ave.

This mural was painted to protest the Chicago Planning Commission's Plan 21, an "urban renewal" project which would have displaced many low-income residents from the West Town and Humboldt Park communities. Sponsored by neighborhood groups and churches, the work shows local people carrying a banner reading "Save Our Homes" and rolling a large cogwheel that goes on to topple City Hall (along with its fat-cat bureaucrats).

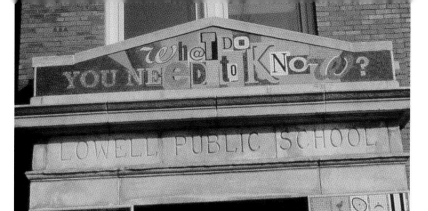

90

# LOWELL SCHOOL MOSAICS

## 3320 W. Hirsch St.

Created for the elementary school's centennial, this series of mosaics frames the building's doorways, greeting the children as they enter each morning. **PEDAGOGY OF APPLES AND ORANGES** (1994), by Olivia Gude, Beatriz Santiago Muñoz, and Juan Chávez, "reopened" bricked-in windows with trompe l'oeil mosaics, revealing a Toltec ruin and a view of earth from outer space. In a parable on communication, shell-shaped symbols used in Aztec manuscripts to represent speech emanate from the mouths of a rooster, a snake, and an antelope.

Further west is **WHAT DO YOU NEED TO KNOW?** (1998) by Gude and Chávez. Combining a variety of techniques—collage, text, and photorealistic portraits of students—the mosaics are an art education in themselves. They include the systematic charts used to teach color theory as well as whimsical drawings by primary school children suggesting that good education is both logical and magical. (CPAG)

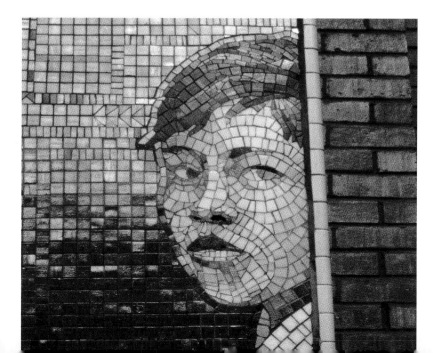

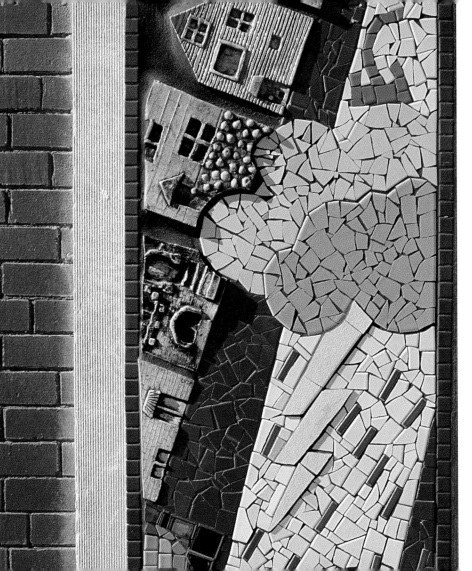

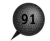

## SHAPESHIFTING IDEAS, TRANSCENDING THE SURFACE 1996

**JUAN CHÁVEZ, STEPHANIE GEORGE, AND JULIA SOWLES**
**1234 N. Monticello Ave.**

Consisting of eleven separate sections, this 180-square-foot mosaic that adorns the façade of Cameron Elementary School is about transformation. It combines handmade ceramic pieces and cracked-tile mosaic to portray the changeable chameleon as a symbol of adaptation—the animal can become part of the environment that surrounds it. Though a whimsical image it's also a metaphor for life: children, like the chameleon, reflect their environment; if their surroundings—such as schools and neighborhoods—are safe and nurturing, they can develop their creativity, learn, and explore positive opportunities. The teens used a variety of differently shaped tiles to create interesting patterns and textures within the mosaic. (CPAG)

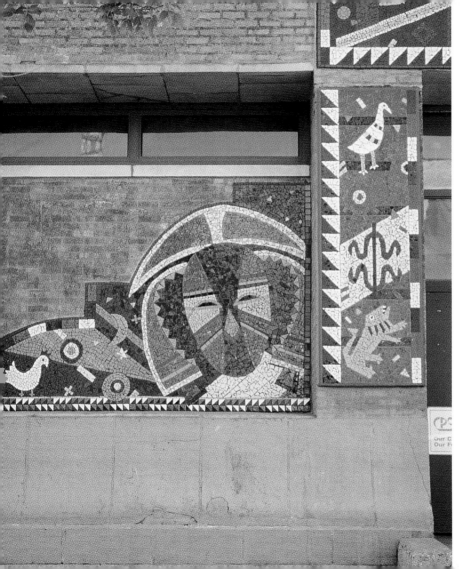

**92**

# SUNRISE OF ENLIGHTENMENT 1987, 1995

## NINA SMOOT CAIN AND MIRTES ZWIERZYNSKI
## 4127 W. Hirsch St.

The first community mosaic to adorn a Chicago public school, this beautifully designed cracked-ceramic-tile piece around Nobel Elementary's main entrance celebrates both the learning experience and the diversity of the Humboldt Park community. Using vivid primary colors, the original mosaic framed the doorway with icons to represent mathematics, language, nature, and culture. In 1995 Cain and Zwierzynski designed additional side panels; Zwierzynski led YSP teens in remaking a damaged portion of the mosaic and in fabricating and installing the new designs. (CPAG)

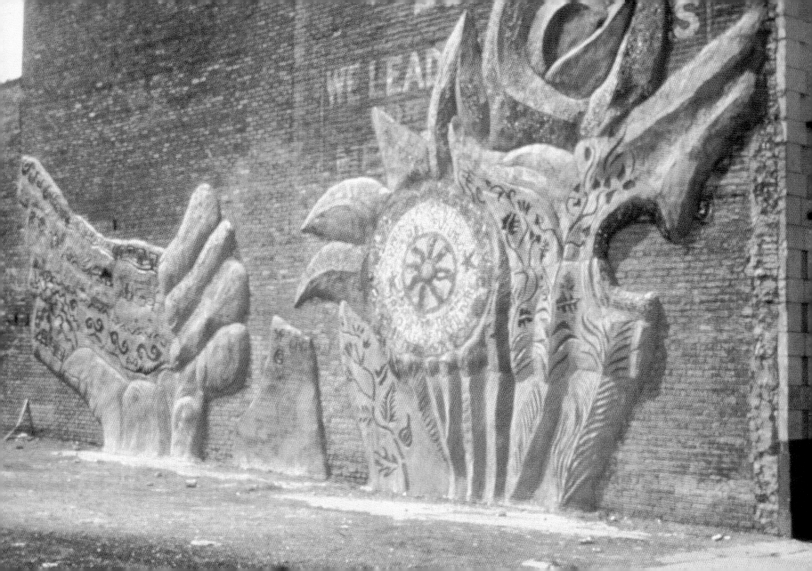

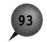
93

## FOR THE PEOPLE OF THE FUTURE—PARA LA GENTE DEL FUTÚRO 1980

**LYNN TAKATA, JOHN PITMAN WEBER, AND JOSÉ GUERRERO**
**North and Springfield Ave.**

This hand-sculpted concrete relief mural, which features mosaic tiles and large areas of sgraffito, sends a message of hope and peace to future generations. With designs inspired by Pre-Columbian art and Eastern European folk art, the piece's theme is the duality of human action, represented by the hand and banner, and nature, represented by the plant- and moonlike shapes. The artists created an aesthetic controversy in the neighborhood by deciding to leave the faded commercial sign in the background. This influential work was executed with a YSP team.

# POSITIVE MOVES IN THE GAME OF LIFE 1988

### JOSÉ BERRIOS AND CONCETTA MORALES
### 3942 W. North Ave.

This cracked-ceramic-tile mosaic mural was created for the Youth Service Project's Humboldt Park building. The mosaic opens with a youth gazing in a mirror, contemplating the future. The piece uses the metaphor of a game board to illustrate YSP's role in supporting neighborhood youths in shaping positive futures for themselves. In their path through life, youths are presented with such obstacles as teen pregnancy (symbolized by a baby bottle) or drugs (symbolized by a white horse wearing sunglasses). Having eluded the jester who tries to throw them off course, the youths take the path of opportunity and find that the buildings have become books and employment applications and that the playing pieces are now the hats of various trades and professions. (CPAG)

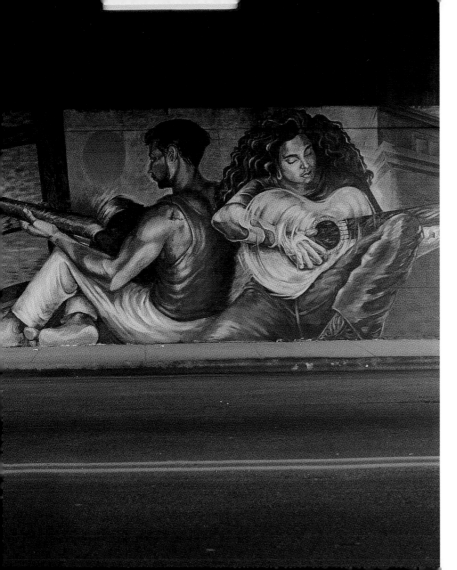

## ES TIEMPO DE RECORDAR— IT'S TIME TO REMEMBER
**1992**

**SANDRA ANTONGIORGI,**
**MARCUS AKINLANA,**
**AND ROLF MUELLER**
**Pulaski Rd. and Wabansia Ave.**

Covering an area of 2,000 square feet, these facing murals use a musical theme to represent people of diverse heritages living in harmony with nature and to suggest the transmission of culture from ancient times to the present day. On one side, two guitarists (who look remarkably like artists Antongiorgi and Akinlana) are shown spreading the power and joy of music; on the other side, a mythic archer figure representing indigenous peoples shoots music into the world from his bow and arrow. The mural was painted with a YSP team. (CPAG)

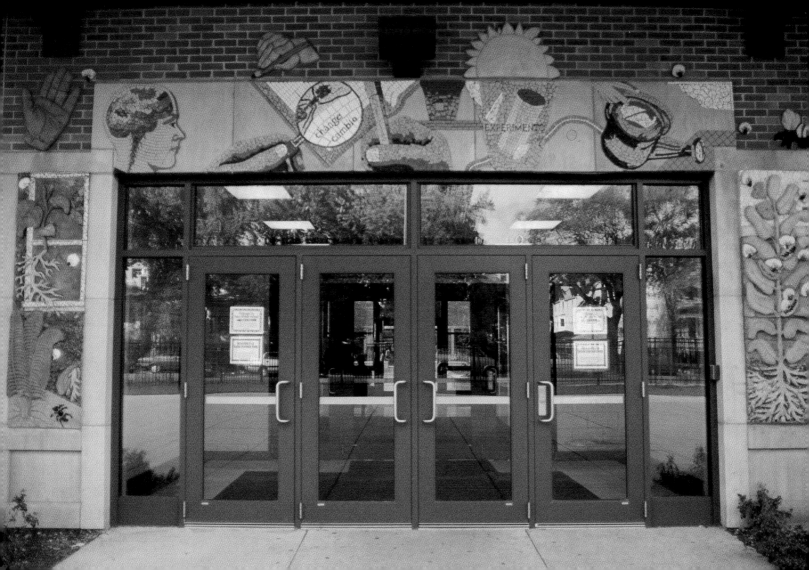

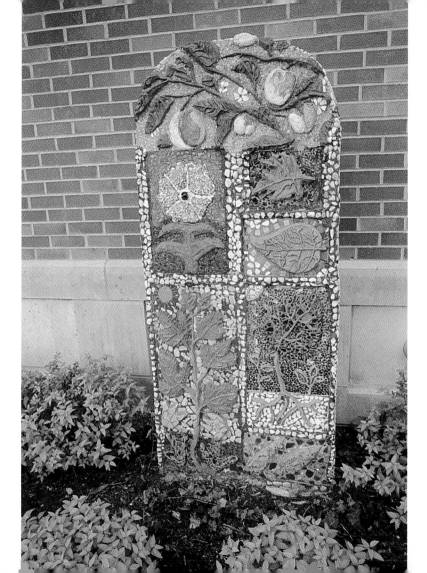

## CAMBIOS DE SEMILLAS: THE NATURE OF EDUCATION 1999

### ROBERT MORIARTY AND PHIL SCHUSTER
### 1920 N. Hamlin Ave.

The artists see this concrete relief and cracked-ceramic-tile mosaic artwork as an "aesthetic intervention"—adding color and creativity to the plain exterior of the newly built Ames Middle School. Framing the entryway, its imagery evokes the theme of transformation—the social change the students experience through learning, the change of going from elementary to middle to high school, and the change of the site from commercial to educational use. The project was one in the ongoing series of collaborations of YSP, Gallery 37, and CPAG.

Across the street to the north, see various mosaic works by CPAG artists, including **MULTICOLOR REWRAP** (1991) by John Pitman Weber and Mirtes Zwierzynski. (CPAG)

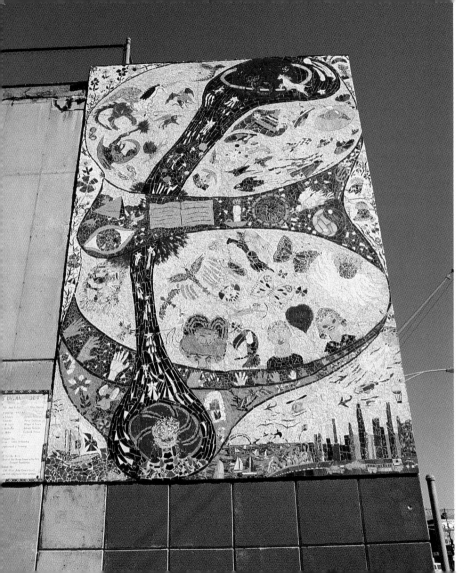

# CHICAGO'S DREAM 1984

## PEDRO SILVA AND JOSÉ GONZÁLEZ
## 3600 W. Fullerton Ave.

This glass-tile mosaic on the west side of the Logan Square YMCA building was the result of a community-artist exchange program between CMG and New York's Cityarts Workshop. Silva, best known for his serpentine mosaic benches (1972–1974) surrounding Grant's Tomb in Manhattan's Riverside Park, directed youths of different cultural backgrounds in the making of this 12-by-18-foot piece on the theme of dreams.

In typically eclectic Silva fashion, it includes a wide variety of imagery, including city and tropical beach scenes, wildlife, and cultural symbols. The upper part shows images of flight from unicorns to jet planes to UFOs. It's a message to youth to break the bonds of earth and reach for the sky and beyond. The mosaic was cosponsored by YSP and MIRA, a González-led advocacy group for local Latino artists. (CPAG)

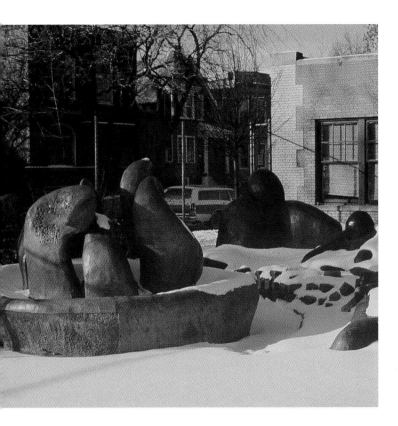

**98**

## LIVING CIRCLE—CIRCULO VIVO
**1981**

**LYNN TAKATA AND JOHN PITMAN WEBER**
**3228 W. Palmer Blvd.**

The centerpiece of the Logan Square Boys and Girls Club's Barnet Hodes Sculpture Garden, this sculptural bench and fountain project holds the distinction of being the city's first free-standing, community-built artwork—a feat that involved the use of reinforced concrete, landscape design, and mechanical and electrical engineering. The undulating seats evoke the shapes of reclining figures; the glass mosaics in the fountain basin recall Taino designs and symbols. The form of the work was inspired by Pedro Silva's Grant's Tomb Mosaics (1972–1974) and Antonio Gaudi's Güell Park ceramic-fragment-encrusted benches (1900–1914), as well as by the work of David Harding in Glenrothes, Scotland, who introduced the CMG to concrete as a community art medium in the 1970s.

Also in the sculpture garden: **URBAN OASIS** (1985) by José Berrios, a mosaic featuring glass and ceramic tiles, molded ceramic shapes, and terra-cotta pieces. (CPAG)

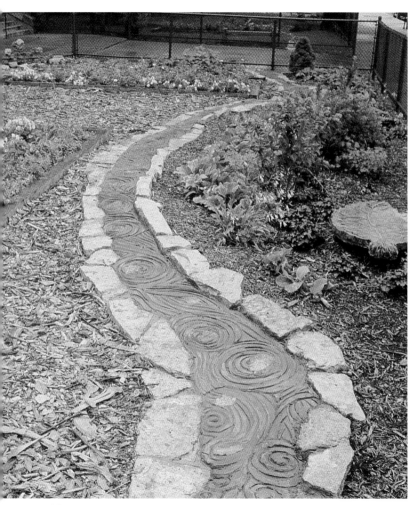

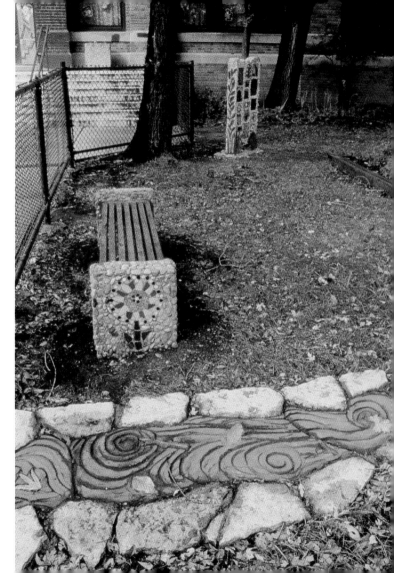

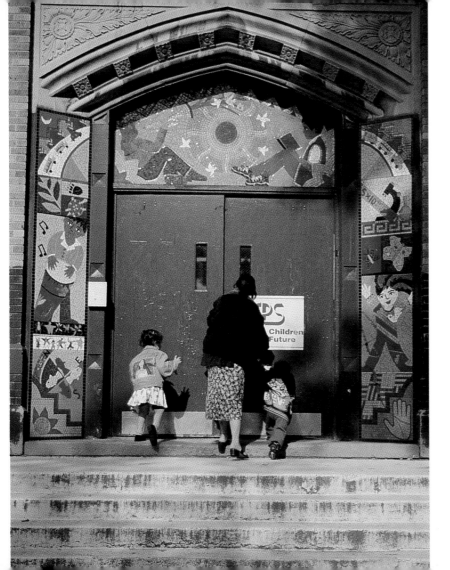

**99**

# PULASKI COMMUNITY ACADEMY GARDEN GALLERY

## 2230 W. McLean Ave.

The elementary school's Garden Gallery (1997), an archi-treasures project, features more than a dozen separate artworks. Using sculpted and cast concrete, ceramic relief, ceramic mosaic tiles, limestone, wood, and paint, artists Phil Schuster, Neil Gaffney, Frank Crowley, and Tony Zahner worked with eighth-graders to create such pieces as a leaf-shaped birdbath, a turtle sandbox, benches, a game table, a hopscotch walk, and a "name wall" containing kids' artwork. A concrete "river path" connects the artworks.

Working as an artist-in-residence with Community Arts Partnerships in Education (an organization dedicated to school reform through the integration of arts into the curriculum) and CPAG, Cynthia Weiss created the entryway mosaic **NOTE BY NOTE: THE LANGUAGES OF OUR LEARNING** (1996) with the help of students and their parents.

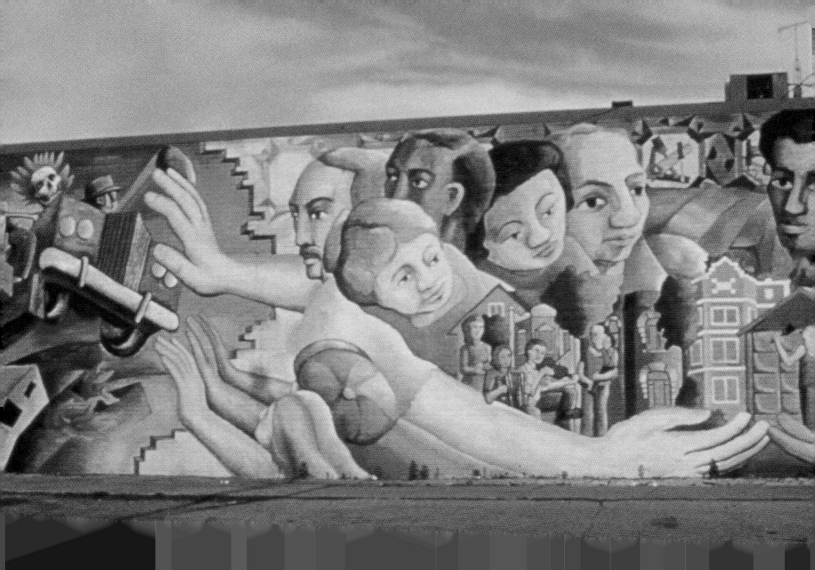

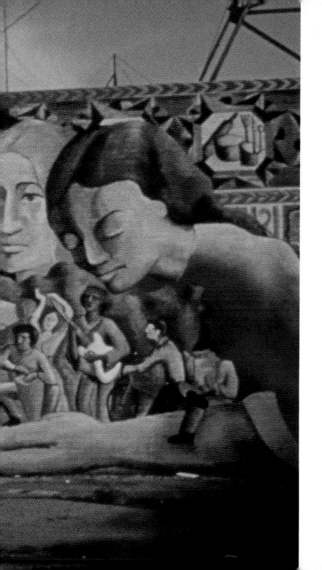

**100**

# TILT (TOGETHER PROTECT THE COMMUNITY)
1976

**JOHN PITMAN WEBER**
## Fullerton and Washtenaw Ave.

A fading classic, painted with neighborhood residents, **TILT** (as it's popularly known) is still relevant to this Logan Square neighborhood and to many city neighborhoods. The south half of the 90-foot-long mural depicts a monumental, racially mixed group of people protectively embracing their homes against a background of decorative patterns similar to old-fashioned wallpaper. While smaller figures "build" their community through work and play, others fend off drugs, vandalism, gangs, absentee landlords, real estate speculators, unemployment, and freeways—all of which threaten the quality of life. These dark, tilted images on the north half are meant to be seen only by the local audience; eastbound traffic on Fullerton sees only the positive, harmonious images.

The mural's composition exemplifies the aesthetic problem sometimes associated with depicting the community's problems; they often are the most dramatic images in a mural because they look more exciting than representations of a harmonious community. But in this work the sweetness and strength of the positive imagery balances the drama of the negative forces. (CMG)

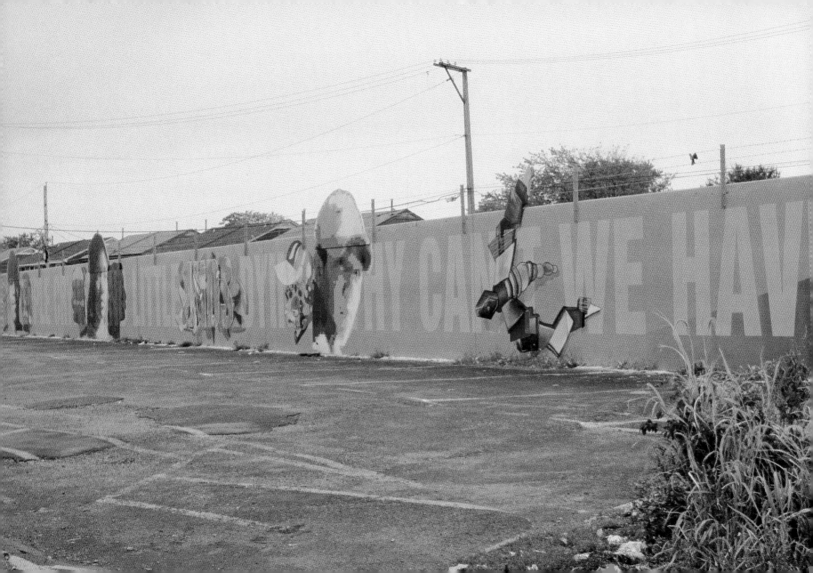

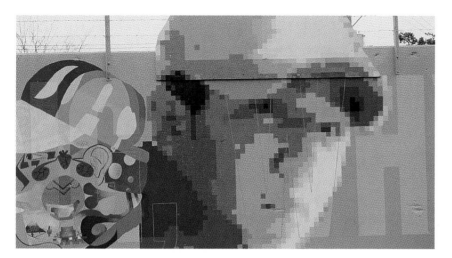

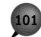

**101**

# TELL ME WHAT YOU SEE
**1997**

## JOSHUA SARANTITIS
## 2500 N. Milwaukee Ave.

Sarantitis, a San Francisco artist, and Gallery 37 teens covered this 450-foot-long CTA retaining fence along the Discount Mega Mall parking lot with images and texts about their lives. The huge portraits are digitalized images of the youth participants. Alongside their computer portraits, teen artists created expressionistic, symbolic portraits of their inner selves.  Running the length of the innovatively designed work is a poem, written by one of the youths, painted in 4-foot-high letters: "Look around you/Tell me what you see!/Do you see the earth's true beauty?/All I see is humanity/When I walk around/All I see is people crying/And little kids dying/Why can't we have unity?" The word "unity" closes the mural in "wildstyle" lettering. (CPAG)

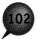

## THE EAGLE 1993

### JOSÉ BERRIOS AND KHARL WALKER
### Kedzie and Milwaukee Ave.

The wall facing this CTA terminal has been enlivened with "Welcome to Logan Square" murals since 1985, when Trixter and the ABC graffiti writers crew spraypainted on the wall; it was one of the city's first permission pieces.

The current mural, painted with Logan Square Boys and Girls Club youths, takes its title from the giant eagle surmounting the neighborhood's most prominent landmark—the towering Doric-style Illinois Centennial Memorial Column (1918); in the mural, the bird has left its lofty perch and come down to earth. The work includes references to other local Berrios murals—the firemen in **MURAL OF HEROES** (see next entry) and the façade of the Animal Kingdom pet store.

Working largely out of the Logan Square Boys and Girls Club, Berrios (often with Gamaliel Ramirez) was an extraordinarily active muralist in the neighborhood during the 1980s. His **PREPARING FOR LIFE** (1980), a block north at Spaulding and Milwaukee Ave., is one of the few works from this period that is still extant.

**103**

# MURAL OF HEROES 1985

## Diversey and Milwaukee Ave.

This work located at Firemen's Memorial Park honors three Chicago firemen who died on February 1, 1985 battling a nearby arson blaze. Captain Daniel Nockles, Michael Forchione, and Michael Talley of Engine Co. 58 are shown wearing the white wings of angels as they enter a burning building. The inscription reads: "Our modern day heroes still, and always will be, those who are brave enough to risk their life, in order that another be saved." The project was directed by Phil Greco of the 14th (Shakespeare) Police District, and was painted by José Berrios along with his neighborhood art crew CBA (Creatin' Blastin' Art).

## PAX ET BONUM 1997

### OSCAR ROMERO
### 4055 W. Belmont Ave.

Latin for "peace and all good things," this mural at the Madonna High School in the Avondale community shows a giant image of the Madonna reaching out to a treelike figure of Mother Earth. Assisted by teen artists from the all-girls school, Romero painted images of young, culturally diverse women representing ideals of physical prowess, intellectual power, and female spirituality.

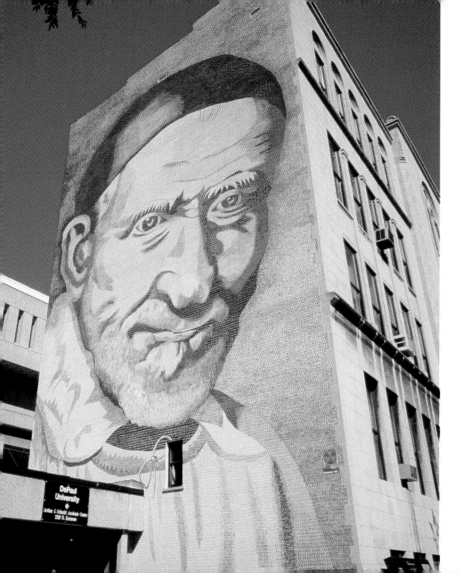

## WE ARE DEPAUL 1999

### MARK ELDER
### 2322 N. Kenmore Ave.

This 68-foot-high mural depicts St. Vincent DePaul, the patron saint of DePaul University. His portrait, made up of hundreds of tiny stenciled faces, is a reference to the Christian ideal that all believers make up the body of Christ; here the tiny two-inch-high portraits symbolize the university's commitment to exemplifying the qualities of St. Vincent in its service to the Chicago community.

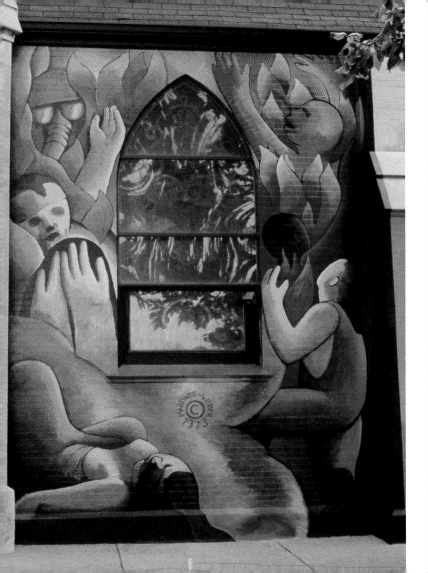

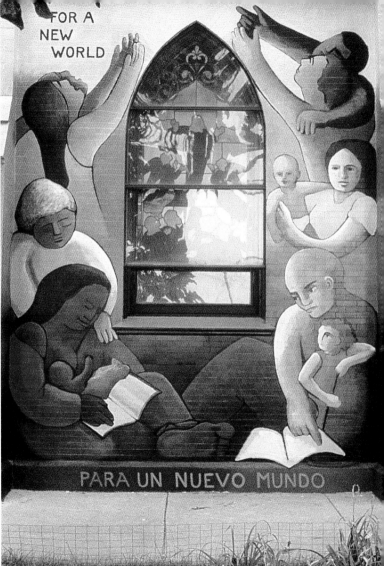

FOR A
NEW
WORLD

PARA UN NUEVO MUNDO

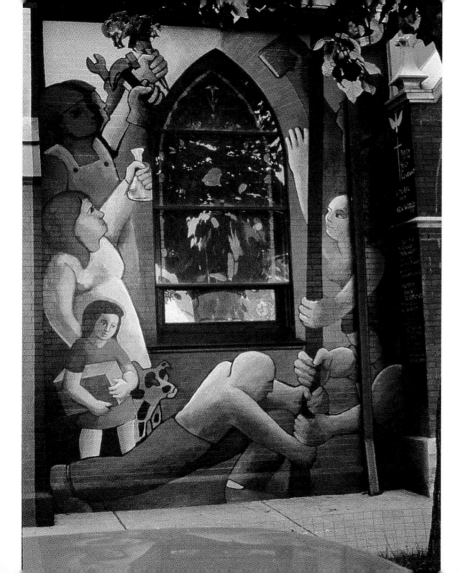

## FOR A NEW WORLD— PARA UN NUEVO MUNDO
### 1973

**JOHN PITMAN WEBER AND OSCAR MARTÍNEZ**
**925 W. Diversey Pkwy.**

Once called the "most hopeful mural in the city of Chicago," this work on the Holy Covenant United Methodist Church doesn't shy away from showing the world's evils. An early CMG work, the mural's three sections represent the areas of the congregation's worship service: **CONFESSION**, **THE WORD**, and the **OFFERING**. **CONFESSION** depicts political brutality, killing, and repression; **THE WORD** shows the promise of a new world where all people—men and women, young and old, gay and straight, all racial groups— will live in peace and harmony; **OFFERING** urges us to dedicate our lives to bringing about a new world of justice through our daily work. With the support of CPAG and the congregation, in 1996 the mural was restored by Weber and Bernard Williams. (CMG)

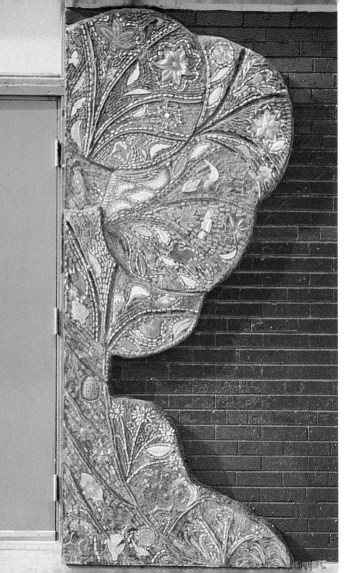

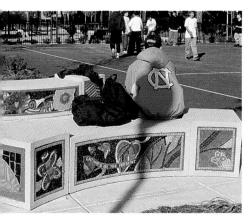

**107**

# LAKE VIEW HIGH SCHOOL MOSAICS

## 4015 N. Ashland Ave.

Since 1984 art teachers, students, and CPAG artists have transformed this North Side high school into a public mosaic showcase. On the west side, Esther Charbit worked with 350 students to create **CHICAGO SKYLINE**, a continuous cast-concrete and glass-tile bench featuring images of city landmarks and of the surrounding neighborhood. Charbit and students also created the concrete and glass-tile totems. Miriam Socoloff, Susana Erling, and students made the wrought-iron and glass-tile **BIRDS OF PARADISE**. The beautification project was cosponsored by the Oppenheimer Foundation and the Friends of Lake View High School.

More recently, CPAG artists have collaborated with students and art teachers Socoloff, Erling, Donna Terry, and Rick Ceh to produce mosaic projects on the east side of the school. Phil Schuster and Mirtes Zwierzynski helped create four cast-concrete entry pieces (for two doorways) in ceramic relief and glass tile (1995). With the creation of Lake View High School Park in 1997, Schuster made three concrete benches, also in ceramic relief and glass tile; and, Karen Ami and Julia Sowles worked with Gallery 37 youths to create eighty ceramic- and glass-tile panels for ten concrete benches (1997–1999).

The most recent addition to this still evolving site is Schuster and students' **ILLINOIS PRAIRIE WILDLIFE HABITAT** (1999), a series of concrete relief flora and fauna.

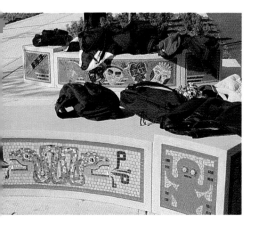

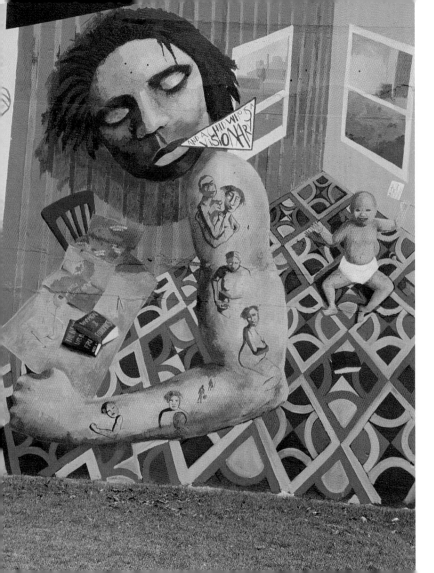

## MATRIARCHY FOR A NEW MILLENNIUM 1997

### TIM PORTLOCK AND BEATRIZ SANTIAGO MUÑOZ
### 825 W. Sheridan Rd.

Painted with area youths on a wall behind the Gill Park fieldhouse, this mural focuses on the impact that gentrification, displacement, and redevelopment are having on this low-income, racially mixed Uptown neighborhood, especially as it relates to police-harassed youths and single working mothers. The issues of women's lives are repeatedly invoked in the work—a reference to the mural painted at the site in 1979—*Women's Equality*, by Celia Radek and Cynthia Weiss (on which several of the teen artists' parents or relatives had worked).

Seeking fresh mural imagery, the artists created a series of scenes—a woman returning from her day job to the work of maintaining a household and then finally treasuring a quiet moment to herself. The mural's style was influenced by the work of painter David Hockney. (CPAG)

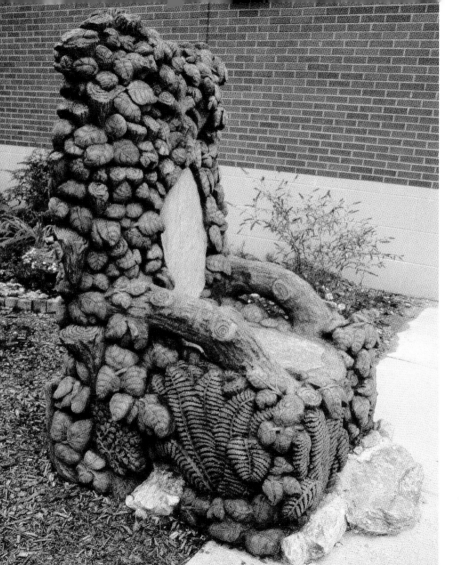

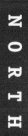
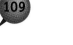

## STORYTELLING THRONE 1998

**PHIL SCHUSTER**
**929 W. Buena Ave.**

Located in the "secret garden" courtyard of the Uptown Branch of the Chicago Public Library, this sculptured seat was designed as a place for librarians to read stories to children. Constructed out of cement tree-branch forms interwoven with cast concrete bean leaves, the fairy tale–like throne also incorporates silver quartz and Canadian mica. This work was created as part of the Blue Skies for Library Kids program. (CPAG)

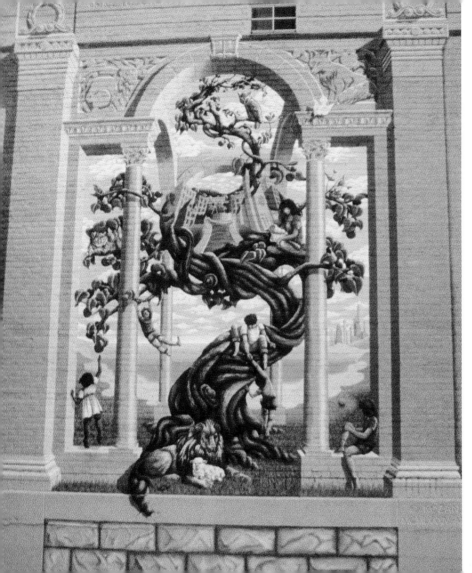

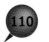

# OUR NEIGHBORHOOD 1984

**KATHRYN KOZAN**
**1026 W. Buena Ave.**

Combining trompe l'oeil technique with figurative painting, the style of architecture pictured in this mural is borrowed from the surrounding St. Mary of the Lake church and school buildings. A massive tree framed in an open archway represents the neighborhood as a living thing that can grow and change, yet must also be nurtured and cared for in order to blossom and bear fruit. Nestled in the branches are a view of the neighborhood, a Cheshire cat, and other symbolic elements. At the base of the tree, neighborhood children frolic as a lion and a lamb lie down together. (CMG)

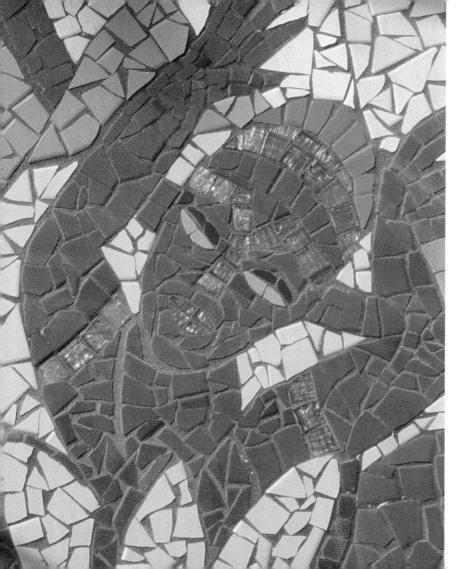

# OVER THE RAINBOW 1999

**GINNY SYKES**
**4420 N. Beacon St.**

These two archway panels, created with cracked ceramic tile interspersed with clay relief elements, enhance the façade of Stockton Elementary School. The artist, who lives in the community, led the children in examining the present environment of this diverse Uptown neighborhood through myths, games, writing, and varied artistic styles. In future years the children will complete the façade with mosaics on the themes of their ancestral pasts and their future possibilities.

The African goddess figure is an homage to artist Rene Townsend, who died just before she was scheduled to begin work on the project. (CPAG)

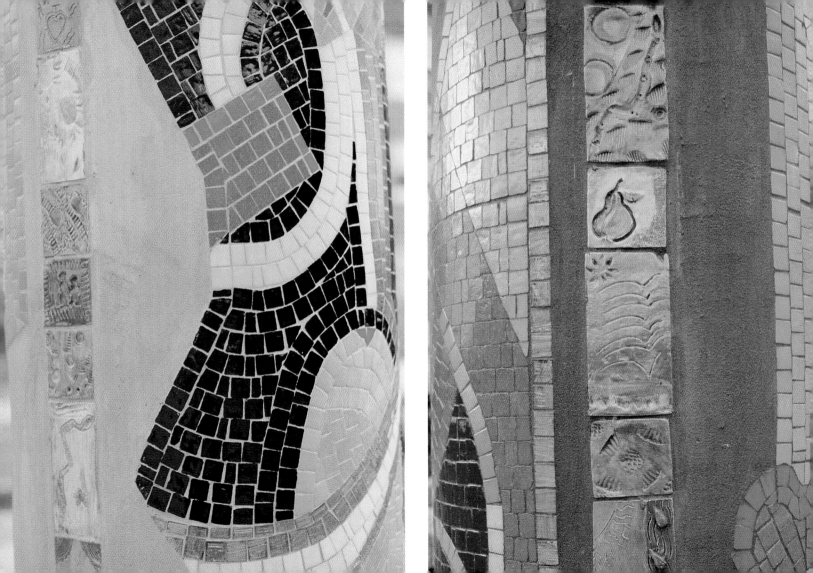

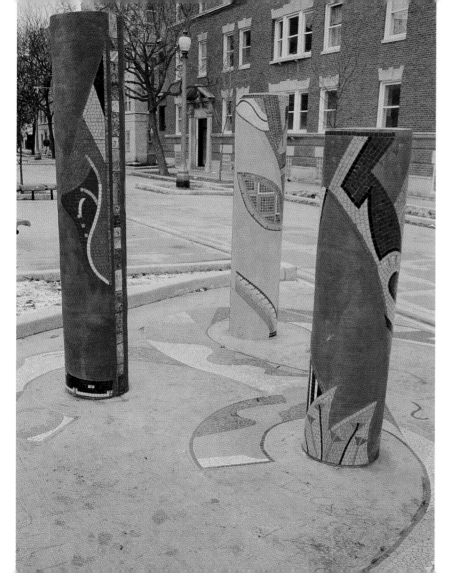

**112**

## FROM MANY PATHS WE COME 1997

**MIRTES ZWIERZYNSKI AND GINNY SYKES**
**Sunnyside Ave. between Beacon St. and Magnolia Ave.**

This cast-concrete-and-mosaic landscape design project lends a contemplative sense of place to a newly created two-block pedestrian mall. On the west side of the mall, the artists installed understated glass-mosaic squares in traditional brick and stone entry gates. On the east side, a cracked-ceramic-tile pavement winds among three columns covered in glass and handmade ceramic tile. The mosaics were created with a multiracial team of Gallery 37 youths whose makeup reflected the vibrant diversity of Uptown. The project was the result of a five-year collaboration among various organizations and agencies, including Beacon Street Gallery, CPAG, Gallery 37, and the City of Chicago Department of Transportation. (CPAG)

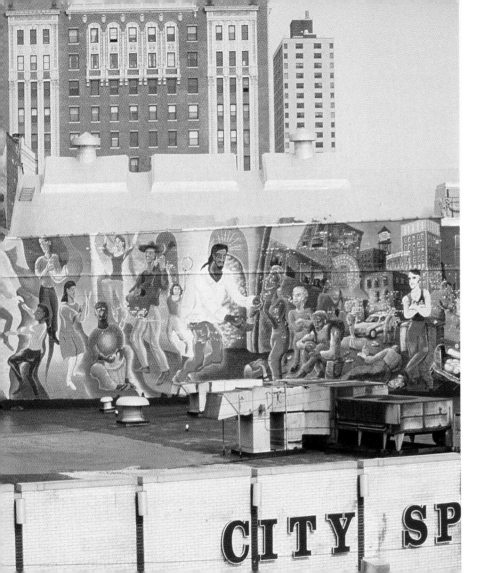

## UPTOWN PRODIGAL 1994

**BRIAN BAKKE**
**1050 W. Wilson Ave.**

Painted by members of the Uptown Baptist Church and the Jesus People Church, this mural above the TCF Bank shows a contemporary version of the prodigal son as he gives up street life—exemplified by drug dealers, alcoholics, and porn shops—and returns home, to be met by his joyful father amongst music and dancing. One of several outdoor works in the community created through the Uptown Baptist Church's arts program, including the **RACIAL RECONCILIATION MURAL** at Sheridan Rd. and Sunnyside Ave. and a Christian spraypiece at Wilson Ave. and Hazel St.

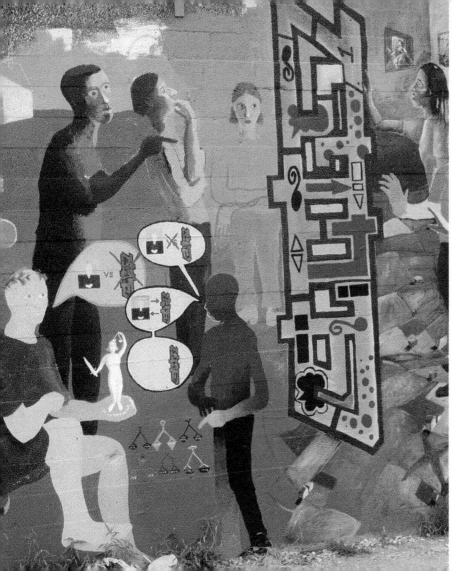

114

# FISHING AT HOGARTH'S HEAD BAY 1995

**TIM PORTLOCK AND
BEATRIZ SANTIAGO MUÑOZ
1108 W. Lawrence Ave.**

This aesthetically challenging mural aims to reflect the heterogeneity of the artist group—students from Prologue Alternative High School—and of the polyglot Uptown community itself. Eschewing a singular narrative for a style foregrounding experimental collaboration, the team drew from a variety of artistic and literary sources—comics, collage, classical painting, WPA murals, graffiti, and William Carlos Williams's poem cycle *Paterson*—to present a complex vision of the neighborhood—indeed, of America. This mural explores the notion of "community" and the role that public art can play in defining various communities within a diverse urban neighborhood. (CPAG)

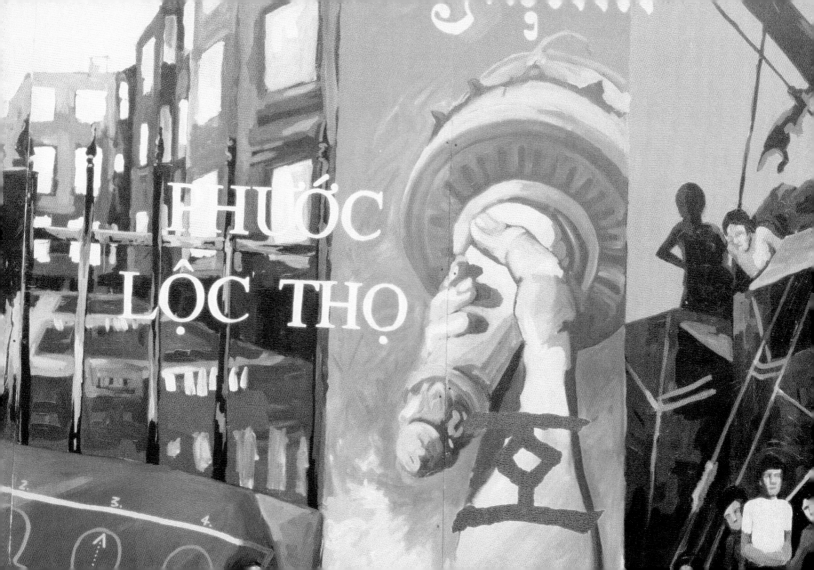

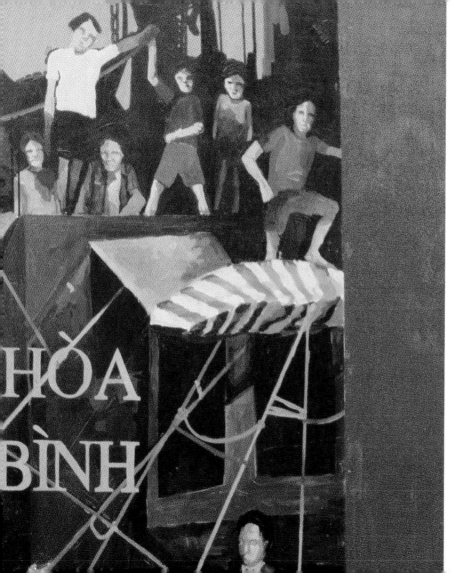

115

# CHANGING HOME 1996

## JUAN CHÁVEZ
## 1016 W. Argyle St.

Located in the heart of the New Chinatown neighborhood, this stylish mural addresses the Southeast Asian immigrant experience. Cosponsored by the Chinese Mutual Aid Association, the mural depicts refugees, the arrival to the U.S., the establishment of a community, and the different paths youths may take to enrich themselves as well as their community. (CPAG)

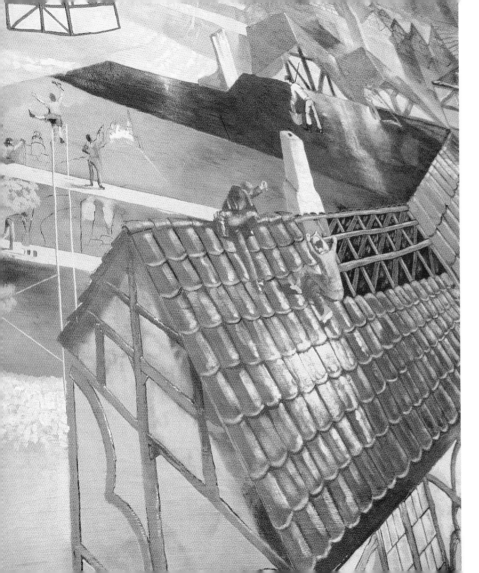

# LINCOLN SQUARE MURAL
## 1991

**LOTHAR SANCHEZ-SPEER**
**4662 N. Lincoln Ave.**

This monumental, 3,000-square-foot mural, painted on the Northern Home Furnishings store, reflects the German heritage of the Lincoln Square neighborhood. Celebrating German culture, architecture, and tradition, it depicts a sweeping, imaginary German landscape—collaging together well-known churches, castles, houses, and other landmarks from places throughout Deutschland. A stork nesting on a roof is believed by Germans to be a sign of good luck.

On the lower left, children of all ethnic backgrounds at play represent the culturally diverse residents of Chicago enjoying the beauty and accomplishments of German culture. The muralist was assisted by a diverse group of art students from Amundsen, Clemente, and Senn high schools.

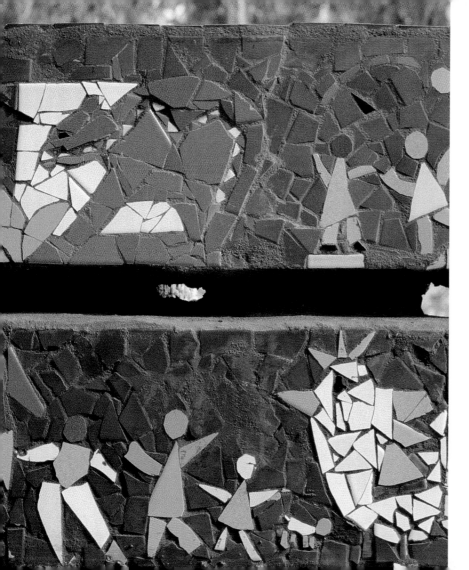

117

# JOURNEYS AND REFUGE
1999

## CYNTHIA WEISS AND PHIL SCHUSTER
## 4540 N. Campbell Ave.

Weiss, a mosaicist and art education consultant, and Schuster, among the city's foremost concrete sculptors, teamed with the Waters Elementary School community to create this concrete and mosaic bench, surrounded by paving stones. It's the centerpiece of a developing garden and meeting area. The mosaic's images relate to stories written by students and parents about journeys in their lives—including childhood memories and immigration stories, as well as images of people, places, and things that provide strength and hope for the future. (CPAG)

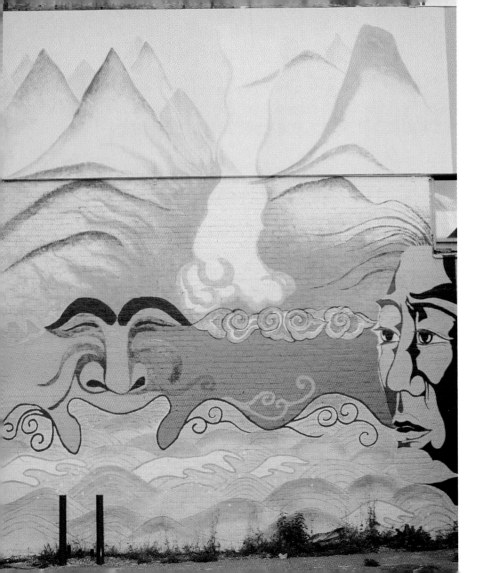

## MOUNTAINS + WATER + WE THE PEOPLE 1995

### SUN YUN
### 3555 W. Lawrence Ave.

This mural celebrates the Korean heritage of many residents in the Albany Park community. Cosponsored by the Chicago Committee on Korean-American Concerns, the mural's design is based on a traditional folk painting style previously unknown to many of the American-born Koreans who volunteered to work on the mural. (CPAG)

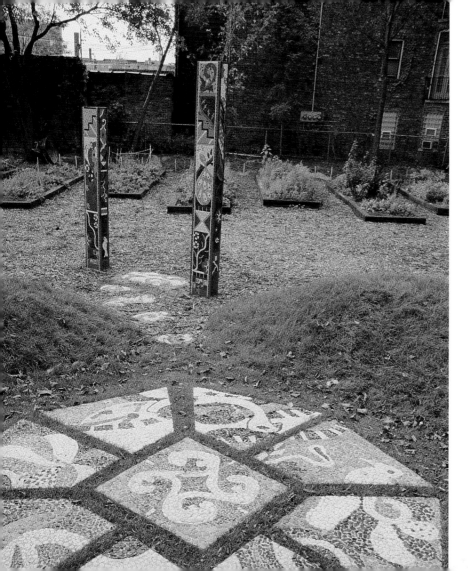

119

## NEW PATTERNS/FUTURE VISIONS 1997

### MIRTES ZWIERZYNSKI
### 1500 W. Thorndale Ave.

This ceramic-tile mosaic installation—consisting of a cast concrete, octagonal pavement and two columns—features patterns and images reflecting the student participants' diverse cultural heritages. The mosaics enhance the circular arena of Senn High School's Unity Garden, created by landscape architect Chet Jakus's Big Sky Gardens. (CPAG)

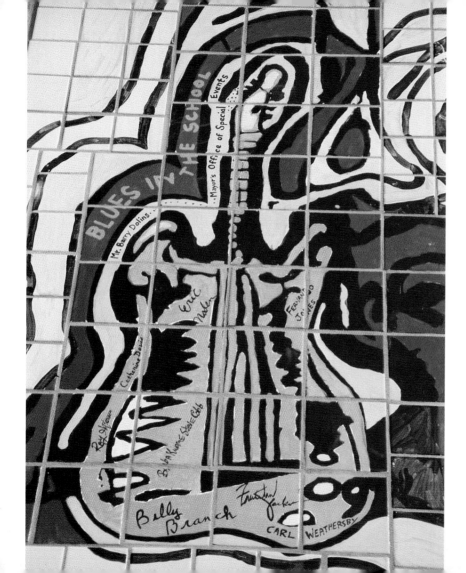

## STONE ACADEMY BLUES REVIEW 1997

**MARK NELSON**
**6239 N. Leavitt St.**

Art teacher Nelson directed more than 150 Stone Academy students in the design and creation of this musically themed mosaic mural for their Rogers Park school. The work skillfully integrates the students' handmade ceramic and commercial-tile mosaics with the carved stonework on the school's façade. It was created to complement the Blues in the School Program, in which students are mentored by professional musicians to learn the history and techniques of the blues.

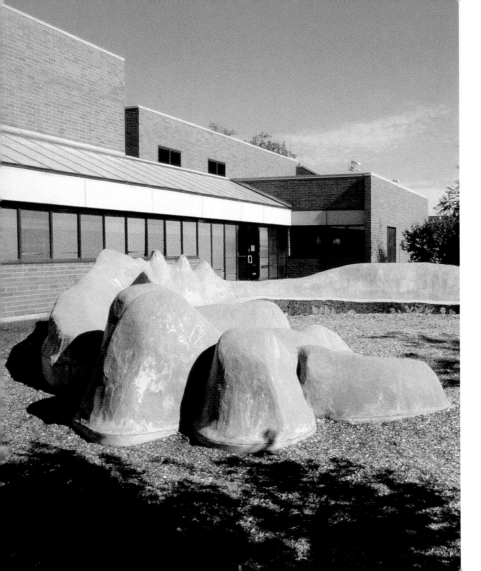

 121

## WARREN PARK BENCHES
1989

**LYNN TAKATA**
**Pratt and Western Ave.**

This free-formed concrete seating area, located outside the park's fieldhouse, is decorated with cracked-ceramic-tile foliage designs. Sponsored by the Rogers Park Historical Society and the Chicago Peace Garden and created with an intergenerational group, this is the final work created by Takata in Chicago.

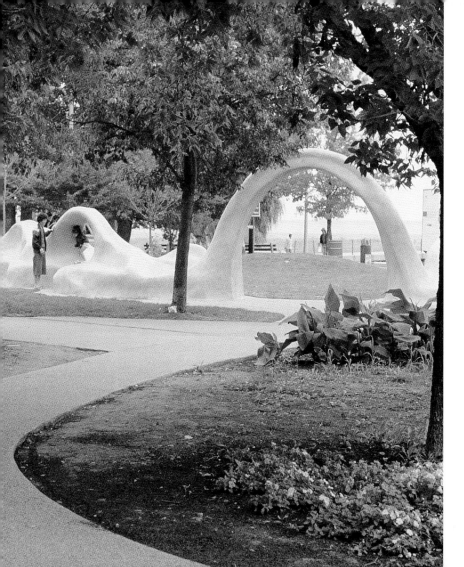

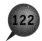

## WINDFORM 1985

**LYNN TAKATA**
**Pratt Boulevard Park**

This free-formed concrete sculpture was created with the aid of a multigenerational group of community volunteers as a way to revive a neglected common area at the south end of Loyola Beach. The piece's long, flowing forms and rounded recesses invite climbing and lounging. (CMG)

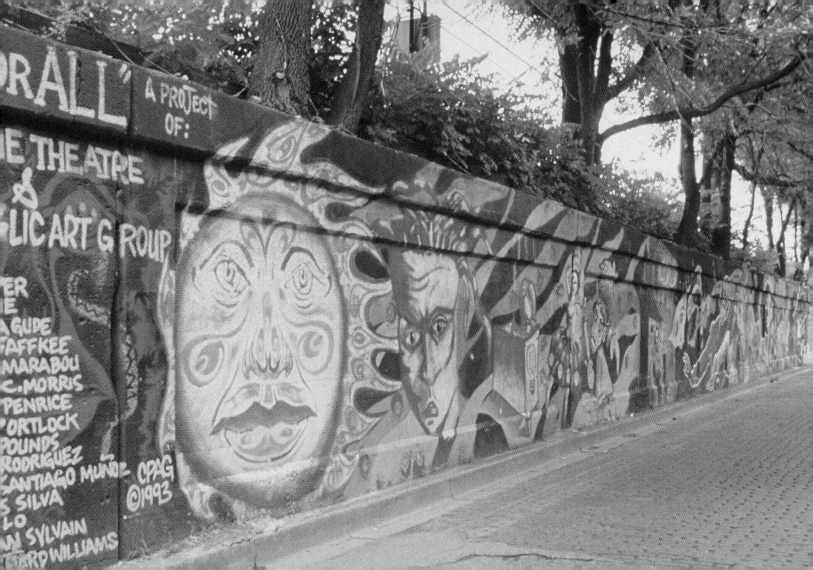

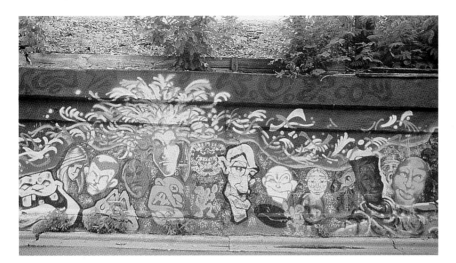

## ARTS FOR ALL 1993

### ARTIST COLLABORATION
### 6900 block of N. Glenwood Ave.

This groundbreaking piece, the result of a CPAG-initiated Spray Mural Workshop coordinated by Olivia Gude and Dzine, provided muralists and graffiti artists the unique opportunity to learn about each other's techniques and styles. The spray and brush artists formed pairs to collaborate on sections of the 350-foot-long wall. The entire block-long mural was completed in a mere two days! The project was cosponsored by Lifeline Theater. In the summer of 1993 **ARTS FOR ALL** was the kickoff to a series of unique NEA-sponsored spray-mural collaborations. (CPAG)

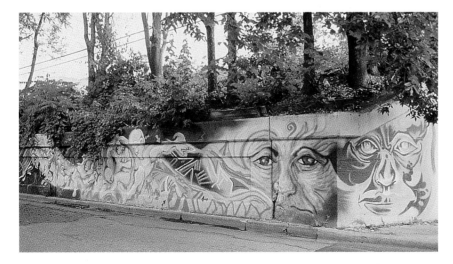

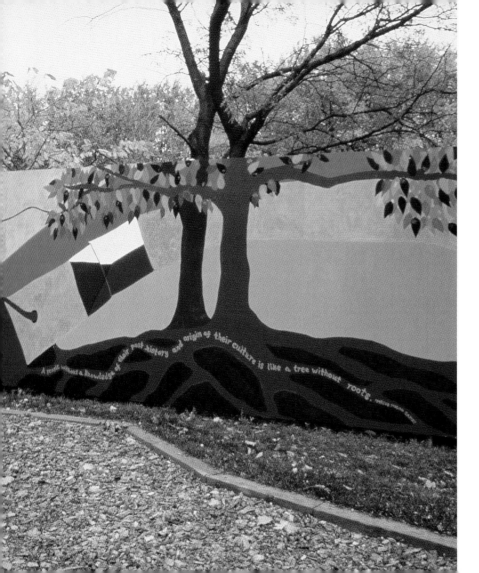

## WALL OF STRUGGLE AND DREAMS 1993

### KIELA SONGHAY SMITH
### Clyde Ave. and Brummel St.

Sparked by a gang shooting that left a thirteen-year-old girl dead, this collaborative mural painted on a plywood fence depicts the dreams and ideals of people in the community, the sharing of culture, and negative realities in the neighborhood. A ribbon of twenty-six flags runs through the length of the 326-foot-long piece, which also features poems, portraits of men, women, and children, and white birds carrying the peoples' dreams to heaven. One hundred forty community volunteers worked on the mural, which was cosponsored by the Evanston Neighborhood Conference as part of the Clyde-Callan Neighbors' efforts to revitalize and reclaim their park. (CPAG)

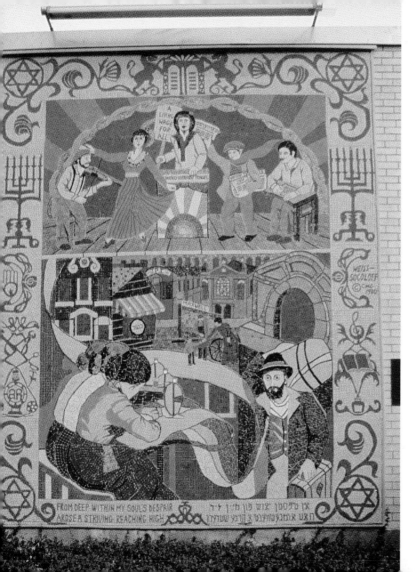

125

# FABRIC OF OUR LIVES 1980

## MIRIAM SOCOLOFF AND CYNTHIA WEISS
## 3003 W. Touhy Ave.

This ceramic- and glass-tile work—CMG's first mosaic—was inspired by a line from Irving Howe's *World of Our Fathers*, "They reached for the heavens with dust on their shoes." The 12-by-14-foot piece depicts the fabric of Jewish immigrant life, labor, and culture in Chicago—from sweatshops and tenements to Yiddish theater and music to the trade union movement and labor organizing. Depicted in the mural's background is the now-lost Maxwell St. market area. The project—which was supported by Jewish agencies as well as historical societies and labor unions—was completed with the help of fifty community volunteers, many of them senior citizens.

This influential piece encouraged numerous Chicago artists to work in the form of community mosaics. CPAG artists, working in various collaborations, have created a unique Chicago mosaic style which is characterized by its stylish and varied tile work. (CPAG)

# SELECTED ARTIST BIOGRAPHIES

**MARCUS AKINLANA** (Mark Jefferson) Akinlana came to Chicago from Washington, D.C., as a teen to attend the School of the Art Institute of Chicago, hoping to connect with the city's mural movement. He established his mural career in the late 1980s through his work with CPAG. He is best known for his use of African spiritual themes in public art. Currently residing in New Orleans, Akinlana, through the Walls of Nyabinghi Mural Society, has received numerous mural and public art commissions in such cities as Denver, Atlanta, and Liverpool, England.

**MIKE ALEWITZ** Founder and artistic director of the Labor Art and Mural Project, Alewitz is also artist-in-residence for the New Jersey Industrial Union Council, AFL-CIO, both based at Rutgers University's Labor Education Center. With union support he has created labor-related murals throughout the country.

**BRIAN BAKKE** Bakke is an artist and director of the Uptown Baptist Church's arts program. His studio work and public art reflect his commitment to Christian values.

**JOSÉ LUIS BERRIOS** A Chicago native of Puerto Rican descent, Berrios is noted for his work with youths in the Logan Square area, where he has led many mural projects. He has often served as an artist-in-residence in schools through Urban Gateways.

**BARRY BRUNER** An early figure in the Chicago mural movement, Bruner directed many student mural projects. He is currently chairperson of the art department at Whitney Young Magnet High School and a rhythm-and-blues bass guitar player.

**NINA SMOOT CAIN** An artist, arts educator, and arts administrator, Cain is among Chicago's foremost community mosaicists. Active with CMG/CPAG since 1982, she has been an artist-in-residence in schools throughout the Chicago area. Cain is also a painting instructor at Roosevelt College.

**CATHERINE CAJANDIG** Longtime art teacher and chairperson at Whitney Young Magnet High School, Cajandig worked in concrete relief, paint, and mosaic with CMG/CPAG in the 1970s and 1980s. She is also a widely exhibited painter and printmaker.

**MITCHELL CATON** (Theodore Burns Mitchell) A key figure in the mural movement, Caton's numerous, Afrocentric collagelike walls (frequently painted with Calvin Jones), and his commitment to representing community issues and values, influenced succeeding generations of muralists. Born in Hot Springs, Arkansas, Caton was also a prolific painter and well-known jazz aficionado. He died in Chicago in 1998 at the age of sixty-seven, leaving behind hundreds of unseen artworks.

**ESTHER CHARBIT** A former longtime teacher and chair of the art department at Lake View High School, Charbit painted several early street murals in Chicago. She created many murals and mosaic projects with her students at Lake View High School.

**JUAN ANGEL CHÁVEZ ESTRADA** Chávez immigrated to Illinois from Chihuahua, Mexico, with his family in 1985; he worked on his first mural as a high school student two years later at Navy Pier in a project directed by Olivia Gude. An active CPAG artist since 1994, working in paint and mosaic, Chávez has also shown artwork at area

galleries and has created many nonpermission pieces, often using urban detritus.

**JEFFREY COOK** Cook, raised in Chicago's South Shore community, is a sculptor who currently lives in Baltimore, Maryland.

**CARLOS CORTEZ** Born in Milwaukee of Mexican-Indian and German parents, Cortez—who moved to Chicago in 1965—has inspired generations of socially committed artists. A longtime Industrial Workers of the World union member, Cortez incorporates his radical politics in his numerous relief print posters which have been shown in museums and galleries throughout the country. He is also known for his poetry/art books. Although not active as an outdoor muralist since the early 1980s, Cortez has continued to support the movement through his Pilsen mural tours, lectures, and as a CPAG board member.

**MARIAH DE FOREST** A former art history and art professor at various Chicago colleges, de Forest has collaborated on many murals with Hector Duarte. She is also a painter who has exhibited nationally and works as a labor relations consultant.

**JUSTINE DEVAN** Utilizing her teaching experience with children, DeVan led many early CMG projects in community schools. DeVan returned to her Philadelphia home to teach but during the 1970s continued to spend summers in Chicago participating in collaborative mural projects. Now a retired teacher, DeVan is an active artist-in-residence, teacher educator, and sculptor.

**AURELIO DÍAZ TEKPANKALLI** Born in Michoacan, Mexico, Díaz emigrated to the U.S. in 1971 and painted numerous murals in California, Arizona, and New Mexico before moving to Chicago. He was among the most prolific muralists in the 1970s and 1980s, particularly in the Pilsen and Little Village neighborhoods, also continuing to create works in the Southwest. Díaz currently lives in Mexico.

**HECTOR DUARTE** A native of Michoacan, Mexico, Duarte studied at the David Alfaro Siqueiros Mural Workshop in Cuernavaca in 1977; Duarte was chosen to work on the restoration of two of the master's murals in Cuernavaca and Mexico City. He has also painted murals in Zacatecas and Michoacan. In 1985 Duarte moved to Chicago, where he has been active as a muralist and studio artist. He is also a founding member of the Taller Mestizarte (print workshop) in Pilsen.

**DZINE** (Carlos Rolon) Beginning as a graffiti "writer" and influential figure in Chicago's street art underground, Dzine has also done pioneering collaborations with CPAG muralists. He has exhibited his abstract and mixed media paintings at numerous galleries in Chicago, New York, and internationally, and has created spray murals throughout the U.S. as well as in Europe and Africa.

**EUGENE (WADE) EDA** An early contributor to the community mural and Afro-American arts movements, Eda was an important figure in the creation of the *Wall of Respect* and other seminal mural projects in Chicago and Detroit. Eda is an art professor at Kennedy-King College where he has painted numerous indoor murals.

**KATHLEEN FARRELL** Since the mid-1970s when she was with the Public Art Workshop in Chicago, Farrell has had a dual commitment to unionism and art. As a member of United Scenic Artists Union Local 829, Farrell has shown her murals and paintings at numerous labor art exhibits. She is the founder of Friends of Community Public Art in Joliet, Illinois, an organization that has created dozens of mural and mosaic works. Farrell is best known for collaborations with Kathleen Scarboro.

**ASTRID FULLER** A longtime Hyde Park resident, Fuller got her start in murals in 1972 as a volunteer on Yasko's *Under City Stone*. Fuller's outdoor murals which deal with themes of local and national social history were painted on underpasses along the commuter train line between 1973 and 1980.

**STEPHANIE GEORGE** George, a muralist and mosaicist, has worked as an an art educator for a variety of community arts organizations and after-school programs in Chicago.

**JOSÉ GONZÁLEZ** Born in Nuevo León, Mexico, González is a longtime arts and political activist. In 1972 he cofounded MARCH (Movimiento Artístico Chicano) in East Chicago, Indiana. The organization was transplanted to Pilsen in 1974 when he moved to Chicago. In 1980 González was a founding member of MIRA (Mi Raza Arts Consortium), also based in Pilsen. González advocated support for murals in the Mexican community and participated in a number of collaborative mural projects. Also a painter and printmaker, he has organized—and participated in—numerous Latino/Mexicano art events in Chicago and nationally, including the landmark CARA (Chicano Art: Resistance and Affirmation) touring exhibition.

**OLIVIA GUDE** A native of St. Louis, Gude, who began her street-art career doing nonpermission pieces with her partner, Jon Pounds, is a longtime community public artist who has been active with CPAG since 1983. Her many murals and mosaics in various Chicago neighborhoods and around the U.S. have explored interracial relationships and collaborative artmaking. Gude is currently coordinator of the Art Education Program at the University of Illinois at Chicago, where she is an assistant professor in the School of Art and Design.

**JOSÉ GUERRERO** A native of San Antonio, Texas, Guerrero moved to Chicago in 1964 and during his art training was introduced to mural painting by John Pitman Weber. An early Pilsen muralist, he also collaborated on a number of significant early CMG works. He works for the Chicago Park District and is a steward for the Service Employees International Union Local 46. He is also an active member of the Taller Mestizarte. Guerrero's wife, Margaret, has often collaborated with him on mural projects.

**CALVIN JONES** Following a successful advertising career, Jones began painting full time in the 1970s. He codirected and owned AFAM Gallery Studio and Cultural Center in Chicago, and painted numerous murals (all with Mitchell Caton). Jones has exhibited his work throughout the country and was featured in the Museum of Contemporary Art's *Art in Chicago: 1945-1995*.

**KATHRYN KOZAN** A CMG/CPAG artist member in the late 1970s and 1980s, Kozan served as the group's project director from 1984 to 1986.

Kozan, who utilized a trompe l'oeil style in her community murals, now runs Kozan Studios, a commercial mural and design business in Chicago.

**HENRI MARQUET** Marquet is a Paris-based *sculpteur* who has created masonry and cement installations for urban spaces, public squares, and school playgrounds throughout Europe, often with the participation of community residents. With Scotland's David Harding, Marquet inspired Chicago artists to experiment with concrete, sculpture, and space design.

**OSCAR MARTÍNEZ** A native of Ponce, Puerto Rico, Martínez was an early CMG member. He has shown his paintings in many exhibits throughout the Caribbean, Mexico, and the U.S. Trained as a medical illustrator, he is now outreach coordinator for the College of Dentistry at the University of Illinois at Chicago. Martinez spearheads the Latin American Museum of Art project.

**JOE MATUNIS** Matunis, who began his mural career as an assistant in Chicago and Madison, Wisconsin, for Olivia Gude and Jon Pounds, is a practicing artist as well as an art teacher and cofounder of the El Puente Academy for Peace and Justice in Brooklyn, New York.

**FRANCISCO MENDOZA** Involved in community art projects with youth in South Chicago in the mid-1980s, Mendoza is best known as the art teacher and mosaic impresario at Pilsen's Orozco Academy. Under the sponsorship of the Mexican Fine Arts Center Museum, Mendoza has led students on mosaic and mural projects at the school and in surrounding areas.

**MILTON MIZENBURG** Mizenburg, a self-taught woodcarver, utilized a chain saw to fashion African-art-inspired sculptures from tree trunks in his South Side Oakland neighborhood as well as at the Boulevard Arts Center and the Donnelley Center.

**ROBERT MORIARTY** A multidisciplinary artist working in sound, performance, and public art, Moriarty is also a CPAG member and an art teacher at Morton West High School in Berwyn, Illinois. Moriarty has also done nonpermission installations at various street locations.

**ORISEGUN OLOMIDUN** (William Bennett) Olomidun is a painter, sculptor, percussionist, dancer, and folklorist who helped found several African performing troupes in Ohio and Chicago. He runs Mojo Hand Studio, a frame shop and gallery in South Shore. Olomidun has worked with youths through Gallery 37 and CPAG to create mosaic and sculptural works.

**KRISTAL PACHECO** Active in CPAG since 1996, Pacheco, a painter and mosaicist, was the most prominent Mexican-American woman muralist in Chicago in the 1990s.

**RAYMOND PATLÁN** Patlán painted his first mural while serving in Vietnam in the late 1960s. An early, influential participant in the mural movement, both through his CMG and Pilsen-based projects, Patlán left Chicago in 1975 to teach at the University of California at Berkeley. He is now the director of a visual arts center for disabled adults in San Francisco.

**CORINNE PETERSON** A ceramic artist with a longtime association with Lill Street Studios in Chicago, Peterson is also a peace and justice activist and a retired psychotherapist.

**DAVID PHILPOT** Philpot is a self-taught wood sculptor who is primarily known for his intricately carved and embellished walking staffs, for which he has achieved national recognition. A lifelong South Side resident and a community artist often associated with the Boulevard Arts Center, in 1995 he began a series of collaborations with chain saw sculptor, Milton Mizenburg on a number of totemlike sculpures carved from tree trunks.

**TIM PORTLOCK** Portlock is a painter who teaches at the Chicago Academy for the Arts and is now a graduate student in Electronic Visualization at the University of Illinois at Chicago.

**JON POUNDS** Executive director of CPAG since 1988, Pounds was an art teacher in the south suburban Bloom High School District, where he and fellow teacher (and future partner) Olivia Gude implemented a mural program. A CMG/CPAG member since 1983, Pounds has done site-specific temporary outdoor artworks, painted murals, exhibited sculptures and installations at various Chicago museums and galleries, and designed the sculptural forms for public art projects.

**CELIA RADEK** A protégé of Caryl Yasko, Radek directed and participated in many collective CMG murals during the 1970s. She is now a landscape architect in Alexandria, Virginia.

**GAMALIEL RAMIREZ** A Bronx native of Puerto Rican descent, Ramirez moved with his family to Chicago as a youngster. He has worked as an educator and muralist for a variety of community arts organizations. A freelance graphics designer, Ramirez's paintings have been featured in numerous local and national exhibits, including many touring Hispanic art shows. Formerly most active in Chicago's Near Northwest Side Latino communities, he is now committed to developing community public art in South Chicago.

**MARCOS RAYA** An early contributor to the Chicago mural movement, in 1964 Raya moved to Chicago from Guanajuato, Mexico, with his family. A longtime Pilsen resident, Raya maintained a studio and mural workshop at Casa Aztlán from the mid-1970s into the 1980s. Raya's paintings and installations have been shown throughout the U.S., Mexico, and Europe. His work was featured in the Museum of Contemporary Art's *Art in Chicago: 1945-1995.*

**MARK ROGOVIN** An early, seminal muralist, Rogovin was one of the few artists from the U.S. to work under Siqueiros in Mexico in the late 1960s. In 1972 Rogovin founded the Public Art Workshop in Chicago's Austin neighborhood. He was a coauthor with Marie Burton and Holly Highhill of the classic *Mural Manual.* In 1981 he founded the Peace Museum.

**OSCAR ROMERO** A native of Tabasco, Mexico, Romero is a painter and sculptor who has created mural and public art commissions throughout Mexico and Chicago. Romero moved to the U.S. in 1989 and also maintains a studio in Mexico City.

**BEATRIZ SANTIAGO MUÑOZ** Born in Puerto Rico, Santiago is a multidisciplinary artist who frequently works in video. Santiago was active with CPAG during the 1990s. In 1999 Santiago moved to San Juan, Puerto Rico.

**JOSHUA SARANTITIS** A former member of San Francisco's Precita Eyes Muralists, Sarantitis currently lives in Philadelphia, Pennsylvania.

**PHIL SCHUSTER** A Philadelphia native (by way of California) with a background in ceramics, Schuster is Chicago's most active community sculptor. Utilizing such techniques as cast concrete, direct-sculpted concrete, and stone mosaics, Schuster creates playful garden environments and other site-specific projects. A prolific artist, Schuster's reliefs are installed in outdoor locations throughout Chicago.

**C. SIDDHA SILA** (Cleveland Webber) A naprapath, minister, poet, arts educator, and muralist, Siddha got his start in the Chicago mural movement in the early 1970s by lettering inspirational text onto William Walker and Mitchell Caton's murals. In recent years, Sila has created community murals with the sponsorship of CPAG and the Boulevard Arts Center.

**CHRISTOPHER TAVARES SILVA** Silva started tagging at the age of fourteen, but didn't "get serious" about graffiti until he was eighteen when he began thinking of it as a progressive contemporary art form and painted a number of pieces with THC (Three Hearts Club). He first worked with CPAG on a mural and spray collaborative project in 1993 and joined the Group two years later.

**KIELA SONGHAY SMITH** Trained as a photographer, Smith has been active with CPAG since 1990. She specializes in Afrocentric works in the medium of mosaic and has also exhibited her photographs at many Chicago-area venues.

**MIRIAM SOCOLOFF** As an award-winning art teacher and chairperson of the art department at Lake View High School, Socoloff has integrated public art with art education by turning the school into a mosaic art showcase. An early community mosaicist, she has created several mosaic projects with frequent collaborator Cynthia Weiss. Each summer Socoloff directs the Gallery 37/Urban Gateways painted bench project at its downtown site.

**JULIA SOWLES** A former high school student of Pounds and Gude, Sowles learned community public art with CPAG as a volunteer, assistant, and then lead artist. Sowles studied at the Spilimbergo Mosaic School in Italy from 1996 to 1998.

**GINNY SYKES** Sykes is a painter, mosaicist, and educator who has created community artworks in the Uptown neighborhood where she lives. She teaches a class in traditional oil painting techniques at the School of the Art Institute of Chicago.

**DORIAN SYLVAIN** Well known for her scenic design work for African-American theater companies and as a production designer for film and video, Sylvain has created many murals with youths on Chicago's South Side.

**LYNN TAKATA** A pioneer of community public sculpture with CMG/CPAG, Takata was also known for working with children to create whimsical artworks. Takata left Chicago in the late 1980s to work as a landscape designer and community artist in Portland, Oregon.

**RENE TOWNSEND** Townsend, born and raised in East Chicago, was a figure sculptor and residency artist who taught in Chicago schools as well as at the School of the Art Institute. She completed sculpture and mosaic commissions for a variety of public places and institutions, and also exhibited her work in galleries. She died in 1998 at the age of forty-

six. The DuSable Museum is raising funds to cast her papier-maché sculpture of the Amistad children into bronze.

**ROBERTO VALADEZ** A Pilsen-based painter and community artist Valadez was inspired to attend the School of the Art Institute after participating as a youth on the A la Esperanza mural at Juarez High School. In the mid-1980s, he was among the first Chicago artists to lead graffiti writers on outdoor murals and has since directed mural projects for Gallery 37, the Yolocalli Youth Museum, and Pros Arts Studio.

**SALVADOR VEGA** Vega has taught screen printing, sign-making, and painting in many community settings, including Casa Aztlán. Since the mid-1970s he has worked on many commercial and community murals, mostly in Pilsen, and has exhibited his work widely.

**ROMAN VILLARREAL** A self-taught artist, Villarreal created many murals in South Chicago and in recent years has worked with the Boulevard Arts Center to develop its community sculpture garden. Best known for his carved sculptural works in stone and wood, he has exhibited throughout the U.S.

**WILLIAM WALKER** Born in Alabama in 1927, Walker, an organizer of the *Wall of Respect*, is generally regarded as the father of the community mural movement. He first painted indoor murals in Memphis, Nashville, and, with noted art historian Samella Lewis, in Columbus, Ohio. In 1970 he cofounded Chicago Mural Group with John Pitman Weber. Walker's dozens of works in Chicago and Detroit about the urban African-American experience defined the contemporary street mural movement. He resides in the Bronzeville neighborhood in Chicago.

**JOHN PITMAN WEBER** Weber, a Bronx native, is among the nation's preeminent community public artists and activists. He cofounded Chicago Mural Group with William Walker in 1970; in 1977 he coauthored *Toward a People's Art: The Contemporary Mural Movement*, reissued in 1998 by the University of New Mexico Press. Weber has created many murals, mosaics, and sculptures in Chicago as well as in Los Angeles, New York, Paris, and Managua, Nicaragua. A widely exhibited painter and printmaker, Weber has been an art professor at Elmhurst College since 1968.

**CYNTHIA WEISS** Weiss, who lived in Mexico City as a child, is a painter as well as a veteran community public artist and arts educator. A CMG/CPAG member since 1976, she has worked in mosaics since 1980 and is credited with creating the first community mosaic in Chicago. She is also known for her work with CAPE (Chicago Arts Partnerships in Education), an organization that promotes school reform through arts integration in Chicago public schools.

**BERNARD WILLIAMS** Active with CPAG since 1993, Williams's artwork—both his community murals and studio paintings—frequently explores African-American history sources. His paintings have been exhibited in museums and galleries throughout the country. Williams, who teaches at the School of the Art Institute and is a CAPE artist-in-residence, has also restored many classic street murals.

**MARJORIE WOODRUFF** A neighborhood artist and arts educator, Woodruff teaches ceramics at Harold Washington College, Lill Street

Learning Center, and the School of the Art Institute of Chicago's Continuing Education Program.

**JOHN YANCEY** Active as a muralist in Chicago since the mid-1970s, Yancey created a number of community artworks in the late 1980s and early 1990s. He is now a professor at the University of Texas at Austin. He regularly exhibits his work and creates mosaic commissions.

**CARYL YASKO** A founding mother of the Chicago mural movement, Yasko became recognized for her dynamic, large-scale outdoor works. She also created major works in Whitewater, Wisconsin, and Lemont, Illinois. In the late 1970s she relocated to Walworth County in her native Wisconsin, where she is a public artist and an artist-in-residence in schools.

**JEFF ZIMMERMAN** An artist and freelance graphic designer, Zimmerman has painted several outdoor murals for St. Pius Church in Pilsen. He has also created experimental, unsponsored murals around Chicago and several commercial spraypaint and acrylic works with Dzine.

**MIRTES ZWIERZYNSKI** A disciple of Paulo Freire and a political activist who fled her native Brazil for Paris in the early 1970s, since 1984 Zwierzynski has worked with CPAG. A prolific public mosaicist and active studio artist who has exhibited worldwide, she has worked as an artist-in-residence in schools throughout the Chicago area.

# BIBLIOGRAPHY

## BOOKS

Amalgamated Meatcutters and Butcher Workmen of America, AFL-CIO. *Cry for Justice*. Chicago, 1972. (Illustrated booklet on Chicago murals.)

Barnett, Alan W. *Community Murals: The People's Art*. The Art Alliance Press, Inc., Philadelphia, 1984.

Barthelmeh, Volker. *Street Murals*. Alfred A. Knopf, New York, 1982.

Chalfant, Henry, and James Prigoff. *Spraycan Art*. Thames and Hudson Inc., New York, 1987.

Charlot, Jean. *The Mexican Mural Renaissance 1920–1925*. Yale University Press, New Haven, Conn., 1963.

Cockcroft, Eva, and Holly Barnet-Sánchez, eds. *Signs from the Heart: California Chicano Murals*. Social and Public Art Resource Center, Venice, Calif., 1990.

Cockcroft, Eva, John Pitman Weber, and James Cockcroft. *Toward a People's Art: The Contemporary Mural Movement*. E.P. Dutton & Co., Inc., New York, 1977. (Reprint: University of New Mexico Press, Albuquerque, 1998; with additional essays by Tim Drescher, Lucy Lippard, and Ben Keppel.)

Doss, Erika. *Spirit Poles and Flying Pigs: Public Art and Cultural Democracy in American Communities*. Smithsonian Institution Press, Washington, D.C., 1995.

Drescher, Tim. *San Francisco Murals: Community Creates Its Muse*. 3rd ed. Pogo Press, St. Paul, Minn., 1998.

Dunitz, Robin J. *Street Gallery, Guide to Over 1000 Los Angeles Murals*. RJD Enterprises, Los Angeles, 1998. (Second printing)

Dunitz, Robin J., and James Prigoff. *Painting the Towns: Murals of California*. RJD Enterprises, Los Angeles, 1997.

Fulton, Jean, ed. *Art Out There—Toward a Publicly Engaged Art Practice*. School of the Art Institute of Chicago Press, Chicago, 1996.

Harris, Moira F. *Museum of the Streets: Minnesota's Contemporary Outdoor Murals*. Pogo Press, Minneapolis, 1981.

Hurlburt, Laurance P. *The Mexican Muralists in the United States*. University of New Mexico Press, Albuquerque, 1989.

Kahn, Douglas, and Diane Neumaier, eds. *Cultures in Contention*. The Real Comet Press, Seattle, 1985. (Includes "Our People Are Internal Exiles" by Judith Francisca Baca.)

Kenna, Carol, and Steve Lobb. *Mural Manual*. Greenwich Mural Workshop Ltd., London, 1991.

Lacy, Suzanne, ed. *Mapping the Terrain: New Genre Public Art*. Bay Press, Seattle, 1995.

Lippard, Lucy R. *Lure of the Local*. The New Press, New York, 1997.

———. *Mixed Blessings: New Art in Multicultural America*. Pantheon Books, New York, 1990.

Mamary, Ann, and Gertrude James Gonzalez, eds. *Cultural Activism: Poetic Voices, Political Voices*. SUNY Press, New York, 1998. (Includes "Individuals and Elders: Painting in the Streets" by Olivia Gude, Beatriz Santiago Muñoz, and Marcus Akinlana.)

Marling, Karal Ann. *Wall-to-Wall America: A Cultural History of Post-Office Murals in the Great Depression*. University of Minnesota Press, Minneapolis, 1982.

O'Connor, Francis V. *Art for the Millions*. New York Graphic Society, Ltd., New York, 1973. (Essays by artists and administrators of the WPA Federal Art Project.)

Rogovin, Mark, Marie Burton, and Holly Highfill. *Mural Manual*. Tim Drescher, ed. Beacon Press, Boston, 1975.

Sorell, Victor, ed. *Guide to Chicago Murals: Yesterday and Today*. Chicago Council on Fine Arts, Chicago, 1979. (Booklet)

Stiles, Kristine, and Peter Selz, eds. *Theories and Documents of Contemporary Art*. University of California Press, Berkeley, 1996. (Includes "Murals as People's Art" by John Pitman Weber; originally published in *Liberation*, September 1971.)

## ARTICLES

Gude, Olivia. "An Aesthetics of Collaboration." *Art Journal*, Vol. 48, No. 4 (Winter 1989): pp. 321–323.

———. "Beyond Monological Monuments: The possibility of heteroglossia in public space." *Public Art Review* (Spring/Summer 1995): pp. 40–41.

——— and Beatriz Santiago Muñoz. "Two Women on the Street." *Feminist Studies Journal*, Vol. 20, No. 2 (Summer 1994): pp. 301–317.

Hoyt, Roger. "The Explosion of a Dominant Art Form: Chicago's Murals." *Chicago History* (Spring/Summer 1974): pp. 28–35.

Huebner, Jeff. "Dangerous Women." *Chicago Reader* (September 8, 1995): pp. 1, 22–31.

———. "God Guided His Chainsaw: Milton Mizenburg's stunning totem poles." *Chicago Reader* (November 26, 1999): pp. 1, 20–26.

———. "The Man Behind the Wall: Thirty years ago Bill Walker helped start an art revolution." *Chicago Reader* (August 29, 1997): pp. 1, 14–32.

———. "Moving Pictures: Mural artist John Pitman Weber reflects on the slow process of change." *Chicago Reader* (December 18, 1998): pp. 14–19.

———. "Olivia Gude speaks your mind." *Chicago Reader* (January 27, 1995): p. 6.

———. "The Outlaw Artist of 18th Street: Marcos Raya, his life, his work, his demon." *Chicago Reader* (February 2, 1996): pp. 1, 10–19.

———. "Painting Large: Hector Duarte and Mariah de Forest bring art to the Swap-O-Rama." *Chicago Reader* (October 29, 1993): pp. 1, 14–17.

———. "Peace and Salvation: It's All in the Wall." *New City* (March 29, 1990): pp. 1, 8–9.

———. "Public Displays of Inspiration: Phil Schuster leaves his mark on West Town." *Chicago Reader* (September 19, 1997): pp. 16–17.

———. "Public Gude: Artist takes her activism to canvas of the people." *Chicago Tribune* (February 4, 1996) Section 13: p. 3.

———. "Up From the Underground: Graff Art in Chicago." *Public Art Review* (Spring/Summer 1995): pp. 38–39.

———. "Wailing Walls: Mitchell Caton's murals had the sting and swing of great jazz." *Chicago Reader* (February 27, 1998): p. 14.

Kerson, Roger. "A Bridge Between Neighborhoods." *Chicago Reader* (February 3, 1989): pp. 8–10.

Krantz, Clair Wolf. "Art's Chicago Public: The Mural Movement." *New Art Examiner* (May 1996): pp. 23–29.

Nathan, Debbie. "Painting in the Streets." *Chicago Reader* (December 17, 1982): pp. 1, 14, 16, 18, 20, 22, 24, 26–27, 30–35.

Obejas, Achy. "Don't just sit there: Navy Pier benches teach seat of the pants history." *Chicago Tribune* (August 4, 1996) Section 7: p. 5.

Patner, Andrew. "Chicago Public Art Group." *High Performance* (Spring 1993): pp. 26–27.

Sweet, Kimberly. "Local Color: the murals and mosaics of Olivia Gude." *The University of Chicago Magazine*, Volume 88, Number 5 (June 1996): pp. 14–19.

Weber, John Pitman. "Community Sculpture." *Art and Artists* (February 1982).

–––. "From the Other Side: Public Artists on Public Art," *Art Journal*, Vol. 48, No. 4 (Winter 1989): pp. 344–345.

## EXHIBITION CATALOGS

"The Barrio Murals." Mexican Fine Arts Center Museum, Chicago, July 21–September 1, 1987. Essays by René Arceo and Mark Rogovin.

"Chicano Art: Resistance and Affirmation." Wight Art Gallery, University of California, Los Angeles, September 9–December 9, 1990. Edited by Richard Griswold de Castillo, Teresa McKenna, and Yvonne Yarbro Bejarano.

"Culture in Action." A public art program of Sculpture Chicago, 1993. Essays by Mary Jane Jacob, Michael Brenson, and Eva M. Olson. Bay Press, Seattle, 1995.

"Healing Walls: Murals and Community, a Chicago History." State of Illinois Center Art Gallery, Chicago, October 27, 1995–January 26, 1996. CD-ROM by Judith Burson Lloyd.

"John Pitman Weber: Art of Social Conscience." Valparaiso University Museum of Art, Valparaiso, Indiana, January 17–February 21, 1996. Essay by Shifra Goldman.

"Murals for the People." Museum of Contemporary Art, Chicago, February–March 1971. *The Artists' Statement* by William Walker, John Weber, Eugene Eda, and Mark Rogovin.

"The People's Art: Black Murals, 1967–1978." The African American Historical and Cultural Museum, Philadelphia, 1986. Essay by Jeff Donaldson, "Upside the Wall: An Artist's Retrospective Look at the Original *Wall of Respect.*"

## NEWSLETTERS AND MAGAZINES

*Chicago Mural Group/Public Artworks* (newsletter), 1984–1985. Editor, Kathy Kozan. (CPAG Archives)

*Chicago Public Art Group* (newsletter), 1985–1986. Editor, Kathy Kozan. (CPAG Archives)

*Chicago Public Art Group Newsmagazine*, 1994–present. Editors, Olivia Gude, Jeff Huebner, Eben Smith, John Pitman Weber. Chicago Public Art Group, 1259 S. Wabash Ave., Chicago, Ill. 60605.

*Community Murals Magazine*, 1978–1987, Berkeley, California. Some back issues available from *CMM*, 1019 Stattuck Ave., Berkeley, Calif., 94707.

*Mural Conservancy of Los Angeles Newsletter*, 1990–present. Mural
Conservancy of Los Angeles, P.O. Box 5843, Sherman Oaks, Calif.
91413-5483.

## UNPUBLISHED WORKS

Cedrins, Inara. *Community Activism and the Arts in Pilsen 1968–1998:
Thirty Years of Radical Change.* M.A. thesis, School of the Art Institute of
Chicago, 1998.

Final project reports of Chicago Mural Group and Chicago Public Art
Group. (CPAG Archives)

# IT TAKES A COMMUNITY!

Community public art in Chicago has been sponsored and funded by many organizations and individuals. The contributions range from brushes donated by the local hardware store to the many dollars of donations from neighborhood residents to generous support from foundations interested in developing community culture as a means to create a unique and beautiful city.

Most community art projects are created with the conceptual, aesthetic, emotional, spiritual, financial, and physical support of a cosponsoring organization. These groups are often initiators of community art projects, contacting artists or arts groups to help them create a new vision of and for their communities.

We would like to recognize the many cosponsors and supporters of the community public art movement. We realize the hopelessness of being totally comprehensive in this task. If we missed your organization let us know so that we can include it next time.

Aids Foundation of Chicago

Albany Park Branch Library

Albizu Campos Cultural Center

Aldo Castillo Gallery

Amalgamated Clothing and Textile Workers

American Friends Service Committee

American Indian Health Services

American National Bank Foundation

Ames Middle School

Amundsen High School

Andrew Jackson Language Academy

Anshe Emet

archi-treasures

Arie and Ida Crown Memorial

Arts Matter Foundation

Association House of Chicago

AT&T Foundation

Atlas Center

Beacon Street Gallery

Bernard Horwich Community Center

Bethel New Life

Better Boys Foundation

The Blue Gargoyle

Bluma Goldman Foundation

Boulevard Arts Center

Boys and Girls Clubs of Chicago

Bruegger's Bagels

Butz Foundation

Cameron School

Canal Corridor Association

Casa Juan Diego

Center for New Horizons

Centre Social-Pessac

Chicago Botanic Garden

Chicago Committee on Korean-
American Concerns

Chicago Community Trust

Chicago Defender

Chicago Department of Cultural Affairs

Chicago Department of Transportation

Chicago Housing Authority

Chicago Park District

Chicago Peace Garden

Chicago Public Library Blue Skies

Chicago Sun-Times

Chicago Transit Authority

Chicago Youth Centers

Chinese Mutual Aid Association

Collins High School

Commonwealth Edison

Community Arts Partnership in
Education

Community Economic and Development
Association

Community Police Partnership

Crane High School

Creative Reuse Warehouse

Douglas Branch Library

DuSable High School

Eckhart Park Fieldhouse

Elliot Donnelley Chicago Youth Center

Esperanza Community Services

Evanston Neighborhood Conference

Farragut Career Academy

Fellowship House

Fel-Pro Mecklenberger

Frente Auténtico del Trabajo

Friends of Lake View High School

F.U.T.U.R.E. Foundation

Galileo Scholastic Academy of Math
and Science

Gallery 37

GATX Corporation

Gaylord and Dorothy Donnelley
Foundation

Gill Park Co-op

Graham Foundation

Greeley School

Harken Foundation

Harper High School

Healey School

Henry Booth House

Housing Opportunities
for Women

Howland School of the Arts

Human Relations Foundation of Chicago

Illinois Arts Council

Illinois Humanities Council

Irving School

Jensen School

John D. and Catherine T. MacArthur Foundation

John Hope Community Academy

Joliet Artist League

Jones Community Academy

Karibuni Place

Kennedy King College

Lake View East Chamber of Commerce

Lake View High School

Lakefront SRO

Latin America Defense Organization

Latino United Community Housing Association

Latino Youth

Lemont Artists Guild

Lifeline Theater

Lincoln Park Children's Zoo

Looking for America

Lowell School

Maine Township High School District 207

Malcolm X College

Marwen Foundation

Mayer and Morris Kaplan Family Foundation

Mayor's Office of Employment and Training

Mayor's Office of Workforce Development

Metropolitan Pier and Exposition Authority

Mexican Fine Arts Center and Museum

Mi Raza Arts Consortium

Mid South Planning and Development Commission

Monroe School

Morris Community Cultural Arts Association

Mount Sinai Hospital Medical Center

Mozart Park

National Endowment for the Arts

Near North Montessori School

Neighborhood Arts Program of the City of Chicago

The Neighborhood Institute

New City YMCA

New Horizons Center

Nicholson School

Nobel School

Northern Trust Company

Northwest Youth Outreach Services

Open Lands Project

Oppenheimer Foundation

Orr Community Academy

Ottawa Main Street

Parish of the Holy Covenant

Polk Bros. Foundation

Portage Park Animal Hospital

Project Artreach

Prologue Alternative High School

Pulaski Community Academy

Regal Theater

Roberto Clemente High School

Robeson High School

Rogers Park Historical Society

Ruiz Belvis Cultural Center

Saint Benedict's Academy

Saint Pius Parish

Sara Lee Foundation

Schurz High School

Senn Academy

South Shore Bank Corporation

Southwest Catholic Cluster Project

Southwest Community Congress

Spalding High School

Steinmetz Academic Centre

Stockton School

Stone Community Academy

Su Casa

360° Communications

United Electrical Workers of America

United Methodist Church

University Village Association

Uptown Baptist/Jesus People Church

Uptown Library

Uptown Youthnet

Urban Gateways

Visitation Grammar School

VOA Associates Inc.

Waters School

Wells Community Academy

Wendell Phillips High School

Wirth School

Wolff Clements and Associates, Ltd.

Woman Made Gallery

WPWR-TV Channel 50 Foundation

Young Chicago Authors

Youth Service Project

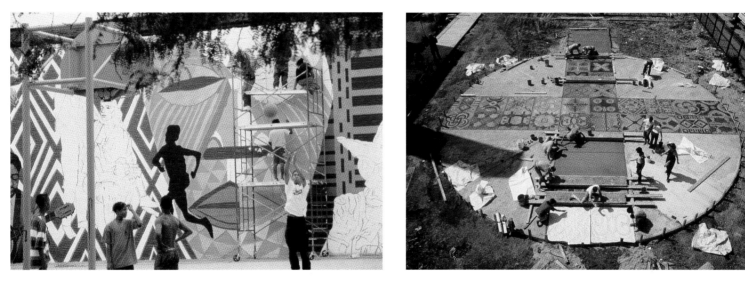

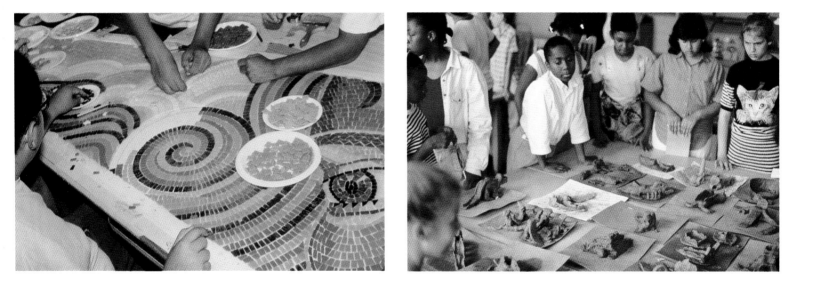

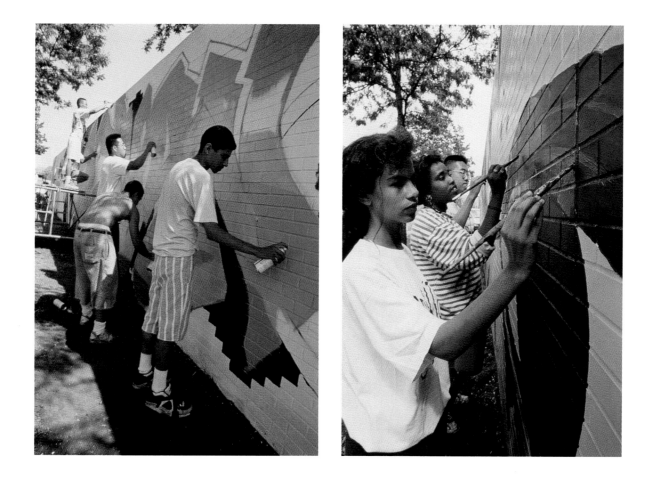

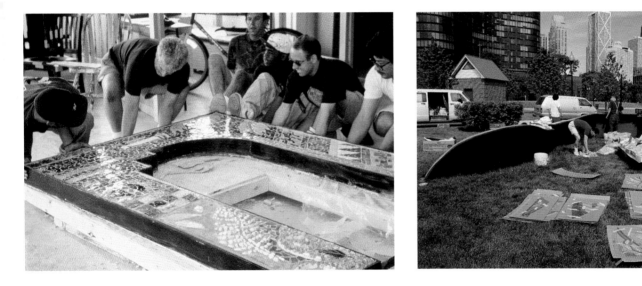

# PHOTO CREDITS

Unless otherwise noted, the photographs in this book were drawn from Chicago Public Art Group archives. If the photographer of a work is identified in the archives, it is noted in the list below.

Photographs on pages 108 and 109 by Anthony D. Allen.

Photograph on page 116 by Hector Duarte.

Photograph on  page 70 courtesy of Astrid Fuller.

Photographs on pages 23, 24, 46, 47, 73, 75, 82, 87, 98, 131, 134, 136, 139, 143, 166, 167, 174, 175, 181, 196, 197, 212, 216, 239 (right), 240 (left), and 241 by GudePounds.

Photographs on pages 26, 45, 56, 63, 64, 69, 81, 117, 118–119, 129, 168, 193, 194, and 210 by Sofya Hatten.

Photographs on page 214–215 courtesy of Mark Nelson.

Photographs on pages 29, 30, 96–97, 99, 104, 105, 126, 132, 133, 140, 141, 162, 176, 187, 190, 191, 198, 199, 200, 204, 205, 213, and 242 (right) by Mark Pokempner.

Photographs on pages 21, 48–49, 52, 53, 54–55, 57, 62 (lower), 65, 66, 67, 74, 80, 83, 100–101, 102, 113, 114, 115, 124–125, 127, 128, 130, 137, 138, 156, 163, 164, 165, 170, 171 (lower), 173, 184, 185, 188–189, 192, 206, 218, and 219 by James Prigoff.

Photograph on page 18 by Mark Rogovin.

Photographs on pages 186 and 201 by Phil Schuster.

*Wall of Respect* photograph on page 16 by Bobby Sengstacke.

Donnelley Center photo on page 33 by Jennifer Swenson.

Photographs on pages 58–59, 72, 110, 111, 123, 143, 154, 171 (upper), 178, and 179 by John Pitman Weber.

Photographs on pages 158 and 159 courtesy of Marjorie Woodruff.

## SLIDE AVAILABILITY

Many images of extant as well as lost artworks mentioned in this book are available in slide form from Davis Art Slides. Call for information and prices: 1-800-533-2847.

# CPAG ARCHIVES

In 1989, recognizing the value of preserving the history of the Chicago mural movement, CPAG embarked on the mission of reconstructing a complete archive of its early years. Since that time the archive project has expanded to collecting documentation of all Chicago community murals.

The following people have been instrumental in the restoration and expansion of the CPAG archives: Lenore Fleming, Olivia Gude, Sofya Hatten, Frank Mitchell, Jon Pounds, James Prigoff, Karin Warch, and John Pitman Weber.

If you or someone you know has slides, photographs, or other materials documenting the early years of the mural movement, please consider donating the original or a copy to the CPAG archives. Doing so will guarantee that these images are available to future generations of scholars and mural lovers.

Contact: Chicago Public Art Group, 1259 South Wabash Avenue, Chicago, Illinois 60605
312-427-2724

# ABBREVIATIONS

| | | | | |
|---|---|---|---|---|
| **CETA** | Comprehensive Employment Training Act | | **MFACM** | Mexican Fine Arts Center Museum |
| **CHA** | Chicago Housing Authority | | **MIRA** | Mi Raza Arts Consortium |
| **CMG** | Chicago Mural Group | | **NEA** | National Endowment for the Arts |
| **CPAG** | Chicago Public Art Group | | **RK** | Righteous Kreativity Productions |
| **CTA** | Chicago Transit Authority | | **SCC** | Southwest Community Congress |
| **CYC** | Chicago Youth Centers | | **SYSC** | Southwest Youth Service Collaborative |
| **MARCH** | Movimiento Artístico Chicano | | **WPA** | Works Progress Administration |
| **METRA** | Metropolitan Rail Authority | | **YSP** | Youth Service Project |

# INDEX *(Works of art appear in boldface)*

# THE AUTHORS

**JEFF HUEBNER** is an arts journalist and writer who has written on public and community art for many local and national publications including the *Chicago Reader*, the *Chicago Tribune*, *Chicago Magazine*, *ARTnews*, *High Performance*, *Labor's Heritage*, *New Art Examiner*, and *Public Art Review*.

**OLIVIA GUDE** is a muralist and mosaicist who writes on community public art and art education. She is an assistant professor in the School of Art and Design at the University of Illinois at Chicago. Her work has appeared in such publications as the *Art Journal*, *Feminist Studies Journal*, and *Public Art Review*, as well as in the book *Cultural Activisms: Poetic Voices, Political Voices*.

Send us names, locations, and photos for works to consider for the next edition.

Olivia Gude and Jeff Huebner
Chicago Public Art Group
1259 South Wabash Avenue
Chicago, Illinois 60605